Victorian Jewelry

Victorian Jewelry

Nancy Armstrong

Macmillan Publishing Co., Inc.

New York

Macmillan Publishing Co., Inc.
866 Third Avenue, New York, N.Y. 10022

Library of Congress Cataloging in Publication Data
Armstrong, Nancy J
 Victorian Jewelry
 "A Studio Vista book"
 Includes index
 1. Jewelry, Victorian I. Title
NK7309.8.A75 739.27'09'034 76-12573
ISBN 0-02-503220-8

First published in Great Britain in 1976
by Studio Vista, an imprint of
Cassell & Collier Macmillan Publishers Ltd.,
35 Red Lion Square, London WC1R 4SG
and at Sydney, Auckland, Toronto, Johannesburg,
an affiliate of Macmillan Inc., New York.

First Printing 1976

Printed in Great Britain

Contents

For my dear friend and guide
Winifred Ward
with love and eternal thanks

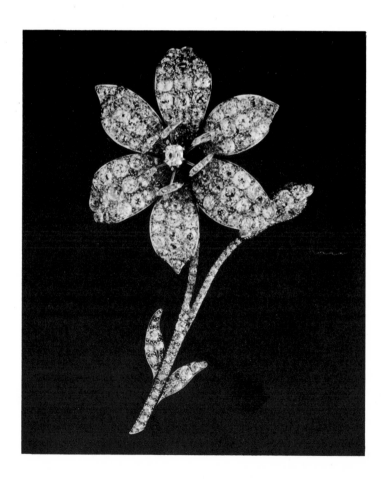

A naturalistic spray brooch showing a lily
set with brilliant-cut diamonds – the
petals curl over convincingly. English, _c._
1845. Courtesy of Collingwood of
Conduit Street Ltd.

Preface

I speak on the subject of jewelry up and down the country in Britain, Europe and America, and on all aspects of jewelry at that, from ancient gold to modern brilliance. But by far the most popular aspect of the subject is Victorian jewelry. People find it hard to tear themselves away and, until the hall closes, member after member of each Club or Society keep coming up to have a word about some treasure they own. Shyly I am often shown a delicate pendant-brooch of gold set with peridots and seed pearls, a small amethyst heart, a mourning jewel of black and white enamel and a section (covered with crystal) of finely plaited hair – and I am both asked about it *and* told about it. The answers are relatively easy, the confidences are fascinating because it is just this quality of question and answer which makes Victorian jewelry so intriguing.

'Tell me why it is *this* shape' they ask – and I do – and then the story comes pouring out: 'You see, it belonged to my twin sister (she died abroad in very tragic circumstances) and it was left to her by our Grandmother, and so it eventually came to me. But I loved them both so dearly and it is all I have left of them.'

So often Victorian jewelry is a last link with a half-remembered past, far too dear for money to buy or insurance payments to replace, a tangible and often beautiful reminder of someone deeply loved. Much that I am shown is worth little in financial terms but it is treasured like the Crown Jewels for its own sake. I can look and I can give historical facts for its making or details about stones or metals, but mainly the value of such lectures and talks is the time that I can take to listen. Treated like an old friend I listen attentively to a really private background story and see uncovered, for so short a time, a hidden facet of a stranger's life.

'I've never heard that before, Margaret, and I've known you fifty years,' has often been said by a by-stander. 'I know, I don't like to talk about it, but its different today,' is the reply. Different? Yes, because it has opened up a hidden corner of a woman's emotions. Englishwomen are shy to show how much they care, but if you show you care too and can add to their treasure in some small way, then they blossom. Most people who own Victorian jewelry are people with tender and wistful hearts and who love beautiful things of the past.

1. A new Era

Queen Victoria reigned for sixty-three years, the longest reign in English history. Born on 24 May 1819, a Gemini according to her stars, the only child of George III's fourth son, Edward, Duke of Kent, and his wife, Victoria Maria Louisa of Saxe-Coburg. She was christened Alexandrina Victoria, and she became Queen of England on 20 June 1837, when her uncle William IV died. Almost a year to the day later she was crowned (28 June 1838) and wrote in her diary 'I shall remember this day as the *proudest* of my life.'

England had a certain sense of isolation before Victoria's time but her policy on free trade led to a definite rapport with many other countries. The exciting development of her industries during productive years revolutionized the whole social structure in the country; now the middle classes came into prominence with the spread of wealth, which again reflected back into the factories, the machines and trade in general. As the monarch was young and gay she enjoyed change, colour and variety in her clothes and accessories and jewels, and those of her own age-group were delighted to take her lead, to copy her when and however they could.

The Queen was to have an extraordinary rapport with her beloved people which lasted to the end of her days. Even though she spent too long wrapped up in her sorrow and morbid introspection after Albert's death, her Golden Jubilee celebrations revived all their smug approval and personal pleasure, and the newspapers underlined her achievements by reminding everyone of the massive benefits which they had acquired during her reign – the railway, Free Trade and exports, the telegraph, progress, prosperity and, above all, peace.

Although Victoria was only eighteen years old everyone had high hopes that youth on the throne would change the tone of the country. Too many recent monarchs had been old or ill or merely incapable; there was now a chance that a youngster (albeit a girl) might be more malleable and lighten the atmosphere – but much would depend on who was chosen as a husband.

They all wanted her to marry, and Victoria did not delay; she did exactly as was expected of her. She married her Prince Albert, younger son of the Duke of Saxe-Coburg-Gotha on 10 February 1840, and

cemented the succession by producing a satisfactory total of four sons and five daughters in twenty-one years of married life.

One strength behind Victoria's reign was that she had inherited the Industrial Revolution. Arnold Toynbee dated the Industrial Revolution from between 1760 and 1840, the years in which steam was brought into use in the textile and iron trades and was applied to land and sea carriage. Britain was pushing forward to come first in many financial races, the most significant of which was the development of the steam locomotive in the face of fierce Continental competition.

Under the new Queen and her Consort the court, which so recently had been an object of scandal, set a national example of sobriety and hard work; austerity now seemed compatible with prosperity, success the reward of virtue. Education seemed to be the key. If a man could read and write he had every advantage over the man who could not. Schools were rapidly being built; education came within the reach of all and the learned part of each community was held in great respect, especially by the middle classes, who saw in their scholars the highest product of their own particular environment. Between the years 1820 and 1860 no-one was more popular in Europe than the professor. By this time it was quite feasible for a man of the lower classes to get a university degree. This was no longer the sole prerogative of his 'betters'. The opportunity of a good education gave the average man a feeling of uplifting optimism. Each person was bent on self-improvement; everyone thirsted for knowledge and wanted to know what was going on, and this state of affairs was one of the most influential in breaking down social barriers.

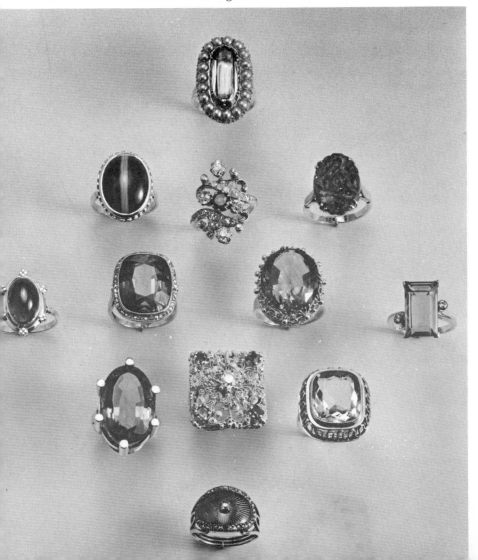

A collection of Victorian rings, showing their great variety. *Top* a foiled topaz with pearls. *First row* a banded onyx, a sapphire with diamonds, carved jade. *Second row* a carbuncle with diamonds, a tourmaline framed with small diamonds, an amethyst set in carved gold and a peridot with two small diamonds. *Third row* a citrine in a pillared setting, cannetille work with a central diamond and four emeralds and an aquamarine set in gold. *Bottom row* a royal blue enamel ring with a central diamond and tiny diamonds forming a frame. English. Mostly mid-Victorian. Courtesy of Cameo Corner Ltd.

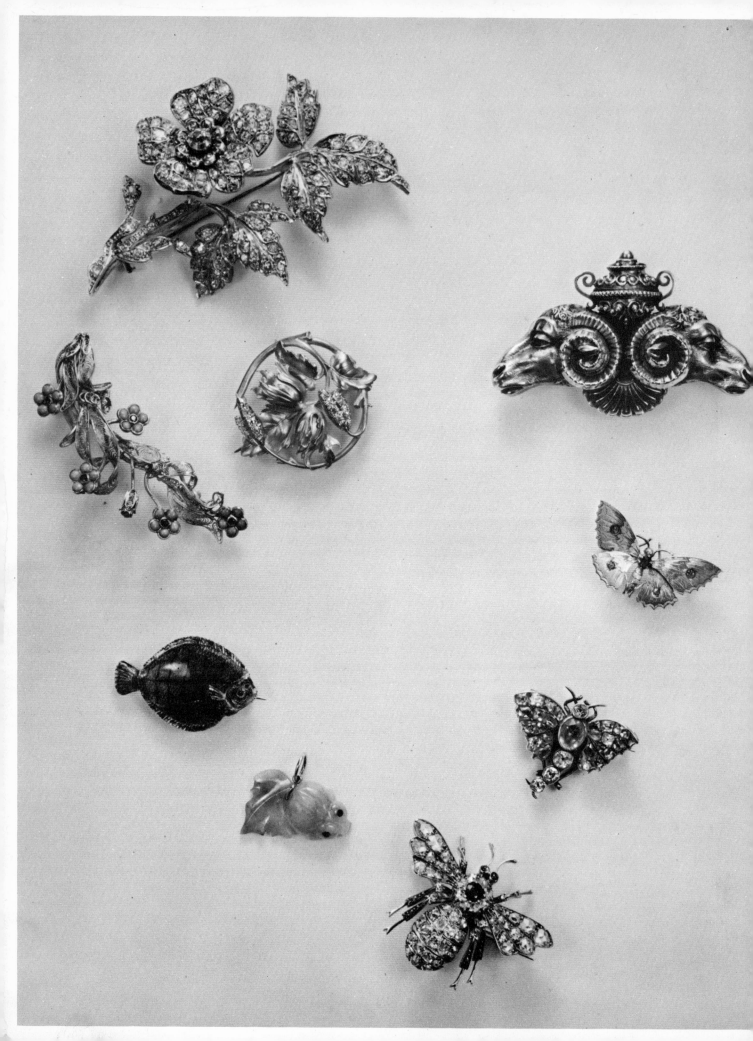

But people needed advice. The written word became gospel and people turned more and more to books. A leader in the *Illustrated London News* of the time wrote:

'There is a fashion in books as well as in everything else. . . . Thus Scott extinguished the Radcliffe school of romances, and found his own poetry extinguished by Byron; thus cookery books flourished for a long season, bringing fortunes to the publishers, and these books on Etiquette have of late occupied so much space in public attention as to demand grave consideration in the pages of the *Quarterly Review*. Of twelve books on the *art* of politeness, which have recently been published in England, twenty-thousand copies have been printed of one, some have run into several new editions, one has reached a fourth edition, another a sixth edition, another a seventh edition, and another, which has taken the lead of them all, has attained an eleventh edition. The audacity with which these books upon etiquette are brought up, is a proof that they are required.'

Hand in hand with the optimism went personal ambition and a strong feeling that national prosperity was everyone's individual responsibility. Although Victoria's early queenhood was not entirely untouched by thoughts of revolution – there were even two attempts on her life by 1840, when she was twenty-one – her perpetual example, enforced by Albert's, together with the nation's deep religious faith, laid the bed-rock of Victorian middle-class respectability and its energetic pursuit of excellence. Hindsight tells us what was achieved at that time, but whilst it was happening it must have been frightening, absorbing, exciting and curiously hopeful. No-one could really see what would happen, and few wished to look back over their shoulders, for they were living for the day and the day ahead.

Politically and economically Britain was getting herself eased into a more comfortable role, the leader, as often as not, in many a commercial venture. For she was expanding the Empire and exploring the commercial world, going into strange countries which offered untapped resources and new ideas in design. But prosperity was on the increase too throughout Europe and North America as industrialization spread.

The style that accompanied this increasing political certainty and growing prosperity was a developed form of Romanticism.

The Romantic movement dominated early Victorian art and design, painting, literature, and the styles of dress and jewelry. It was a fantasy world of back-to-nature, but an idealized nature, perfect, simple and without any of the ugly parts showing at all. Leisured people lived a good deal in a dream-world of snow-clad mountains seen in the sunset and wimpled ladies at tournaments, prompted by the novels of Sir Walter Scott and the poetry of Lord Byron, wrenching their minds away from reality and especially from the thoughts and consequences of the French Revolution scarcely fifty years before. People were equally affected by the Industrial Revolution which not only gave European countries the opportunities to develop their factory productions but had other side-effects.

For instance, new machines and tools were developed which aided digging up the ground, especially digging for gold and later digging for

A collection of Victorian brooches. *Top left* a tremblant diamond spray. *Top right* two handsome horned rams' heads with an urn and shell in gold (this Assyrian design motif was popular after Sir Austen Layard's discovery of Nineveh). *Centre right* gold butterfly with 'gypsy' inset diamonds. *Lower right* chrysolite butterfly mounted in silver-gilt. *Bottom* bumble-bee of sapphires and diamonds. *Lower left* a bracelet charm made of a carved jade fish (showing the Japanese influence after 1860). *Centre left* an enamelled plaice, brilliantly golden brown. *Upper left* a spray brooch of gold, turquoises and rubies. *Centre* brooch of gold and diamond hazelnuts. English, all periods. Courtesy of Cameo Corner Ltd.

diamonds and opals ... and digging also meant excavating, and excavations were to mean changes in jewelry styles. Herculaneum and Pompeii had been known as most thrilling sites to excavate since 1711 when the first statues of their ancient civilization (the two cities were buried by lava from Vesuvius in AD79) were brought out through tunnelling into the bowels of the buried city of Herculaneum. Systematic excavation of the cities began in 1748 and continued for years and years – indeed there are parts still being opened up today. Subsequently the French were granted the concession to excavate Pompeii even more thoroughly from 1806 to 1814 during the Napoleonic Empire period, and in the Cavaliere Campana collection in the Louvre (bought by Napoleon in 1860) there are about 1200 pieces of Greek, Etruscan and Roman jewelry ferreted out of Pompeii.

Later in the century we have Heinrich Schliemann with inspired but incredibly lucky finds in Turkey and Greece in the 1860s and 1870s and then Evans's excavations at Knossos on the island of Crete.

What they, and others, were looking for were basically two things: the

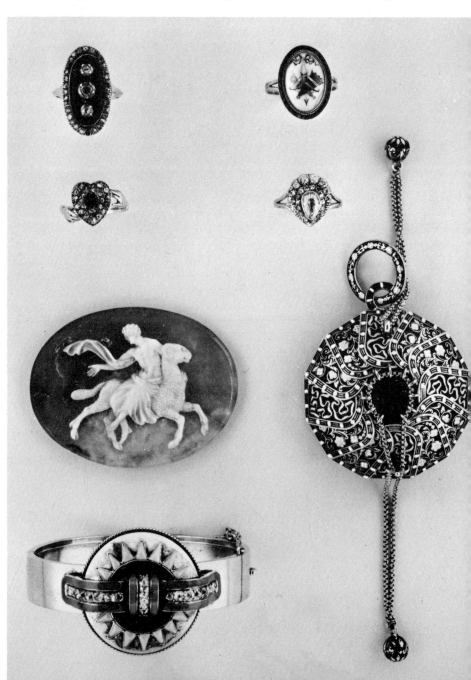

A selection of mid-Victorian jewelry. *Top right* a mourning ring showing a trophy of arms made up from curled hair set under an Essex crystal. *Second right* a ring made of a pear-shaped diamond framed by other graduated diamonds. *Bottom right* a tiny articulated coin purse enamelled in Switzerland. *Bottom left* a heavy gold bangle set with corals and diamonds. *Centre left* an unframed cameo brooch. *Second left* a heart-shaped diamond ring held by two hands, known as a 'Gimmel' ring. The original idea came from Roman rings before the birth of Christ and were known as *fede* rings (from *mane in fede*) and were especially popular in Gothic times. *Top left* oval-shaped ring (very flattering to plump fingers) of navy-blue enamel set with diamonds. English and Swiss, *c.* 1820–60. Courtesy of Madeleine and Elizabeth Popper, Bond Street Antique Centre.

Parisian Ladies, '*Die Frau in Karikatur*' by Fuchs in 1800. This cruel view of fashionable ladies does at least convey the spirit of fashions at the time, with diaphanous materials (sometimes drenched with water to give yet more cling), the interest towards the head, and the floral look, showing botanical exactitude and the general Neo-Greek style throughout. Victoria and Albert Museum, Crown Copyright.

past, no matter when, so that history might be authenticated and scholarship extended – and for precious metals, preferably gold. They found both, and amongst the gold there was a great deal of personal jewelry.

At the end of the eighteenth century design and inspiration was hugely influenced by the excavated past. Painters such as Jacques Louis David meticulously painted 'the Antique' in pictures like *The Oath of the Horatii*; men and women were painted in correctly classical clothes – gone were the Fragonard and Boucher-like dresses of silk brocades interwoven with solid gold or silver thread, and in their place came the severely simple draped dresses in the classical colours of white, gold or purple. No Georgian spray of diamond roses would look suitable on a 'Grecian' dress of white batiste with an embroidered border of purple key frets. If you went to those lengths of looking erudite in your dress it was essential to have the correct jewelry to match.

Later on, in the Victorian era, when fashions changed faster and faster and more and more excavations were uncovered some jewelry designs went on being classical, but the correct alignment of dress and jewelry was drifting apart until there was scarcely any marriage between them at all.

From the 1830s to the 1840s it had been considered rather bad taste to wear too many jewels, at least in Britain, but then the tide turned and they came back in full flood. The jewels worn by the Baroness Rothschild at a masked ball given by the Duc d'Orleans in 1842 were valued at one and a half million francs.

13

Jewels from now on were mainly in the possession of women rather than men. Gradually, as men declined from being peacocks to become reasonably sober-suited hard-working money-earning beings, their wealth was displayed on their wives rather than themselves; whether they cared for it or not women were to become the showcases of their husbands' achievements.

What of the New World? What of the North American continent? On the whole it took a lead from Europe and quickly travelled along the same lines of expansion. The Americans had their successes and their troubles, they took great pride in their new towns and societies and yet it was their general quality of life which troubled them the most in their restless era. Mrs S. T. Martyn (a regular and popular commentator) wrote about their lives in New York in *The Ladies Wreath* of 1848:

'We talk of improvement, and we do truly know more of the arts and sciences, whilst our commerce is gigantic. We can criticize paintings, invent machines, cross the Atlantic in a fortnight, copy European styles of dress pretty faithfully, marry while boys and girls, and rejoice in our multitudinous play houses, but what does it all amount to? Are we any happier? No.

'We have sacrificed the substantials of life, to its follies and its deceptions. To seem great, we are content to be very small. The question is not, "How can we make existence a source of unalloyed enjoyment?" but "How much money can we make, and how many fashionable amusements can we indulge in?"'

In those early years business or mere curiosity took many a man across the Atlantic, looking for his fortune – and a proportion returned bitter and disillusioned at the lack of generosity he found, the constriction of not being able to express his opinions freely, and at the narrow-minded approach of the inhabitants.

General American behaviour, however, had a certain eighteenth-century panache and laxity which, although old-fashioned, gave a sneaking sense of pleasure. Mrs Trollope visited New Orleans and wrote about it in her book of 1832 *Domestic Manners of the Americas*:

'The general manners and habits are very relaxed. The first day of my residence here was Sunday and I was not a little surprised to find in the United States the markets, shops, theatres, circus, and public ball-room open. Gambling houses throng the city; all coffee-houses, together with the exchange, are occupied from morning to night with gamesters. The general style of living is luxurious. The houses are elegantly furnished. The ballroom at Davis' Hotel I have never seen exceeded in splendour. Private dwellings partake of the same character and the ladies dress with expensive elegance.'

The straight-laced behaviour of the social upper-crust had yet to emerge; Americans had much the same way of life as the British. They had their social 'pecking-orders' too, and all their fashion news came from Europe. Men turned to London for their tailors, women turned to Paris for their fashionable ensembles, from the jewelled hat-pins in their millinery to the buckles on their shoes.

Fashion plate from *Courier des Dames* in 1840. Notice the interest on the coiffure with its pearls plaited through the hair, the sloping shoulders and the expanse of flesh now available to decorate. Victoria and Albert Museum, Crown Copyright.

Victoria's influence on dress during the first decade of her reign was nervous and lacked direction. You *had* to follow fashion, however sadly you had fallen on hard times, even if it only meant a new ribbon for the hair. A section of *Cranford*, genteel and shockingly poor, but of the social class who were expected to take a lead, made a tremendous attempt to follow the prevailing modes:

> 'Old gowns, white and venerable collars, any number of brooches, up and down and everywhere (some with dogs' eyes painted on them; some that are like small picture frames with mausoleums and weeping willows neatly executed with hair inside; some, again, with miniatures of ladies and gentlemen sweetly smiling out of a nest of stiff muslin) – old brooches for a permanent ornament, and now caps to suit the fashion of the day; the ladies of *Cranford* always dressed with chaste elegance and propriety, as Miss Barker once prettily expressed it.'

These ladies of fallen gentility were pitiful because an effort of some sort was expected of them all. Nothing at all was expected of the servant class or poor women in rural communities, and they were not encouraged to stretch outside 'their station'. A really poor woman was grateful enough to own a wedding ring and, whilst she was still young enough to have a bloom her man might buy her a trinket or two at a local fair, coloured glass to look like a 'sapphire' necklace, or cut steels to look like 'diamonds'. These 'jewels' were commercially made, many in Birmingham, and sold for a few pence; because of their cheapness they simply

Opposite Three superb examples of early nineteenth-century craftsmanship. *Top* textured gold head ornament of a floral design set with flowers of emeralds, rubies and turquoises, which can be dismantled and worn as three separate brooches. By Garrards of Panton Street, *c.* 1820. *Centre* three-coloured gold bracelet set with turquoises, rubies and diamonds, carved gold flowers, etc, *c.* 1825. *Bottom* a gold, enamel, and coloured stone set bracelet of Gothic influence. The circular clasp lifts up to reveal a watch signed by Petit of Paris. French, second quarter of the nineteenth century. Courtesy of Harvey and Gore.

Another selection of 'flower jewels' showing craftwork and no faceted gemstones. *Left* two gold and painted enamel buttons. *Left centre* an Art Nouveau 'iris' brooch. *Centre* bracelet; made from green enamels and gold, very flexible. *Top centre* a pair of pink enamel and gold 'wild rose' earrings. *Top right* an oval brooch and matching earrings of Florentine mosaics. English, all periods. Courtesy of Cameo Corner Ltd.

were never worth re-setting when fashions changed; because of their durability many are to be found today tucked away in some old box in the attic. Some wedding-rings were buried with their owners as being their most dear (and perhaps only) possession, others were worn by a daughter in remembrance, others were melted down for their value.

As for the lady of fashion, the lady who led the way, the lady with sufficient money to indulge herself with all the latest fads and fancies, she was extremely fussy about the most minute detail of her appearance. From the top of her head to her small, well-shod foot, she was coached by the example of the late Beau Brummel, who was known amongst his other peccadilloes to order his gloves from two firms, one only making the thumbs, the other the four fingers.

The textiles during the earlier part of the century had been light, such as unbleached batiste, water muslin, checked barège and embroidered organdies; the waist slender, the shoulders sloping and broad. The skirt had, at long last, reached the ground again by 1837 and for about twenty years its length remained untouched by fashion as the interest centred on the bodice and the sleeve. There was plenty of colour: a male dandy in 1840 might easily choose a light-blue tail-coat, lilac waist-coat and white trousers. In May 1849 the first number of *David Copperfield* was published and in it Dickens introduced his public to Little Em'ly, who confided to young David that such was her adoration of Mr Peggotty that if she ever became a lady she would 'give him a sky-blue coat with diamond buttons . . . a large gold watch, a silver pipe, and a box of money'. By 1844 the *dernier cri* for a man was to wear a waistcoat of crimson gold-embroidered velvet, or of white satin worked in coloured silks, to be worn with a black dress suit.

It was a colourful time in dress, and jewelry was worn to match.

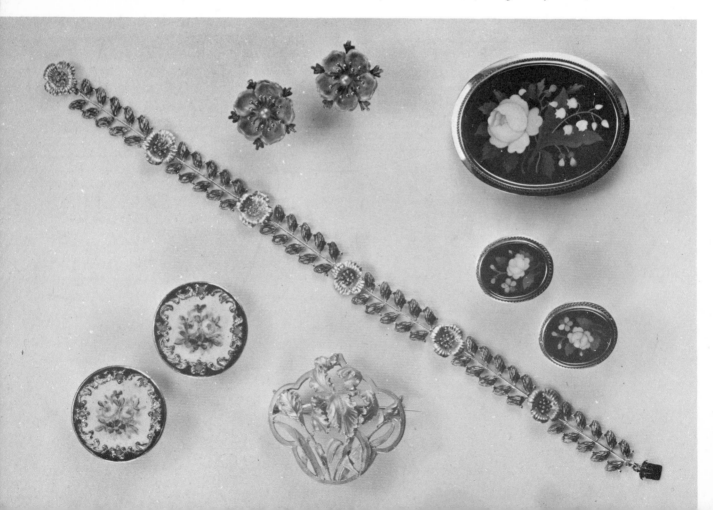

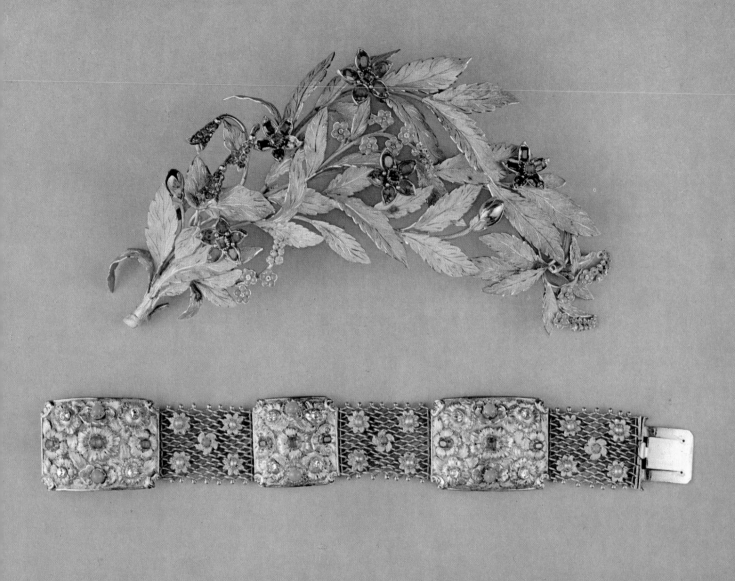

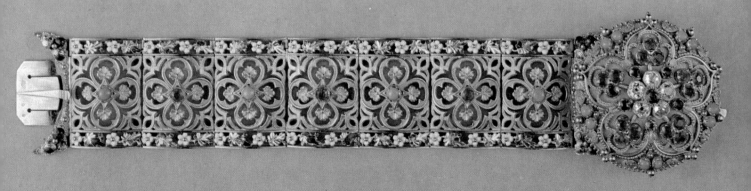

2. Jewelry under the New Queen

A selection of mostly stylized 'flower jewels', all set in gold. The gemstones used are of the cheaper varieties, such as garnets, topazes, turquoises, etc., but they are all most delicate and suitable for the young unmarried girl to wear. English, all periods. Courtesy of Cameo Corner Ltd.

Fashionable girls 'came out' into society around the age of seventeen, were modest and biddable and perfectly aware that their first duty was to take themselves off their parents' hands and marry well. Their clothes reflected this attitude and so did their jewelry. By day they were demure and well-covered up, by the evening a trifle less demure and décolletée; unless they were heiresses (and there were far fewer than we are led to believe by modern novels) they had very little jewelry of their own.

Hair was in ringlets or bunches, combed high at the back, with curls on either side of the face; some of the older women wore turbans, originating in England from the Indian nabobs, and the craze spread rapidly across the heads of Europe. Although younger women wore their hair in long curls on either side of their face, and men spoke of their hair as one of their greatest beauties, it still remained to be 'dressed'. In 1848 the Parisian coiffeur, Croizat, wrote a book about dressing the hair and it ran into five volumes, so it will be no surprise to learn that their shining tresses were adorned with gold and silver fillets, silk and velvet ribbons, feathers, nets of gold thread – or chenille – and veils of blond lace worked with gold.

The wearing of personal ornaments had rather declined for the ten years preceding 1840, so on her arrival into society most certainly her mother, grandmother and possibly her aunts as well would delve into their own jewel-cases and provide her with the necessities of fashionable life – after all, one should never look like a pauper. If she never got married of course she never got the chance of having anything new belonging to herself.

She would almost certainly be lent or given a long, thin gold chain, a small string of pearls, some seed-pearls and a cameo which might be placed upon a velvet ribbon and tied about her throat. If she were lucky she might also be given a small Wedgwood ring set with a border of cut-steels, a locket, a cross, and on her eventual honeymoon perhaps some souvenir jewelry from Rome, Naples or Florence. At her coming-out ball she would be extremely well chaperoned by her Mamma, who would wear jewels suitable for the older woman.

Diamonds were considered unsuitable for the young but could definitely – and preferably – be worn by the older established woman in society. She would also wear other faceted gemstones which began by

18

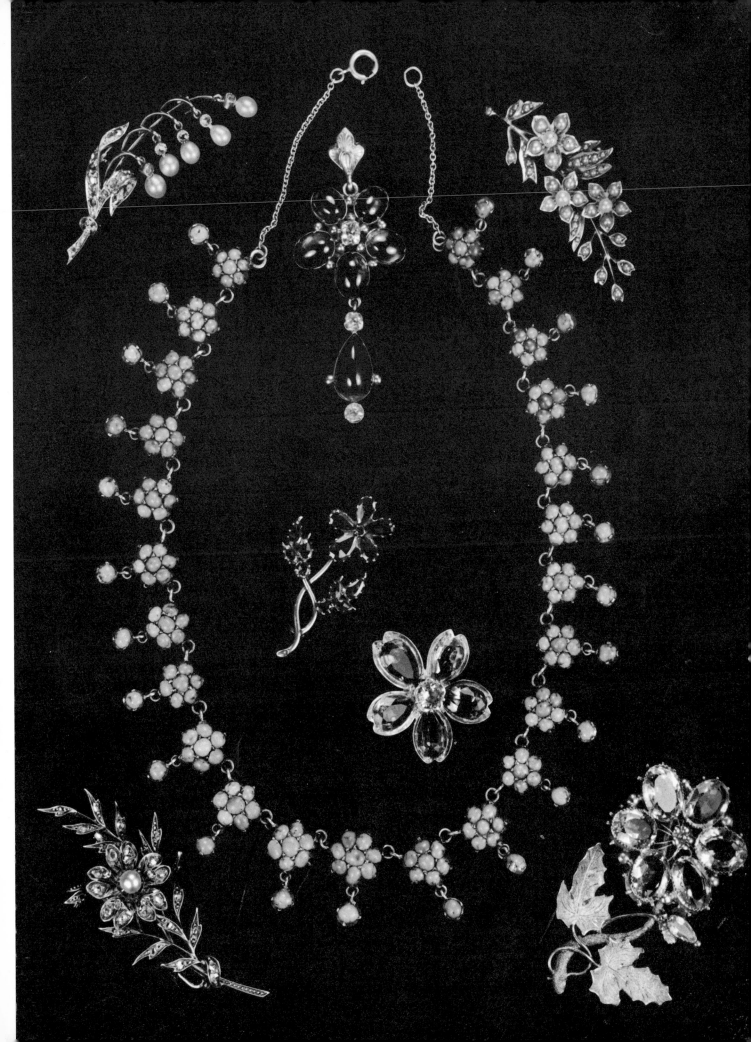

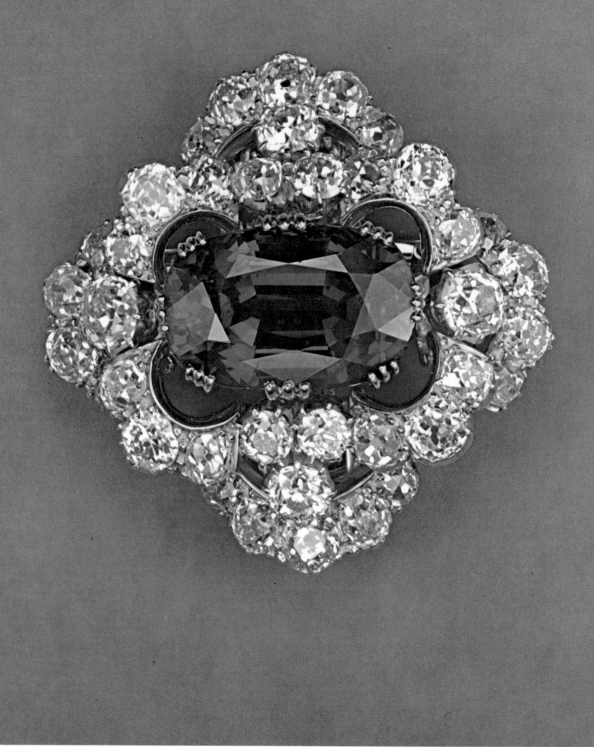

Superb sapphire and diamond brooch. This type of brooch is a hangover from the Georgian period, and because of the use of the deeply coloured sapphire set in gold with brilliant-cut (as opposed to rose-cut) diamonds, its probable date is *c.* 1845. London or Paris. By courtesy of Sotheby and Co.

A parure comprising necklace, earrings, bracelet, brooch and belt buckle in gold with emeralds and diamonds. Possibly Russian, *c.* 1835. Gold was extremely expensive until after the 1848 Gold Rush to California; it then became cheaper, especially after it was found in the Transvaal in 1884. Courtesy of Harvey and Gore.

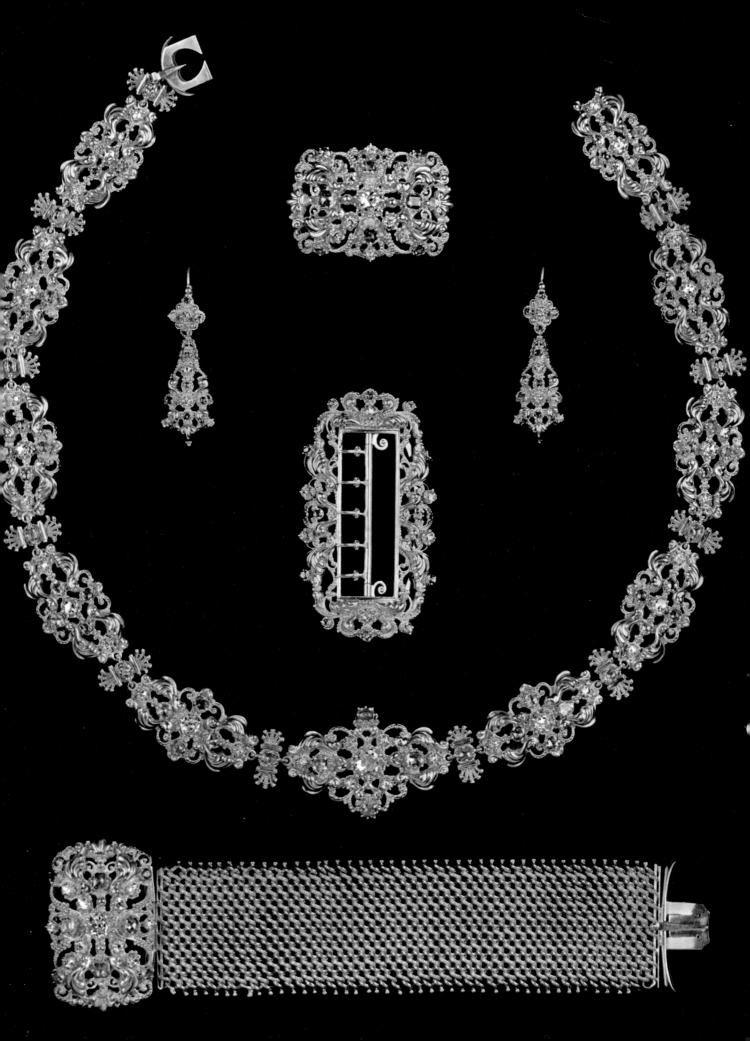

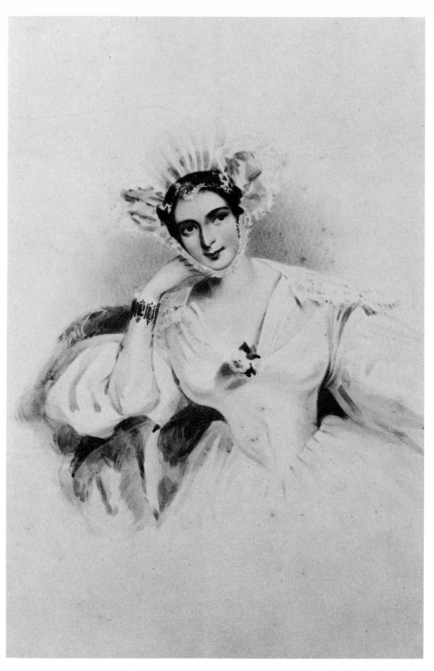

The Countess of Blessington, authoress and friend of Lord Byron. This shows the early fashion in dress as worn in 1834. After Alfred Edward Chalon. National Portrait Gallery, London.

being reasonably small and grew larger and larger until the 1870s when they were vast. These gemstones, some relatively new in fashion, such as amethysts, topazes and peridots, would often be surrounded by a circlet of small diamonds or pearls and worn in parures or demi-parures (matching sets) and mounted in gold.

Combs would spotlight the elaborate dressing of curls and ringlets, diadems would be worn low on the forehead (à la Grecque) or fillets threaded through the curls; or even the extremely fashionable *ferronière*, a brow ornament held by a slender chain and copied from Leonardo da Vinci's painting *La Belle Ferronière*. Then a matching pair of girandole earrings would be worn, where a large stone was set at the top, against the

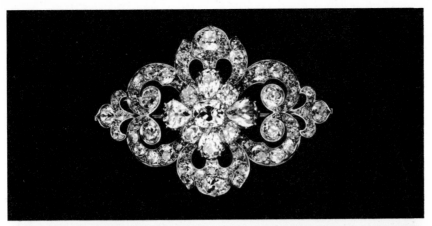

An openwork brooch of brilliant-cut diamonds, showing a central cluster set amongst scrolls. Its stylized form is reminiscent of the work of the Georgian age. There is no added colour but just the flash and sparkle of diamonds, dramatic and theatrical, suitable for the rich married lady. English, *c.* 1840. Courtesy of Collingwood of Conduit Street Ltd.

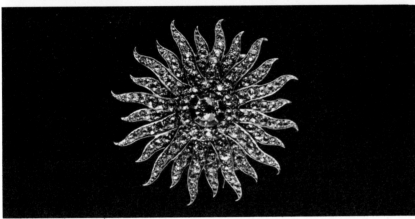

A sunburst diamond brooch, $1\frac{1}{2}$ ins. (3.5 cm) across, sometimes known as 'the sun in splendour' after similar ones worn by Louis XIV. English, *c.* 1845. Courtesy of Cameo Corner Ltd.

A necklace of foiled amethysts and fine goldwork; the draped chains are exceptionally graceful and settle most becomingly about the throat. English, *c.* 1830. Courtesy of Cameo Corner Ltd.

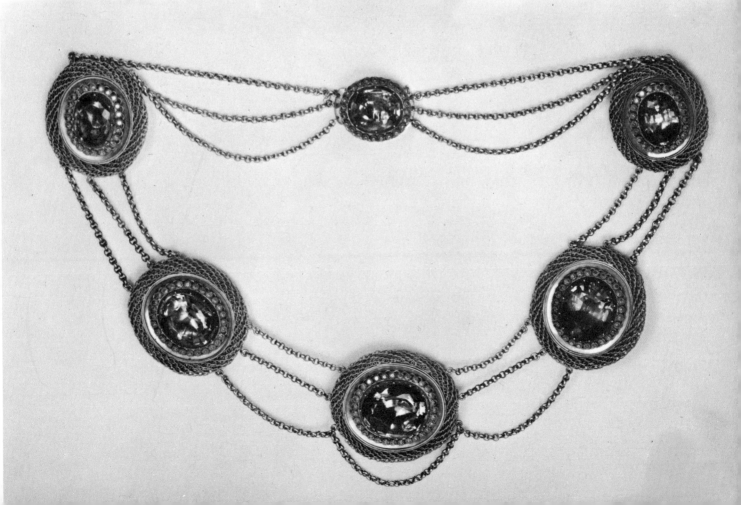

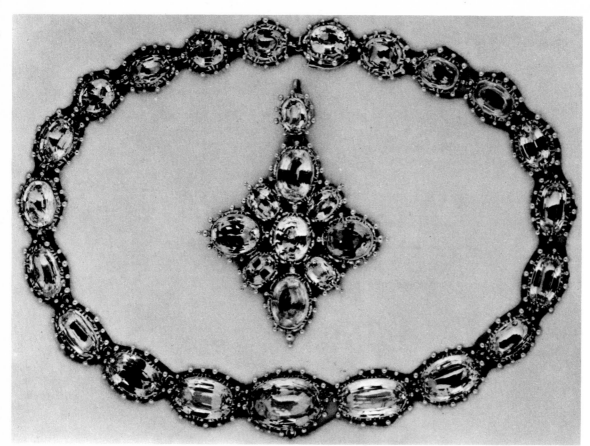

An extremely pretty pink topaz parure set in gold, comprising a necklace, pendant earrings, ring and head ornament. The sharply faceted stones would be foiled and backed to keep a uniform colour. English, *c.* 1840. Courtesy of Collingwood of Conduit Street Ltd.

Opposite Necklace, pendant-cross and earrings, mid nineteenth century, Austrian. These show work 'in the Renaissance style' which was much admired throughout Europe. They could have been copied from any of a dozen Court portraits of the fifteenth or sixteenth centuries when the technique of painting jewelry was at its height – Nicholas Hillyard wrote a complete treatise about it. Courtesy of Sotheby and Co.

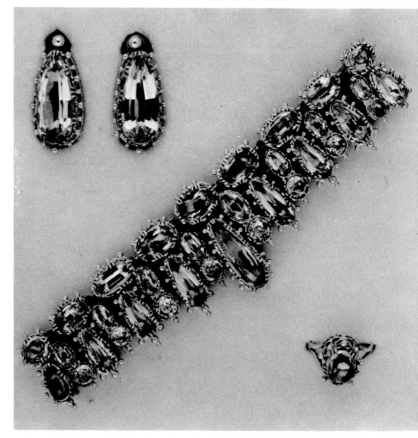

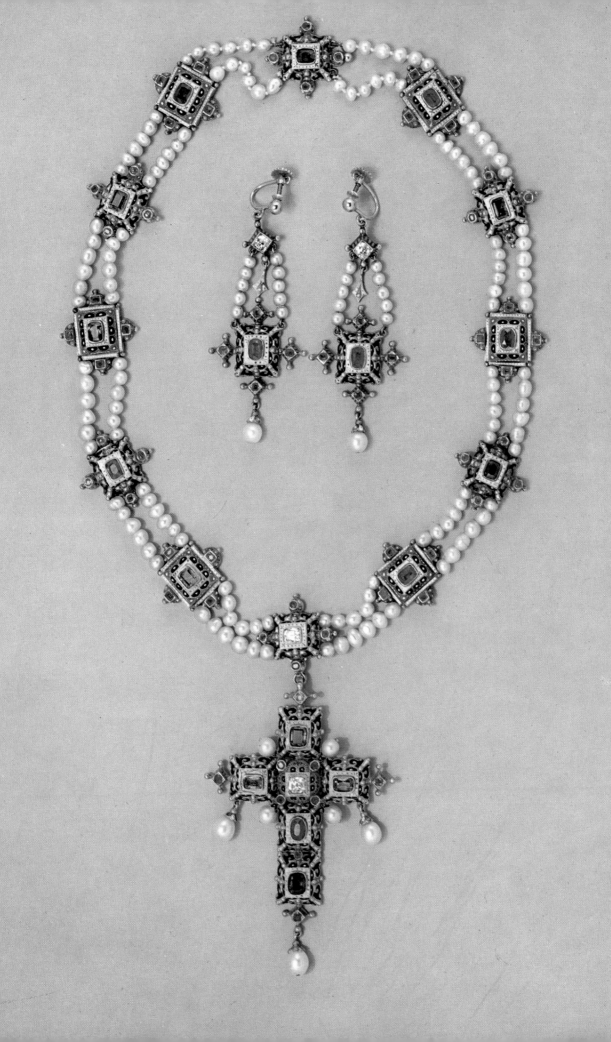

lobe of the ear, from which a hinged section would hang with three pear-shaped drops, the central one being slightly larger than the others; it was a fashion hang-over from Georgian times but no less flattering all the same. To infill the deep neckline and expanse of neck and shoulders the older woman would wear a wide necklace, sometimes the central section mounted in silver, and a matching wide bracelet or solid bangle. Bracelets would be worn in a multitude of ways, as one can see in this report taken from *The World of Fashion* of September 1844:

'Bracelets are now considered indispensable; they are worn in the following manner; on one arm is placed the sentimental bracelet, composed of hair and fastened with some precious relic; the second is a silver enamelled one, having a cross, cassolette, or anchor and heart, as a sort of talisman; the other arm is decorated with a bracelet of gold net work fastened with a simple noeud, similar to one of narrow ribbon; the other composed of medallions of blue enamel, upon which are placed small bouquets of brilliants, the fastening being composed of a single stone; lastly a very broad gold chain, each link separated with a ruby and opal alternate.'

An attractive early nineteenth-century aquamarine and gold cannetille parure comprising a collar, the front with nine oval-shaped stones each set among scallop shells and scrolls, the back composed of double chains of *piqué* links; a pair of girandole earrings and a cruciform brooch-pendant ensuite. English, *c.* 1830. Courtesy of Sotheby and Co.

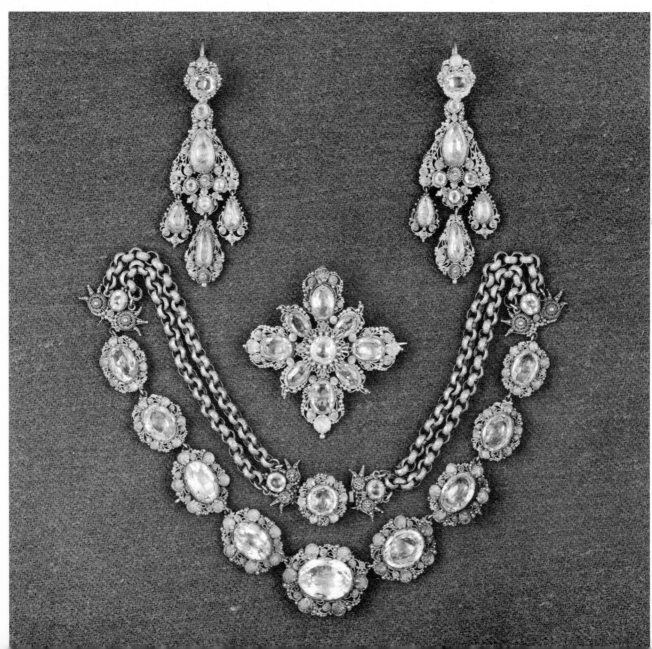

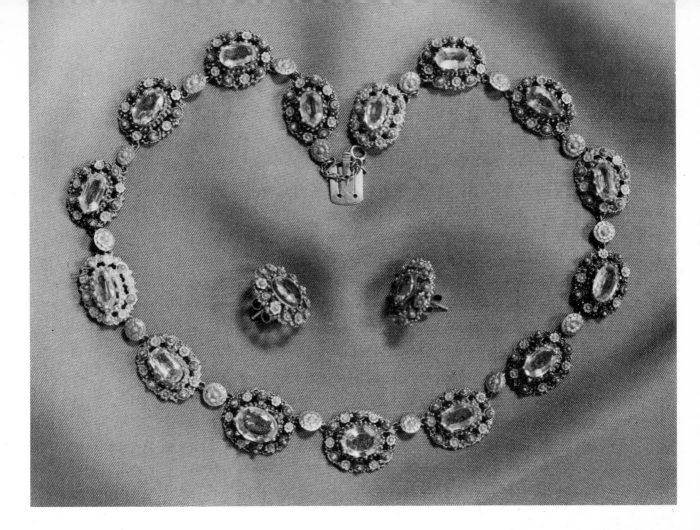

The design motifs for these early Victorian items of jewelry would be centred on birds or serpents or a very few extremely stylized flowers. It is almost impossible to date Victorian jewelry accurately to within twenty years or so, as several styles trickled on through the entire century. Gold dominated the precious metals of the Victorian era, until the last quarter of the century when platinum made its first appearance in fine jewelry. Because the British are essentially a nation who enjoy crafts before art, they treated gold in the nineteenth century with utmost technical virtuosity and played with it and teased it around in ways never all seen before at the same time. They now either hand-wrought it or stamped it out by machines (by 1835); they coloured it, sometimes six different shades by experimenting with different alloys; it was reeded and beaded, bloomed, engraved and etched; enamelled, gem-studded and especially treated in the 'cannetille' fashion, a form of minute filigree and infinitesimally small gold drops.

Lengthy gold chains – they reached to the waist – were made; some were of stamped, rather light metal, showing ordinary oval links, slender cartouches, enamelled serpents, scrolls or rosettes. Others were more elaborate ropes with a special fastening showing a hand, for instance, in gold, with a 'lace' cuff and a tiny ring upon the forefinger. There is a parasol which used to belong to Queen Victoria in her early years, frivolous in pink ribbed silk and lace with a 'push' showing just this type of hand and having minute foiled pink topazes set within the cuff, with a ruby ring on the forefinger.

A necklace and matching earrings of gold filigree and cannetille-work and set with large and glistening yellow citrines. The earrings suited the contemporary hairstyles which were swept up and away from the face and falling into ringlets behind. English, *c.* 1830. Courtesy of Cameo Corner Ltd.

27

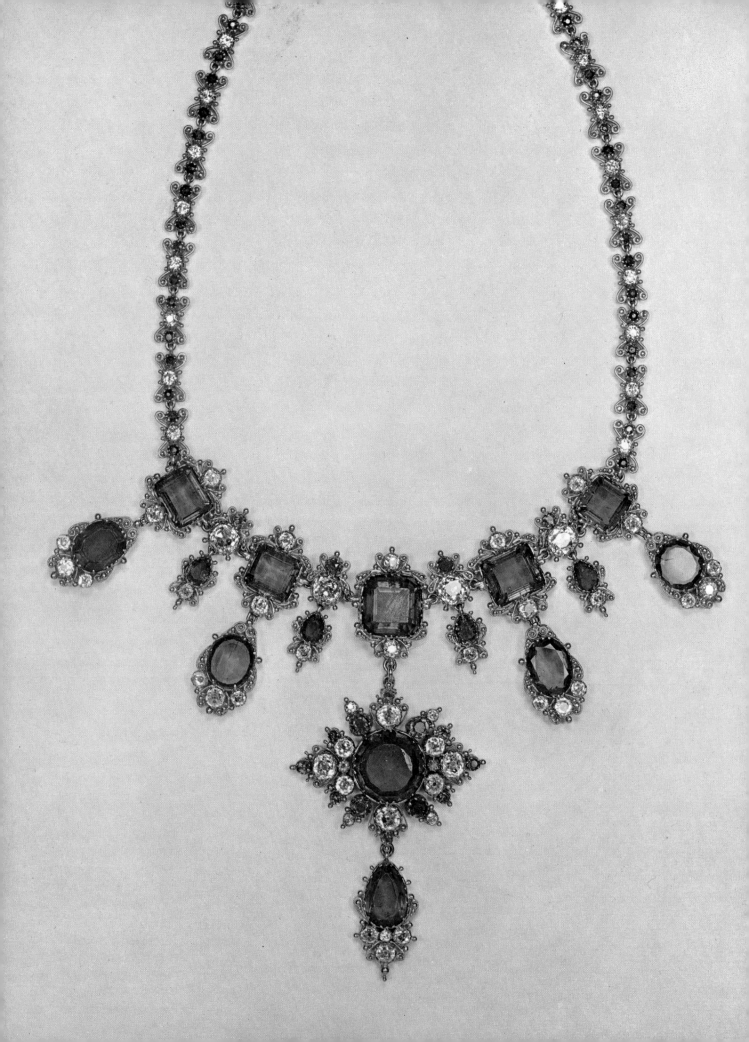

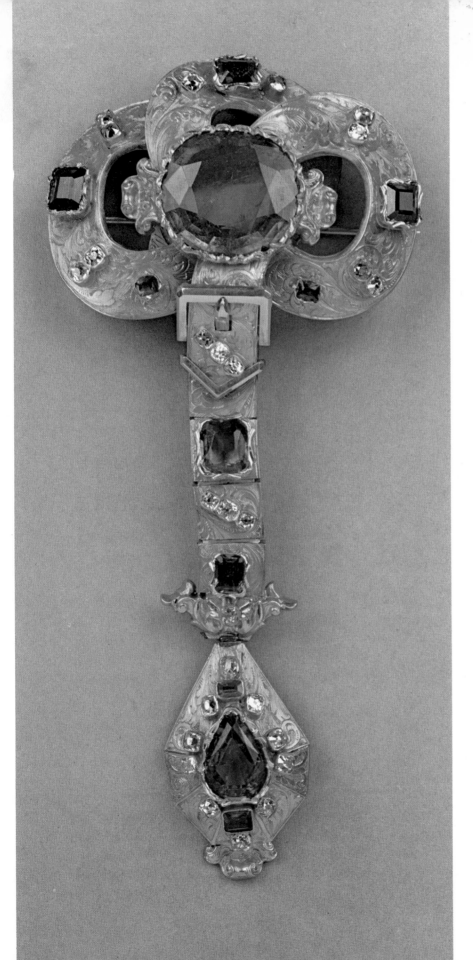

Far Left A magnificent emerald, diamond and gold necklace, *c.* 1850, sold in 1974 for £100,000 ($240,000). Typical of the period is the fact that today we neither know the maker nor its country of origin, and we can only assume it was made in London or Paris. Perhaps for a mistress? Courtesy of Collingwood of Conduit Street Ltd.

A large emerald and diamond bow and strap brooch, *c.* 1855. English or French. The engraving on the gold is of an extremely high quality, a fitting background for this very large and important-looking item. By courtesy of Harvey and Gore.

A suite of turquoise and gold necklace and matching earrings. In wear they would look far lighter, with the skin showing through the gold trellis-work. However this is a good example of how jewelry should always be kept when not in use, in its own shaped velvet-lined case. English *c.* 1840. Courtesy of Collingwood of Conduit Street.

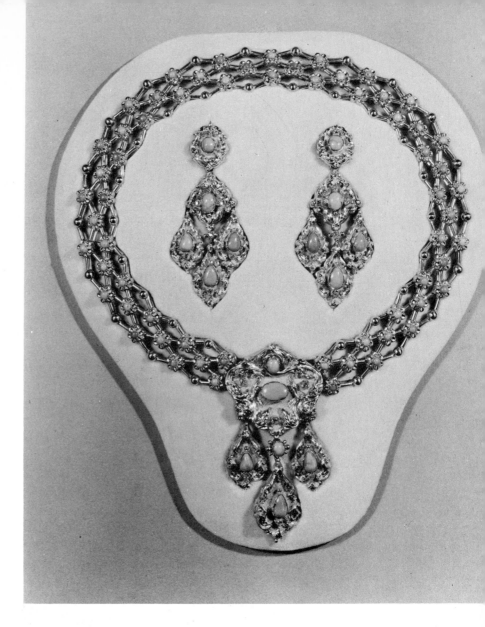

A fob brooch in gold with the central design showing flowers set with corals and diamonds, and having a graduated gold fringe; sometimes these were known as 'bearded fobs'. English *c.* 1850. Courtesy of Cameo Corner Ltd.

Thick gold chokers were also worn, or collars *à la chatelaine* with large flat links, but in the main women preferred the very slender gold chains which they turned to practical uses as well as using them as a fashionable accessory; some held a watch, some held a lorgnette or an eye-glass, some a cross or pendant, fan or muff. Men wore gold chains as well, some were heavy, some ornate, attached to their fob-watches; and chains continued to be worn throughout the Victorian period, showing the very fine craftsmanship of the British jewellers.

As a simple necklace pearls were worn, each bead being spherical and matching in colour, graduating in size until the central pearl was about double the size of those by the snap clasp, and strung with silk, a knot being slid between each. The clasps could be most decorative, set with diamonds or a ruby centred in small diamonds or seed-pearls.

The dependence upon botanical forms in Victorian times is seen most clearly in the formation of seed-pearl jewelry, for many a parure of seed-pearls was created in either strap-work, bunches of grapes or a floral design. The pieces were constructed (there is no other word for such painstaking craftsmanship) on a pierced and fretted mother-of-pearl

backing, onto which were sewn (with a white horse hair or silk) tiny pearls from China or Madras, each weighing half a grain or less in weight. Seed-pearl jewelry was extremely popular for a long time, beginning at the period of the French Revolution (the Ancient Greeks wore pearls and their white colouring fitted in very well in a combination of pure classical ideals and the revolutionary colours) and continuing right up until the 1840s. They had that elusive air of fragility about them which could be worn by the innocent young debutantes very satisfactorily, emphasizing their unsullied youth; but because they were so lightly held in their settings many a set of seed-pearls has now either disintegrated in its case or been discarded because it is not bright enough in tone to wear with modern dress and the products of the aniline dye. Later in the century as their settings became heavier seed pearls were separated from their mother-of-pearl backing and more solidly designed in the Bacchus motif of bunches of grapes and vine-leaves (seen so often in massive Paul Storr silver) and mounted in heavy gold.

The most evocative pieces of Victorian jewelry are cameos, cut steels, lockets, crosses and souvenir mosaics. Cameos came in so many sizes, techniques and compositions; they borrowed freely from the past and gave any wearer the feeling that they had some claim to erudition when

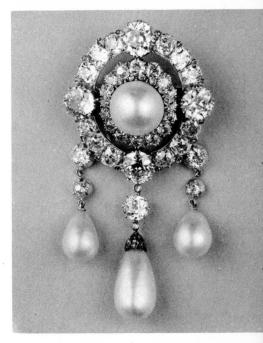

A very fine oriental pearl and diamond cluster brooch. The pair of pearl drops are detachable and can also be worn as earrings. Valued at £20,000 ($42,000) in 1975. English, *c.* 1840. Courtesy of Collingwood of Conduit Street Ltd.

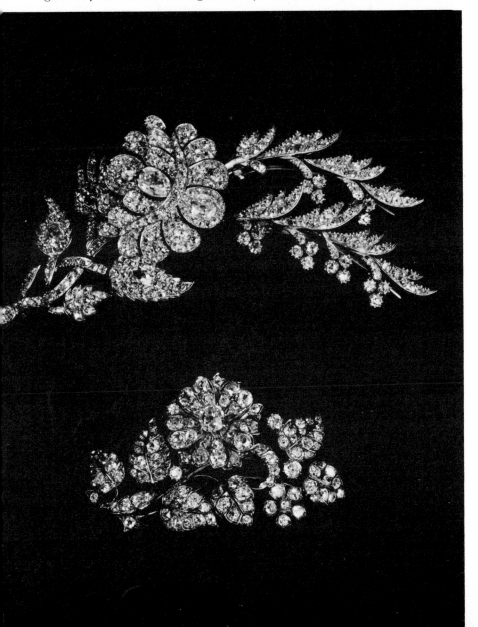

Two naturalistic diamond spray brooches showing wild roses; the larger flower is *pavé*-set with cushion-shaped stones (with two exceptionally large pear-shaped diamonds at the centre) and 'tremblant' upon a spring. Probably English, *c.* 1840. Courtesy of Sotheby & Co.

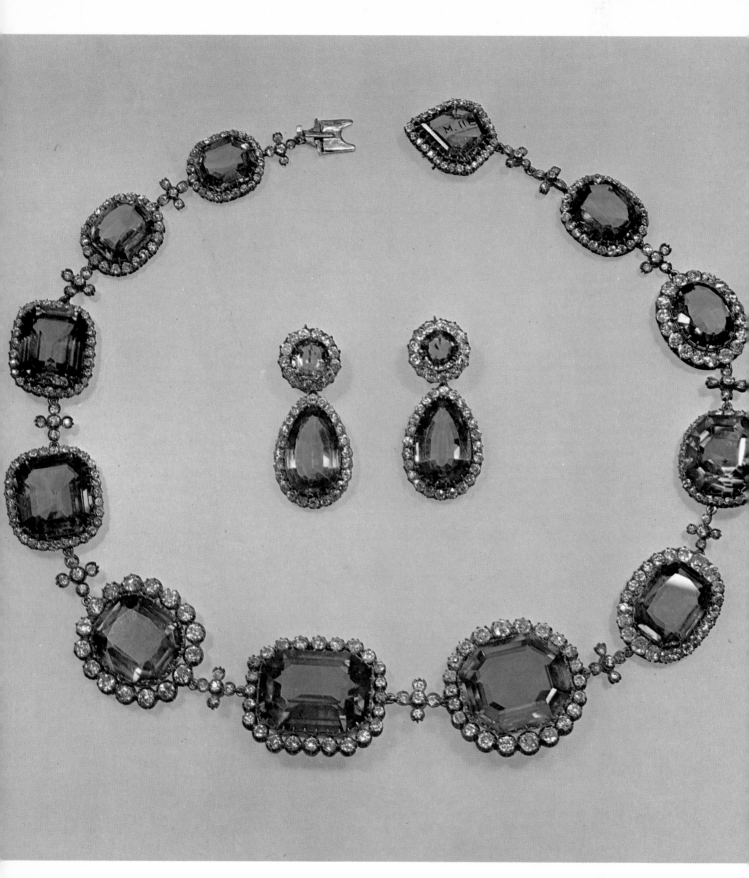

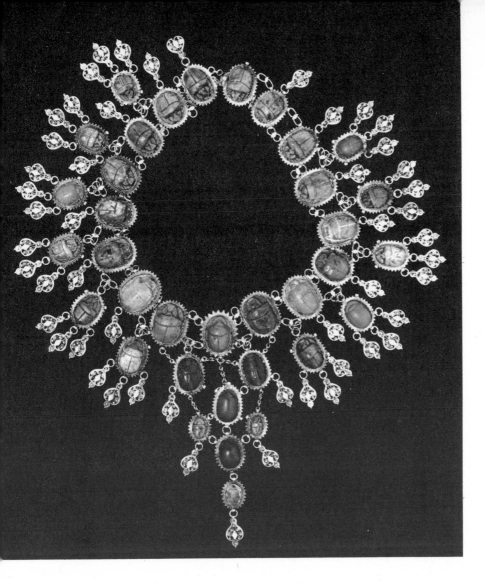

A necklace of mixed scarabs, some ancient, set in decorative cast gold. This type of jewelry appealed to the lady with an 'archeological' turn of mind and reminded people of the exciting excavations in Egypt. French or English, *c.* 1860. Courtesy of Cameo Corner Ltd.

Opposite A handsome necklace of peridot and diamond clusters with matching earrings. These pieces show the interest at that time for large faceted stones, beautifully mounted, and are a great contrast to the later Art Nouveau designs, *c.* 1850. French or English. By courtesy of Collingwood of Conduit Street Ltd.

A lifelike diamond serpent and sword brooch, with the serpent swallowing an oriental pearl. English, *c.* 1840. Courtesy of Collingwood of Conduit Street Ltd.

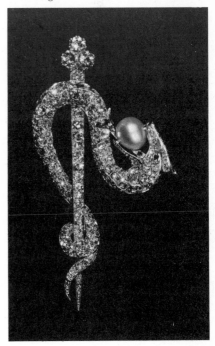

wearing one. Cameo-cutting first reached a peak of craftsmanship during the Hellenistic period of the Greek civilization; then the Romans took up the art and continued it, and both Greek and Roman hardstone cameos have been found in the lands they conquered and colonized. The early ones are miniaturized sculpture carved in relief, a follow-on to the ancient techniques of carving seals.

During the Italian Renaissance there was a revival of the same techniques as well as the re-setting of classical cameos which were being found in newly excavated land, cleared in order to create those masterpieces of Renaissance architecture. They used the old when found, which were venerated because of their historical background and rarity; they fashioned new as well, and they set them both in enamelled gold, sometimes with the addition of gemstones.

During the late eighteenth century and the rise of the Neo-classical movement, they were in fashion again. Copies were made of both classical cameos and the Renaissance ones, and then they made their own modern types which were influenced by the spate of statuary, Greek and Roman – and by now they had learnt to tell the difference – which flooded into England in the wake of travellers on their Grand Tour.

There was such an enthusiasm for them that they almost ran out of materials to make them, and they had to turn to some new techniques.

33

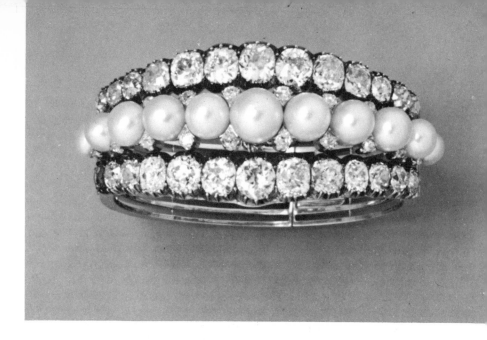

Early Victorian Oriental pearl and diamond bangle, the pearls with small diamonds set in between. English, *c.* 1845. Courtesy of Harvey and Gore Ltd.

Onyx, sardonyx, agate (the traditional materials) were now rivalled by coral, lava and shell. The most mysterious yet exciting to look at were the carved shell cameos which became widely popular and were worn both by day and at night.

Shells, mollusc shells, were cheap and large and you could have matching pieces in the same colouring. At least ten different types of shell were available from the warmer seas. The chief ones used were the pink and white Queen's Conch, the white Black Helmet and the red and white Bull's Mouth. Each of the types of shell evolves in three different layers, giving the craftsman three different colours with which to work. The outer layer is generally completely removed with a file, then there is a white sandwich layer and below this again another coloured layer; the white layer is generally carved in relief against the contrasting background of the coloured layer.

The first shell cameos came from Rome and Naples at the turn of the century, but then Paris and London enticed craftsmen to come and work there and many cameos were seen in exhibitions. Being classical in origin they had no real regional flavour and it is difficult to tell where they originated unless there is a signature (even those could be faked) and trying to tell by the gold mount is equally tricky as many a mount was given to the country at times of war, leaving the older cameo to be subsequently reset.

In the beginning the makers remained faithful to the classical traditions of design. They depicted architectural ruins in simple frames of gold, linked by any number of fine chains, usually either four or six. Then they went into carving the heads of deities, gods and goddesses, with slightly more elaborate mounts and fewer linking chains; followed by complete scenes from Greek and Roman mythology, box-mounted, with reeding and ornamental scrolling, linked by triple chains and occasionally enamelled florets, fastened with lightly enamelled snaps; and then finally they created either copies of well-known Renaissance portraits or contemporary human beings such as Napoleon, the Regent or the Pope in most elaborate frames seen as 'Roman enrichment'.

Cameos (together with intaglios, stones with the design cut deep into the surface instead of being left in high relief) differ from other stones which have facets cut upon them in that gemstones always rely on purity

34

and clarity whereas cameo gemstones make a feature of their impurities and actual lack of clarity. Sometimes the striations of a banded agate, for instance, can create the curve of a cheek or the outline of some classical vase, bringing out the fine techniques of the carver at the same time as highlighting the formation of the stone.

Designers of cameos were often miniaturists of note. Gregoretti in *Jewellery through the Ages* quotes 'De Gault, Sauvage, Parent, de Janvry and Bourgeois who produced paintings en grisaille on blue grounds or in sepia on brown'; Margaret Flower in *Victorian Jewellery* mentions 'at the 1851 Exhibition, we find not only Savalini and Salvator Passamonti of Rome, but Mr Brett of Tyso Street, Wilmington Square' and in 1865 'a young English artist Mr Ronca, created an agreeable sensation by exhibiting at the Royal Academy three cameos carved by him: a bust of the late Prince Consort, a remarkably beautiful head of a young girl, and the helmeted head of Geraint, from Tennyson's *Idylls of the King*.'

The quality of undercutting marks a good cameo, together with certain effects which give a veiled look, showing gauzy draperies blowing

An early Victorian large bouton pearl and diamond star-pendant, English, *c.* 1845, together with a magnificent bracelet. Here there is a massive carved amethyst cameo of a girl's head mounted in a gold frame with flexible bracelet fittings; these are detachable and the cameo can be worn as a pendant. English, dated on the reverse 1854. Courtesy of Harvey and Gore Ltd.

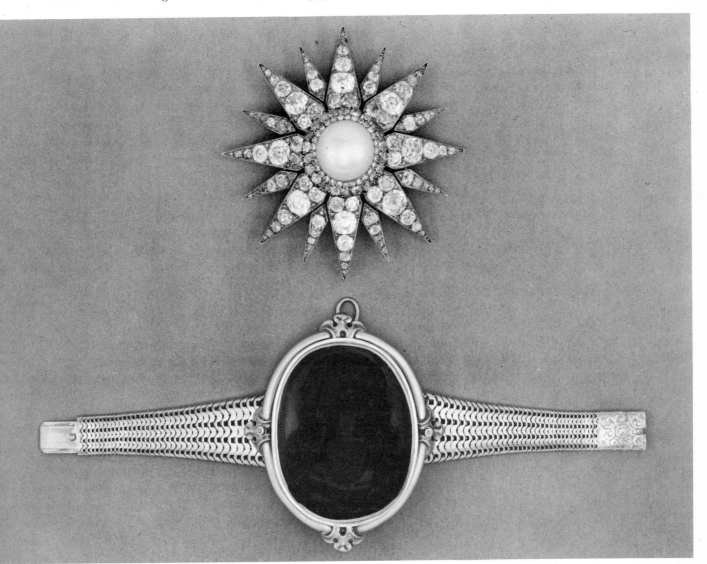

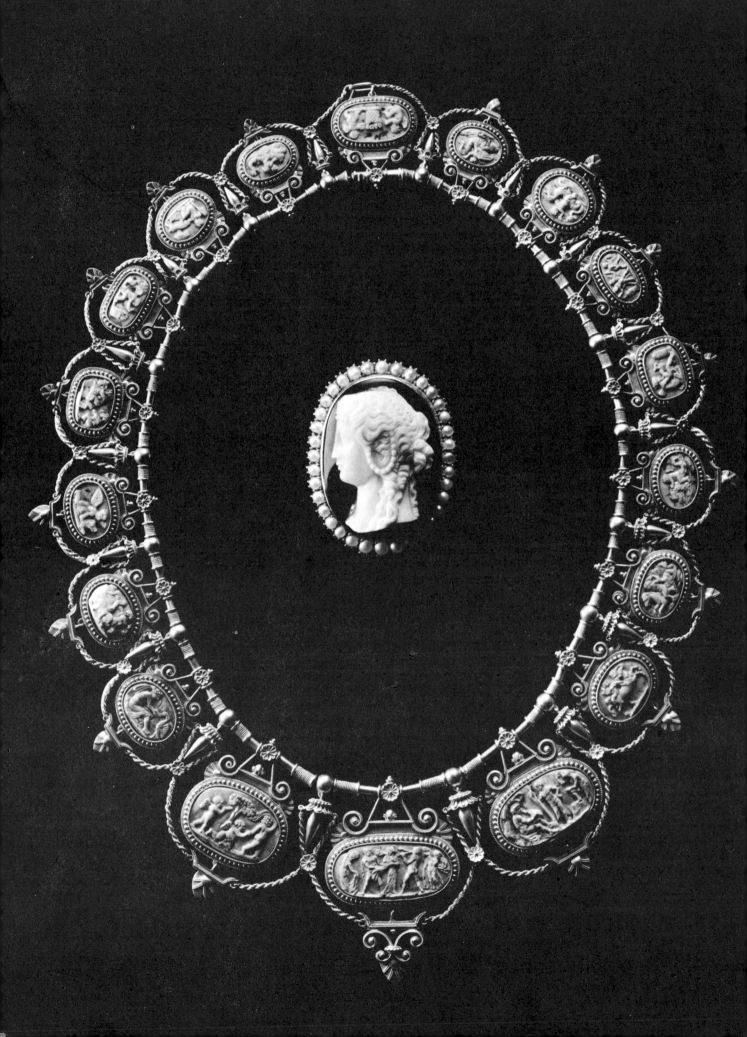

across glowing limbs, as in the finest classical examples; neither technique being satisfactorily copied (as yet) in the contemporary and extremely clever examples of American work in acrylics.

Carving a cameo takes time, patience and very few tools, whether one is working on the relief carving itself, or on cutting away the surround to reveal the coloured background and show various tonal nuances. A shell cameo itself has no intrinsic value (rather the same as the canvas of a painting); what one is paying for is craftsmanship and art – so obviously a quality signed cameo is of more value than an unsigned one.

The principal carvers of cameos came from Italy (Rome and Naples) and Sicily, partly because the materials were available there (sea-shells, coral and lava from Mount Vesuvius) and partly because of the enormous interest shown in the excavations of Herculaneum and Pompeii, making these places prime tourist attractions.

Shell cameos (as well as cameos of hard stones) came in brooches, bracelets or complete parures with earrings and necklace to match, a ring, a pendant and a frontlet or *tour de tête* worn across the brow; they were oval (known as a *garbo*) or circular (a *perla*) and it is said that you can tell the origin of manufacture better by looking at the original jeweller's case. English cases came in red leather with white satin linings and continental cases were of dark green or black leather with matching velvet – but this is only a very rough guide-line if the case is not marked with the maker's name imprinted in gold within the lid.

Cameos are still being made today and are valued almost entirely by the amount of gold or gemstones in the mounts. In the past they could also be set in pinchbeck, or enamelled, and the costliest ones are those furthest away from the original Greek inspiration of purity and simplicity with framing mounts of diamonds, rubies or pearls set in gold, or even cut steels. According to the London shop Cameo Corner the value of cameos has, possibly, increased more than any other form of Victorian jewelry, rising in price and popularity as every year passes.

Cut-steel jewelry has had a very long history in England, beginning in the sixteenth century, reaching a crescendo during the Regency and Victorian periods and made, according to a piece recently seen at Cameo Corner, as late as the 1930s. It is a most worthwhile type of antique to collect and a great deal more research could be carried out on the subject to give some clues as to countries of origin and craftsmen's names.

Marcasites are sometimes confused with cut-steels, but once the technique is properly understood it is absolutely simple to be able to tell the one from the other. It is true that marcasites and cut-steels are both a dense dark-grey in colour, that neither are set with precious gems, and that both will sparkle if turned to catch the light; but there the likeness ends.

The name 'marcasite' is generally applied to iron pyrites, which are cut down into a quantity of minute little stones, like grey diamonds; these are then mounted individually and framed or set in silver. They are expensive when compared with the pyrites, indicating that one is paying almost entirely for the high labour costs.

Cut-steel making was quite different; it is a metalworker's craft carried out in miniature, with patient and expert riveting. First a design is drawn and the main sections are then cut out in thin sheets of metal – brass, silver-alloy, or tin – generally shaped like rosettes. The secret of cut-steel

A small pendant of a carved opal cameo showing a warrior's head. There are touches of white, pink and shaded green enamels and three pearls. By Child and Child, signed with their marigold. English, *c.* 1870. Courtesy of N. Bloom and Son Ltd.

Opposite
A magnificent 'archeological' necklace of carved turquoises showing scenes from mythology. Exhibited at the International Antiques Fair in Bath, but unfortunately it is unsigned. The central brooch shows a cameo of onyx framed by pearls. Italian or French, *c.* 1860. Courtesy of Cameo Corner Ltd.

37

A cut-steels brooch, very early nineteenth century English. This was extremely useful for day-time jewelry, for although it sparkled it did not flash. Courtesy of N. Bloom and Son Ltd.

jewelry was to pack each rosette with as many steel studs as possible, then riveting the rosette onto a base-plate. In marcasite jewelry there are no rivets at all, but in cut-steel jewelry one turns over the piece immediately to look at the number and quality of tiny rivet dots.

The mounted rosettes were joined together by curved sections which were also packed with studs or by links, and which were often strengthened on the reverse if the motifs used were particularly large or heavy. This, however, was rare in the early work since the designers of cut-steel jewelry were aware that too solid a piece would be daunting, depressing and heavy. They strove for an effect of lightness and femininity, using sparkling little rosettes like tiny flowers, spaced apart and joined with undulating curves or open work scrolls. Gradually, developing during the Victorian era, cut-steel designs became heavier and cable-bracelets, heart-shaped locket-clasps, together with butterflies, lizards, stars and crescent moons replaced the light and delicate stylization of the earlier work.

Cut-steels have been expensive in their time. Tiaras, 'stars for the nobility' and chains were obviously worn by the person of some consequence who expected good craftsmanship; one such chain, made in 1813, weighing only two ounces, was sold in France for £170. But on the whole the jewelry was made for more modest pockets and enjoyed by the emergent middle-class; brooches, bracelets, buckles, bangles, necklaces, earrings, buttons, chatelaines and stomachers in varying patterns. Cut-steels were also used to frame a ring or cameo, and sometimes the ring would have a centre of a Wedgwood medallion. They were pretty, suited the dresses of the period, aided women to achieve a classical appearance, and made no pretence to look like a diamond – which was essential for young girls who were considered 'beyond the pale' if they attempted to wear them.

Cut-steels were first made in Woodstock in Oxfordshire. Then the centre moved to Birmingham where Matthew Boulton (amongst others) had a finger in the productive pie and where the firm of Hipkins had a long tradition of exporting buttons and buckles, especially to the Court of Spain. By 1845, after various difficulties through trading with France, there were 3,700 people working in the jewelry trade in Birmingham. We do not know what proportion of these were workers in cut-steels, but it must have been fairly considerable. Sadly it was this centralization in Birmingham and just this expansion of trade which killed it. The passion for machines and the vast pool of available labour made mass-production irresistible. Experiments were carried out with unworthy materials and some of the results proved to be flimsy trash. Unfortunately, it is very difficult to be able to tell where each piece was made. One has to consider the design of other contemporary jewelry as a start. There are no marks to tell if it is French or English, Birmingham or Woodstock, but it seems generally agreed that the French favoured an oval rosette and the English a round one.

Cut-steels are extremely well-made, tough and long-lasting, and it is certainly worth while buying before it becomes too late. In the 1920s and 1930s many women threw away their old cut-steels because they looked dreadfully drab against the massy glitter of diamonds in almost invisible settings of platinum. Those who kept their old cut-steels found they could hardly give them away, far less sell them, and gradually they were

banished to the children's dressing-up box or an old drawer in the attic. In the 1960s some people began to collect again and small antique shops would offer brooches or buckles for a few shillings. By the 1970s they had become very fashionable, and a brooch which was bought for less than the price of a cinema ticket would now sell for a hundred times that.

Lockets pandered to the sentimental side of the Victorians. As a result they were always carefully made and lasted so well that many today are in their original state, never having been repaired but having been regularly worn for over 100 years.

They were much handled, too, examined by friends, inspected by older relatives, opened and closed regularly to show anything which nestled inside – pearls or hair or a portrait.

They were no new idea, lockets having been known for centuries, but during Victorian times they were at their finest and most inventive. Many Renaissance jewels were lockets. They contained minute reliquaries behind sturdy rock-crystal windows, mounted in fine enamelled gold and hung from a long chain around the neck or even attached by short chains to a bejewelled sleeve. If the locket jewel was religious or magical it would generally be concealed beneath the clothes, yet if it contained a miniature in those days it would be openly displayed. Many a locket never left the jewel-case (to be worn insignificantly against the brilliantly coloured textiles) but was picked out to show a special friend, spoken of, admired and then returned to its velvet bed.

The accent was almost more on the reliquary or portrait than the jewelled case, for the whole purpose of this case was both to protect the treasure within and yet give it its due respect, just as the finest looking-glasses, rare treasures, would be marvellously decorated with precious metals and stones because they were reflecting back your most treasured possession – your soul. Your reflection was your soul, your likeness in paints was merely another form, so it had to be protected and enriched. Gold was used, picked out with brilliant enamels in tiny spots of colour or small design motifs, and faceted gemstones were added to give sparkle and wealth.

Other materials were used as well, such as ivory carved like an opening (Tudor) rose, as in the portrait-jewel of Anne of Cleves; or onyx or jet or crystals.

It was equally a mark of respect to have the person's name clearly picked out, engraved or enamelled, around the frame or on the covering case, together with any further or relevant details. The case was generally oval in shape, latched (with a 'locquet') at the top, hinged at the base, with a loop for the chain to pass through. By Victorian times the latches and hinges had been positioned variously at the top or bottom and ended by lying along the side. By the eighteenth century, a time of religious scepticism, reliquaries were hardly seen and the portraits appeared even smaller. Around 1720 there was a change of background on which they were painted, from thin vellum (or the reverse of a playing-card) to a sliver of creamy ivory. The covers of rock-crystal were exchanged in time to flint glass, although many of the original ones have now disappeared because the glass was apt to fracture within its snug gold air-tight rim due to atmospheric changes. Early in the nineteenth century human hair could be found placed in a tiny locket, under glass, to a careful

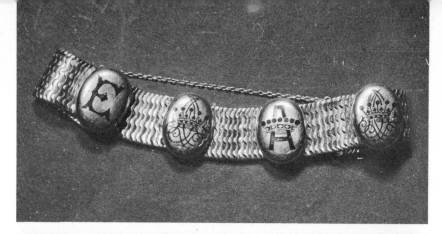

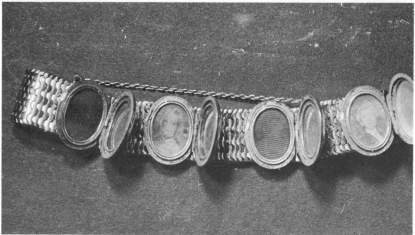

An extremely supple wide gold mesh bracelet set with four locket sections, the covers enamelled in dark blue; made for a member of a ducal family. Courtesy of Lady Elizabeth Cavendish.
The same as above but with the lockets open, showing a tinted miniature on ivory and a daguerreotype and the other two sections left plain. This is a curious mixture for the bracelet was made to hold photographs rather than miniatures, as for the latter there would have been slightly convex protective glass. The safety chain might be a later addition. English, *c.* 1865. Courtesy of Lady Elizabeth Cavendish.

Far right A selection of 'love-token' jewels, based on the heart design. *Top left* a 'regard' brooch. This meant that the first letter of each inset stone spelled out the word, therefore the stones are a ruby, an emerald, a garnet, an amethyst, a ruby and a diamond. *Centre top* another 'regard' brooch with the stones in box settings in a swirl of rolled gold. *Top right* a third 'regard' brooch of chased gold. *Second right* twin hearts made from carved rock-crystal framed with pearls. *Centre right* a 'regard' ring set in a circle. *Fourth row right* a further 'regard' ring set across a hoop. *Bottom right* a gold locket embossed with forget-me-nots and a thistle. *Centre bottom* a huge heart-shaped faceted amethyst, crowned, and framed with small pearls, to be used as either a brooch or a pendant. *Bottom left* a heart-shaped locket covered with pearls and a central diamond framed with corals. *Fourth row left* a Gimmel ring in gold. *Third row left* a ring of twin hearts set with diamonds and crowned. *Second left* intertwined hearts of diamonds and sapphires, crowned, worn as a brooch. *Centre* three heart pendants and a tiny enamelled 'book' jewel worn as a brooch or pendant, with a heart-shaped cover, with '*Séparés, mais toujours unis*'. English or French, all periods. Courtesy of Cameo Corner Ltd.

pattern of a curl or a feather or even creating an entire Lilliputian scene. As often as not, in the 1840s, they were tenderly sentimental and you could have a hollow heart, for instance, made of gold and encrusted with tiny pearls or rubies, sometimes diamonds, containing a wisp of hair. The heart might be simple or with a padlock placed upon the loop above, or merely the loop alone to suggest the missing gold padlock and signifying 'love locked away'.

By the 1870s the lockets had become large and heavy, made from gold, silver or pinchbeck, with small photographs of loved ones placed inside and protected by glass, instead of the beautifully painted (but expensive) miniatures on ivory.

The craftsmen no longer worked by hand exclusively, ornamenting the surface delicately, but stamped out the metal into low and high relief patterns. They took care, as is evident by the amount of them left today, and they were better than lockets made abroad, but they were made by the hundreds and bought in shops rather than being bespoken. By the 1860s and 1870s dress was heavy and dark and colours had to be bold to catch the attention. Enamels were widely used, deep blues, black, reds and greens, always opaque and with gemstones added. The lockets were substantial and so were the matching chains; naturally, for all that expense one expected virtuosity, so occasionally parts of the locket were interchangeable. A central large diamond, for instance, could be unscrewed and either replaced by other gemstones or even a mourning device in black enamels and pearls 'for tears'. Endless shapes were employed other than the familiar oval – circles, stars, hearts, hands and books.

Other materials might be added, too, such as a clear rock-crystal face or the familiar 'Essex' crystals seen throughout the century. The entire

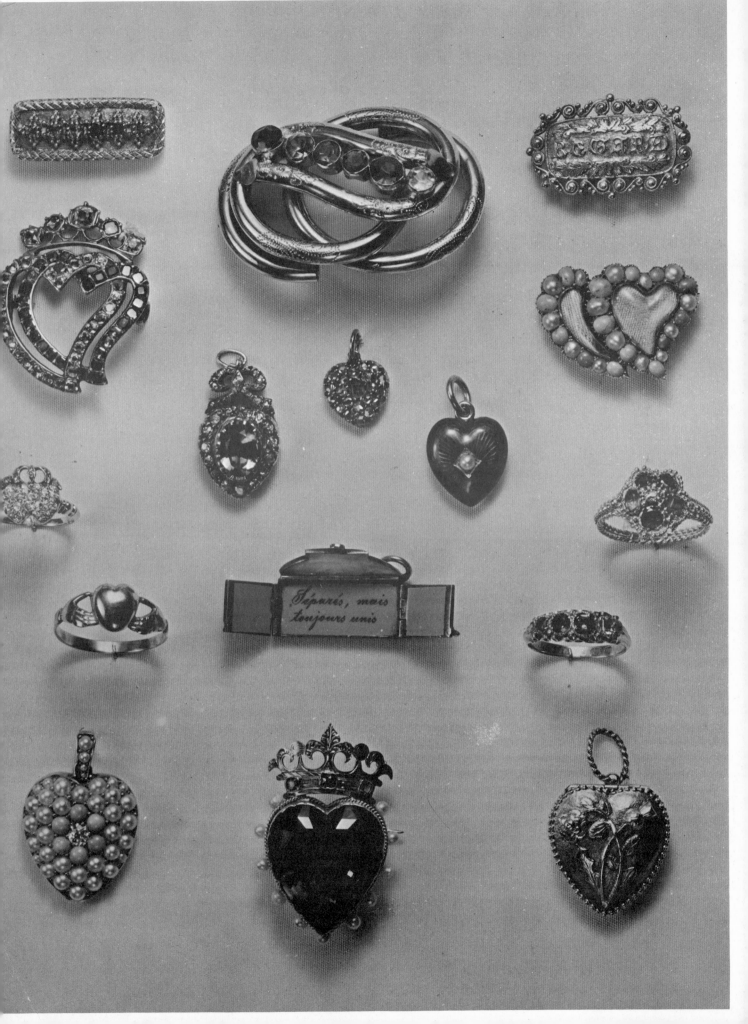

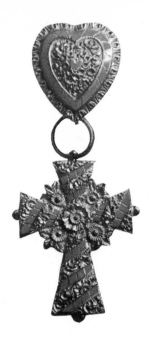

A very pretty Swiss heart-pendant ('Croix à la Jeannette') with cross-drop in carved and textured gold and swirling bands of sky-blue enamels. c. 1860. Courtesy of N. Bloom and Son Ltd.

A gold necklace in the ancient Greek style; each of the nineteen heads are wearing a necklace and minute gold earrings. Signed by Giacinto Mellilo, a pupil of Castellani. Made in Naples, mid-nineteenth century. Courtesy of Cameo Corner Ltd.

locket might now be made of jet or onyx, cairngorms or agates, polished and set in hinged frames of gold.

By the end of the Victorian period lockets became smaller, thinner and pale. Gold, silver or even platinum, encrusted with diamonds or pearls, moonstones, opals or turquoises, threaded onto slender chains and worn about an equally slender neck; or even decorating a charm bracelet, precious and secret to the end.

At this time crosses were considered very proper for young girls to wear (the majority were generally pious) either suspended from a fine gold chain, a length of coloured silk or velvet ribbon to match a dress or made from the same material as the cross itself. Some very pretty Maltese crosses were made in white chalcedony with centres of coloured golds set with turquoises, diamonds or corals. But crosses of gold were the most popular, lightly chased and engraved. Following that were crosses of carved ivory (many carved in Dieppe), coral from Naples or Sicily or bog-oak from Ireland.

These were often made to have a 'rustic' look, every grain of the wood carved upon it, and often with a twist of ivy leaves winding round. As time went by they became more elaborate with anchors and hearts added, almost obscured by the ivy, to show 'Faith, Hope and Charity'.

Another type which was popular from about 1837–42 was the *croix à la Jeannette*, a French peasant design which suddenly became fashionable. Margaret Flower states in *Victorian Jewellery*: 'This ornament . . . was a survival from the distant past. . . . The name, according to Henri Vever, came from the practice of giving or buying them on St John's Day; and servant-girls in France from time immemorial had worn them hanging from a black ribbon.' They hung from a heart (made from either gold, pearls, turquoises, garnets, rubies, amethysts or other gems) often with coloured enamels and small diamonds at the terminals.

One must always bear in mind that the wearing of jewels during the nineteenth century was directly related to the amount of money they cost. Few people wished to wear old pieces, for that made it look as though they had no money to buy the newest fashions and styles and a man's income was to be estimated more and more by the jewels loaded upon his wife.

Wherever a young couple travelled they would almost certainly bring back souvenirs of their journey. Just as the rich young men of the seventeenth and eighteenth centuries had brought back their paintings, *objets d'art* and sculptured marble figures, so the young Victorians would bring back smaller souvenirs, which were generally craftwork, jewels and fans. Craftwork objects were looked upon as curiosities and rarely copied in England apart from Berlin woolwork and the embroidery on Cashmere shawls. The cuckoo-clock from Bavaria was considered clever and amusing and better left to the Bavarians, so were majestic Spanish fans, Brussels lace and Cordovan leather goods. Jewelry, on the other hand, was readily portable and in great demand. Some peasant-work was far too coarse for British conventions – as Castellani found to his cost when he copied it – but the sheer quality of 'antique' or indigenous jewelry made by the better firms in European capitals amazed the British, especially those visiting Paris and Rome. In Rome they would especially look for mosaics, in Florence they would look for mosaics too, but they would be of a different type.

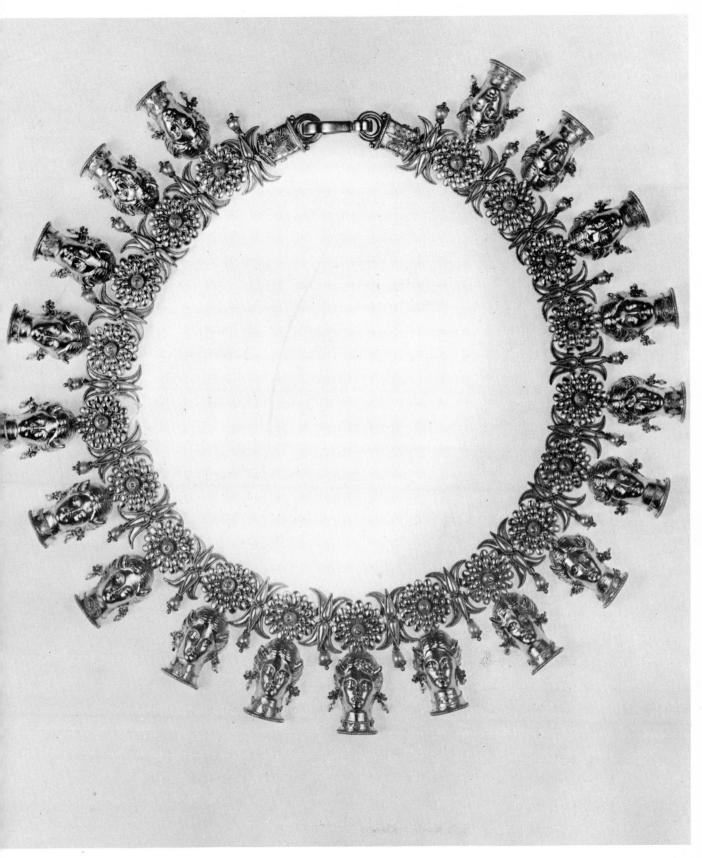

43

In Rome they would find brooches, earrings, rings, necklaces, bracelets or even complete matching parures, linked with delicate chains, or mosaic scenes. They would be made up of tiny little fragments of coloured glass, so small that it all looks smooth but under a magnifying glass one can see the individual 'bricks' would be set into a shaped border of black or red, anything from an inch to three inches across altogether, and the eye would immediately be drawn to the design. This would be classical, generally showing ruins in a landscape or architectural masterpieces well known to all such as the Colosseum or St Peter's in Rome.

It seems that the technique did originate in Rome, actually at the Vatican in 1576, in order to reproduce the paintings of the Basilica for the pilgrims. Early in the eighteenth century, around 1727, it all began to coalesce into a commercial enterprise and the Vatican factory began to produce and sell extensively to the foreign visitors. Running parallel with the flavour of paintings, the subjects reflected the renewed interest in the classical style, much of it due to the recent excavations of the archeologists. Then in the nineteenth century there was a vogue for translating contemporary romantic paintings into the medium and eventually it all degenerated into sentimentality, the Romans obligingly making such horrors for the English market as a scene showing a King Charles spaniel sitting on a velvet cushion.

The little mosaic brooches are very colourful and, in the first half of this century have been bought for a song, a few shillings, even thrown away when people preferred the hard glitter of faceted gemstones. Now there is renewed interest in mosaic jewelry and buyers have begun to appreciate the fine workmanship and sheer delicacy of the techniques, which is resulting in soaring prices. Luckily some sensible owners have retained their inherited mosaics, often in their original cases, and can wear them again with extreme satisfaction.

A really beautifully made gold necklace; the florets are similar to those used in Rhodian jewelry of the seventeenth century BC (there is a diadem from Camirus in the British Museum like this) and the falling fringe of tiny gold chins is similar to jewelry from Thyreatis, about 2000 BC. (Again there is an example, formerly from Berlin, in the British Museum.)

In exactly the same forms jewellers from Florence worked from the fifteenth century in their techniques of *intarsia, commesso di pietra dura* or 'hard-stone' craft. Here they used a black ground and carved and fitted in flush were pretty stones such as cornelian, white chalcedony, malachite and so on, making up designs of flowers, birds and architectural scenes. They had used this technique for centuries, but on a much larger scale in the earlier years for the huge and heavy tables made for the incredibly rich princes of the Italian and German States – especially during the sixteenth and seventeenth centuries. Now they worked in miniature, scaling down their designs to suit the jewel, and some of the quality was very high indeed.

In both cases the jewel might be left without a metal surround, but it was more usual to have a gold mount; and to keep that Neo-classical look the mount might be chased with a Greek key-fret, Vitruvian scrolls and a twist of filigree gold wire. The mosaics from Florence were more controlled and beautifully smooth, concentrating upon the Republican colours of white, gold and purple, whereas the Roman mosaics were more colourful although, sadly, sometimes the glass 'bricks' have worked loose by now and left an unsightly gap which cannot be filled.

Each type was bought and thoroughly enjoyed as a reminder of a memorably happy time. Perhaps the Roman ones were kept more as personal souvenirs and the Florentine ones (if they had a choice) given to a relative in half-mourning, but both are still quite delightful and compare favourably with some modern copies.

Tiny figure of Pan with his pipes standing on a cornucopia laden with grapes and flowers very similar to Hellenistic work of 330–27 BC. This is an earring form turned, in the nineteenth century, into a brooch. Gold, Italian, *c.* 1860. Courtesy of N. Bloom and Son Ltd.

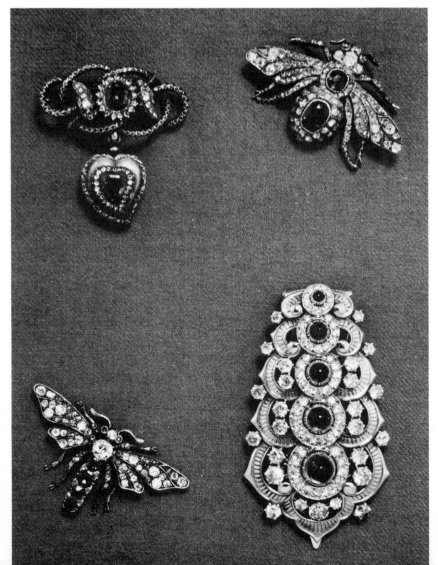

A selection of jewelry showing various different periods. The heart-shaped brooch-pendant is the earliest, *c.* 1840; the bee and insect brooches are *c.* 1880 and the left-hand clip is Edwardian. All could cheerfully be worn at the same time. English. Courtesy of Christies.

3. The Great Exhibition

1851 saw London stage a 'Great Exhibition of the Works of Industry of all Nations'. It was a staggering affair with exhibits from all over the world. Thackeray captured the effect it had upon ordinary people in a poem he wrote in the persona of a country yokel:

There's holy saints,
And window paints,
By Maydiaval Pugin;
Alhamborough Jones
Did paint the tones
Of yellow and gamboge in.

There's fountains there,
And crosses fair;
There's water-gods with urrns,
There's organs three,
To play, d'ye see,
'God Save the Queen', by turrns.

There's statues bright
Of marble white,
Of silver and of copper;
And some in zinc,
And some, I think,
That isn't over proper.

Look! here's a fan
From far Japan,
A sabre from Damasco;
There's shawls we get
From far Thibet,
And cotton prints from Glasgow.

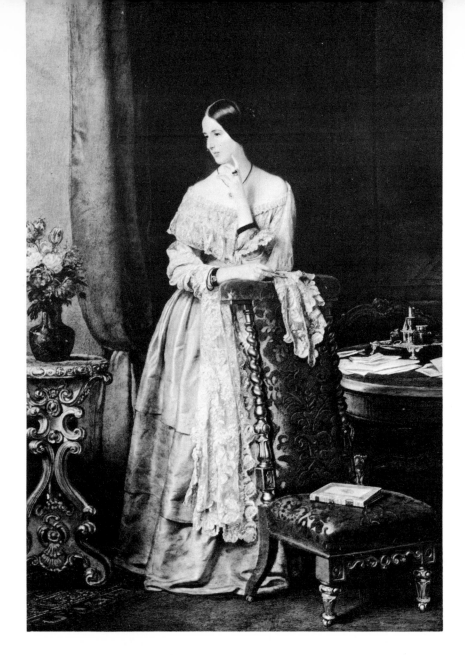

Baroness Angela Burdett-Coutts, daughter of the banker and a great philanthropist. Her dress and the baroque furniture show the styles of richness during the mid-Victorian period. By Sir William Charles Ross. National Portrait Gallery, London.

There's granite flints
That's quite imminse,
There's sacks of coal and fuels;
There's swords and guns,
And soap in tuns,
And ginger-bread and jewels.

There's lashins more
Of things in store,
But thim I don't remimber,
Nor could disclose,
Did I compose
From May time to Novimber!

The bold decision to hold the Exhibition is a token of the prevailing spirit of enterprise, enthusiasm and inventiveness. This industry and sense of purpose led to prosperity, to expansion in trade, to the winning of international competitions and the spread of the Empire. It also led to an increase in world-wide prestige and it led to a great deal of money – and money, as we all know, breeds money and in the Victorian era it bred faster than ever before. Now there were better homes for the enterprising middle class, better machines for more factories, better furniture, clothes and education.

The Exhibition was the first International Exhibition to be held anywhere. Certainly it was the most momentous event of the decade in the country, and all the praise must undoubtedly go to those two great men, Prince Albert and Henry Cole. It was inspired by some very successful national exhibitions held each year from 1847, then in June 1849 the fateful decision was made to hold 'The Great Exhibition' a mere twenty-three months ahead.

What supreme confidence! In retrospect they must have been staggered at their own audacity. From the moment the decision was made, the committees formed and the countries invited to partake, all was frantic bustle and universal interest; to read through the relevant issues of the *Illustrated London News*, a magazine popular amongst the upper and middle classes, and other journals, is absolutely fascinating, both before, during and after, for months and months. Just about everything that happened during that year was in some way connected with this cataclysmic affair and everyone was determined to 'put on the style' for their country and themselves. The results of the Great Exhibition were to alter the lives and ideas of just about everyone who exhibited or visited it; and its effects shook fashion and jewelry, like everything else.

Luckily the original site of Leicester Square, chosen by Prince Albert and Henry Cole, was rapidly re-assessed as the pair very soon realized how enormous the enterprise was turning out to be. So they chose Hyde Park (with protests from the riders in Rotten Row and howls of fury from peppery old gentlemen in the clubs at the thought they would be cutting down some trees). Then they formed hundreds of committees and they chose an opening date of 1 May 1851, less than two years ahead.

Fire risks and lighting were the main headaches until Joseph Paxton produced a design for the largest conservatory in the world (over sixteen acres) and cunningly did not submit it to the Building Committee but had it published in the *Illustrated London News*. Industrialists went wild with delight, *Punch* christened it 'The Crystal Palace' and the general public would hear of no other design.

In August 1850 they laid the concrete foundations; by September the first columns were up and by the end of January 1851 the construction was complete. Goods were pouring into the building by February; hour after hour the drays came rolling up to decant the goods which sailed into the London docks; some of them were huge and all of them were heavy. Today it is quite difficult to take in how massive some of the exhibits were, such as the railway engines and weaving looms and the steam or power-driven tools, the furniture or the sculpture. Everyone was out to impress through sheer size (and they succeeded) for every stand had something gigantic on view such as the colossal Bavarian lion, 'a

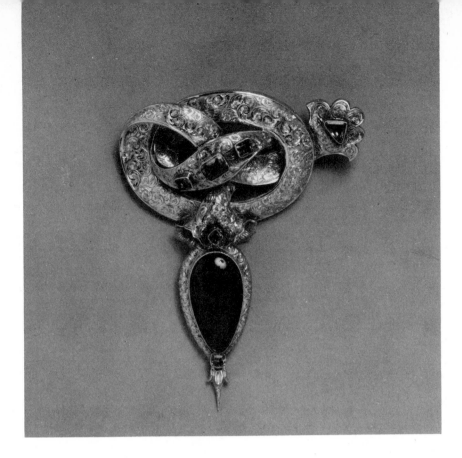

An engraved gold brooch shaped like a tied ribbon, set with six emeralds and an inverted pear-shaped cabochon garnet drop. English, *c.* 1850. Courtesy of Harvey and Gore Ltd.

monster of the forest standing fifteen feet from the head to the tail and nine feet high' who had to be placed upon a pedestal several feet again above the viewers' heads.

What untold treasures there were! Who could have failed to have been excited at the sight of the wonderful howdah given by the 'Newab Nazim of Bengal' to Her Majesty? *The Illustrated London News* described it: 'The sides were made entirely of ivory, inlaid, and painted in gold, and covered with a canopy gorgeously worked in gold and silver brocade, with an awning in front supported by two ivory poles, and acting as a protection from the sun'. Although it came minus an elephant, it gave the watching public a thrill of excitement, wafting the glamour of the mysterious East over them, as they gazed high above their heads at the

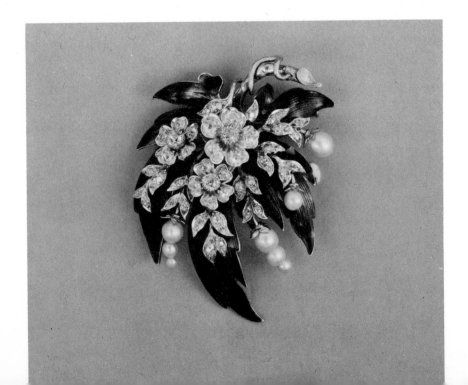

A fine diamond and Oriental pearl brooch showing flowers and leaves against the most brilliant of emerald-green enamelled leaves, mounted in gold. French, *c.* 1850. Courtesy of Harvey and Gore Ltd.

howdah on its enormous stand. Thousands upon thousands of interesting things were there to be seen, but our interest is in the jewels, their type and size and design.

The Exhibition contained 'the finest diamond, the finest ruby and the finest emerald known to the world'. The finest diamond was the Koh-i-noor shown with its two accompanying gems and the curious mounts from which they were taken (now to be seen in the Tower of London amongst the Crown Jewels); it must have given many an ordinary person a stab of excitement, although all the experts were bitterly disappointed in its lack of sparkle. It was reported at the time 'The unpurchasable Koh-i-Noor or "Mountain of Light" (which may be seen by any working man in the country for merely a shilling) is shaped like an egg . . . within a small fraction of 280 carats, and was estimated by Tavernier at £468,959, but, according to the rule prepared by Jeffries, it would be worth £622,000.' (There were other estimates which valued the stone at anything between one and a half and three million pounds.) An experiment was tried, because of its disappointing lack of sparkle and brilliancy through sheer bad cutting, to make a better show. It was 'surrounded by a sort of hoarding covered with crimson cloth, the gilt cage itself having a canopy of the same material. All daylight was excluded from the interior, and its want is supplied by a row of gas-jets standing over the gem, around which on the table are placed a range of metal reflectors, the object being to show the great diamond to the greatest possible advantage'.

Another birdcage frame showed some of the highlights of Adrian Hope's collection of gemstones and jewels – they were both made by Mr Chubb – which showed 'the largest known pearl in the world, shaped like a human hand, two inches long, four and a half inches in circumference and weighing three ounces'; the 'Hungarian Opal', almost two inches long by over one and a quarter inches broad; the 'Murat sword-handle' with its hilt composed of a single acquamarine and 'La Saphir Merveilleux', a sapphire of an amethyst colour by candlelight.

People were absolutely fascinated by diamonds of various types, for they had been conditioned over the centuries to think of them as the costliest of gems. They gaped with disbelief at the Hope diamond, now in the Smithsonian Institute in Washington, because of its amazing deep-

A very large lizard brooch, over 12 cm (5 in) long, made from gold, pavé diamonds and with a row of emeralds down his realistic back. English or French, c. 1850. Courtesy of N. Bloom and Son Ltd.

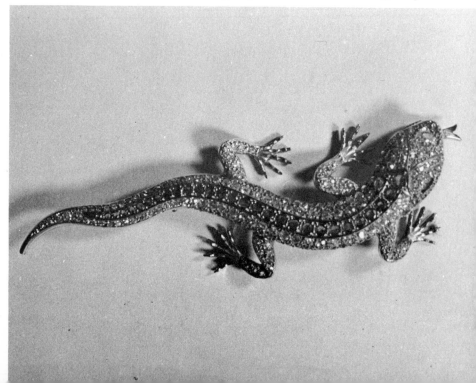

blue sapphire colour and its strong red fluorescence, together with its reported size of 177 carats (today it is 44½).

They were equally astonished at Mr Joseph Mayer's exhibit of a '350' carat black diamond, which 'so far has resisted every attempt that has been made to polish it'.

There were many loose stones gathered together in various sections in the Exhibition, some were described individually, some collectively. Very few people had ever seen loose stones and they were astonished at their possible sizes and their varieties of colour, both of which were to start a whole new trend in personal jewelry. We learn that 'amethysts are as esteemed as diamonds . . . those gems having a blue colour are known as Oriental sapphires; when red they are called Oriental rubies; when yellow, Oriental topazes; when violet, Oriental amethysts; and when they are hair-brown, adamantine spar. The finest blue specimens have been procured from Ceylon; the most esteemed red varieties come from the Capelan mountains, in the Kingdom of Ava; and the smaller stones of the same kind are principally bought from the Carnatic, on the Malabar coast, and elsewhere in the East Indies'. Serious reports like these amuse qualified gemmologists today.

People mostly came to see the set pieces mounted as tiaras, brooches, earrings, necklaces and bracelets. These jewelry exhibits were mainly from England, France, Russia, Holland and some of the German states under the general collective name of Zollverein.

In the main the designs came from nature; the flowers of the garden, the leaves of the forest, the herbiage of the field and the plumage of birds. In Hunt and Roskell's collection the principal and all-attractive object was a magnificent diamond bouquet, exhibited as a specimen of the art of diamond-setting. The flowers (comprising the anemone, rose, carnation, etc.) were modelled from nature.

A gemmological bouquet was made by Morel, 'originally intended and designed as a bouquet, but it is equally, perhaps more appropriately, available as a stomacher; moreover it is so constructed as to separate into several distinct pieces of jewellery, according to requirements. The diamonds are all of the finest water; and the rubies are described as "an unique collection". The setting is contrived with springs, resulting in a waving or slightly oscillating motion when in use, which displays, to the fullest extent, the brilliant colours of the stones.'

Messrs Hunt and Roskell had an enormously varied and exciting show of made-up pieces of jewelry as well as extraordinary fine single gems. They showed the diamond bouquet described above and the 'next object of importance' was an ornament for the head, composed of branch coral, ornamented by leaves of enamel and gold, enriched with diamonds 'a very elegant production, of chaste effect'. Together with these displays of technical virtuosity were an opal bracelet, a parure of emeralds, a suite of diamonds and rubies, a diamond 'throatlet' and a diamond stomacher.

There was also a parure of multi-coloured diamonds, owned by the late Henry Philip Hope, and a head ornament of an ostrich feather of brilliants set in 'ribs' and tremblant, to give that 'swailing of the feather'. Hunt and Roskell exhibited gemstones from the two collections of the Hopes, Adrian J. Hope and Philip Henry Hope, amongst their own productions. They also showed sapphires, one of 133 carats and flawless, another octagonal one of 118 carats, another of 180, together with a mass

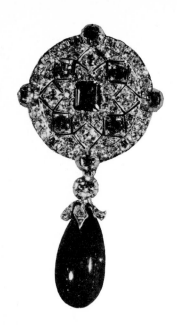

An emerald and diamond cluster brooch mounted in silver and gold; pendant from it is a huge Indian emerald, polished and pear-shaped. English, *c.* 1850. Courtesy of Collingwood of Conduit Street Ltd.

of huge star-sapphires. Then there were the rubies; one carved cameo of the fifteenth century showing the head of Jupiter, and an intaglio of 53 carats showing Minerva. They also showed a sun-stone cameo of a monkey's head which attracted much attention, for this was the opposite of the many gentle moonstones which had been seen before, with a rich variety of aventurine, which reflected a bright flame colour.

Emeralds were not nearly as popular as other stones, at least not emeralds from India, for 'they were much obscured and deteriorated by the coarseness and clumsiness of the setting'; but those forming the girdle of a Sikh Chief must have brought gasps of admiration, as did an exhibit of an emerald in its stone matrix. Yet another, in the Hope collection, was thoroughly condemned by reporters because 'it had been sacrilegiously converted into a vinaigrette' – yet Carl Fabergé was to create several in the same manner for the Shah of Persia thirty years later and they were universally admired. Manipulation of taste by the media was very strong even then.

The Queen of Spain's jewels were exhibited by Her Majesty's jeweller, M. Lemonnier of Paris, and 'are esteemed as the best specimens of well-set gems which the Crystal Palace can boast'. They consisted principally of diamonds, pearls, rubies and emeralds, the diamonds greatly predominating. A head dress, bouquet, bandeau, shoulder-knot, bracelet and necklace were shown; their designs were of ribbon-work, flowers with pavé-set diamonds, buds, leaves and pampille or waterfall-work. All the press went wild with delight over them, partly because of their size, partly for their sheer richness and partly because they were impressed that they were sent at all.

Anything curious and out of the ordinary for those times appealed to the general public, (anticipating the craze we have today for novelties of any type, however hideous). One curiosity was a silver brooch from the Ionian Islands, contributed by Miss Yonge of Otterbourne, combining the Lion and Crown of England – the protecting nation – on a large medallion, with the seven medallions of the Islands hanging from it.

The Swiss, not unnaturally, featured watches in everything, possibly for the first time in bracelets, in rings, in pencil-cases 'all going with the precision of town clocks, though some of them calling for the aid of a microscope to investigate upon them the footsteps of time'. Although jewels came with velvet-lined leather cases of their own, many a lady was tempted by the jewelled boxes shown by the East India Company, made from jasper, pierced and sculptured, touched with enamels and inset with rubies in which to place her inherited family jewels . . . they were so much less prosaic and far more glamorous.

Glamour was everywhere and there was praise for many fine objects in the Exhibition, but criticism was forthcoming when it was considered necessary. For instance, there was a large chatelaine shown by J. B. Durham and very carefully illustrated in the papers with the comment attached 'Here is a specimen, in its utmost completeness, of those *petits affaires de rein* without which young ladies of the present day fancy they are not properly equipped for the domestic circle. Future generations of readers will stare and rub their eyes when they contemplate this childish decoration of their grandmothers'.' Altogether there were twelve items on the chatelaine, made from cut steels and all decorated in the Gothic manner. We may well stare, and we would never dream of wearing one

today, but chatelaines in cut steel are shown with all seriousness in many museums and are avidly collected today. The Victorians loved these curiosities and they also loved display, so nothing pleased them more than seeing the Queen of Spain's jewels, some of the Russian Crown Jewels and the crowns, sceptres, state-sword and other Royal insignia 'belonging to the gentleman who manufactured the coronation jewels for the Emperor of Hayti'.

The Superintendent of the 'Works in Precious Metals' at the Great Exhibition was a Mr Lowe, and he was in charge of the judging of the exhibits. There were sixteen Council Medals awarded altogether, six each to both England and France, three to Zollverein and one to Russia. The various goods were all classified and Class 23 is the one that interests us most, that of 'Working in Precious Metals', which was divided into ten sections: (a) communion services, (b) gold or silver plate, especially presentation pieces, (c) smaller articles for more general domestic use, (d) electro-plated goods, (e) Sheffield plate, (f) gilt and ormolu work (g) jewelry, (h) ornaments, etc. worked in iron or steel, (i) enamelled or damascened work, (j) articles of curiosity, which came into no category above. We have merely considered section (g), a fraction of the whole.

From the profits of this miracle Exhibition untold benefits have evolved; the Governors bought up eighty-seven acres of land in South Kensington and built upon it the Museums – the Victoria and Albert Museum, the Science Museum, the Natural History Museum and the Geological Museum. Then they went further still and built the teaching institutions of the Imperial College of Science and Technology (which incorporates the Royal College of Science, the Royal College of Mines and the City and Guilds Engineering College) plus the Royal College of Art and the Royal College of Music. Added to that, the residue of the money was so well invested that, to this day, bursaries are awarded to deserving students where other finance cannot be raised. All in all the Great Exhibition was perhaps the most important single event in the nineteenth century which influenced taste and design because people had seen such fascinating objects, so many new ideas, so scintillating a series of *possibilities* which they might use or adapt for their own concerns. They came away with their heads reeling with new thoughts, new processes and a whole new approach to life, industry, science and design, whether it was a woven silk ribbon, a cast-iron fender or a jewelled brooch. The world was opened for every viewer from that day forward, the real beginnings of the marriage of man to the machine.

The Gothic

If there was any one style that stood out at the Great Exhibition it was the Gothic.

The roots of nineteenth-century Gothic Revival were partially artistic, stemming from eighteenth-century 'Gothick', but the fervour with which the Victorians took up this style owed more to religion and morality. Whereas the eighteenth century had seen rather a disinclination to piety, the Victorians' religious interest was fervent. They discussed every nuance of the moral teachings of the Bible, every possible alternative ritual, and they illustrated their opinions as well with disastrous results for the twentieth century. Religion really mattered; it had a life of its own

A very large hollow silver cross-pendant, almost 12 cm (5 in) in length, with decoration copied from sections of the Book of Kells, showing typical interlacing and small monsters. Irish, c. 1860. Courtesy of N. Bloom and Son Ltd.

distinct from the State, and its proper observances were vitally important. The religious revival was to be as important artistically as Romanticism, becoming a driving social and artistic force.

Victoria's high moral sense and regard for the liturgy (although she felt that many clergymen went too far) was shared by many of her subjects. The mixture of genuine reverence and a feel for the past culminated in much new architecture in the Gothic style, created by a new wave of architects and designers – a notable example being the new Palace of Westminster designed by Barry with the collaboration of Pugin, and started in 1837.

Augustus Whelby Northmore Pugin was the most strenuous advocate of the Gothic style. He was a man of many parts; architect, antiquary, writer and designer of anything asked of him from churches to lecterns and jewelry. He never made any of these things himself, but merely designed them. His metalwork was executed in the main by the ecclesiastical metalworkers Hardmans of Birmingham. In jewelry he is best remembered for the Gothic pieces he showed at the 1851 Exhibition. These consisted of about eight gold pieces, and he made others much on the same lines for other patrons. There was a brooch, a necklace with pendant cross, a head-band, an 'M' monogram brooch, a pair of earrings and a ring, together with a 'Greek' cross and chain. They were all decorated with blue or green enamels, cabochon garnets, turquoises and pearls; but they all give a curious impression as though one was looking through a looking glass, for they are flat and two-dimensional and lack all that vigour and vital craftsmanship of the true Gothic. When one examines the real articles made in the Middle Ages, such as the cope-clasps and rings and *enseignes* seen in the Kunsthistorisches Museum in Vienna, the Metropolitan Museum in New York and the Victoria and Albert and British Museums in London, then they are obviously wrong in spirit. But then Pugin hardly had that opportunity, for medieval jewelry was scarcely shown at that time in any museum.

Pugin's emotional affairs, better recorded elsewhere, were chaotic; suffice to say that those jewels were originally made for Helen Lumsden but their engagement was broken – so they were rapidly altered (within a few weeks) for his third wife, Jane Knill. They are now in the Victoria and Albert Museum.

Pugin was instrumental in reviving the technique of enamelling for he looked at the only source of Gothic jewelry to hand – illuminated manuscripts and stained glass windows – and found there all the colour so much enjoyed by the Victorians.

He promoted three techniques: cloisonné, champlevé and encrusted enamels, and showed flowers and leaves in their natural colours with gracefully shaded petals. Enamelling on either ecclesiastical metalwork or jewelry had been out of fashion for almost 200 years in England by this time, and had all the charm of novelty, as well as richness and an agreeably 'antique' look; added to that Pugin took endless trouble with his designs. In 1848 he produced an influential pattern-book *Floriated Ornament* which owed much to a German book of 1590 *Eicones Plantarum* in his possession, showing Gothic ornament based on natural forms, many of which can be seen in the lovely carving of Southwell Minster in Nottinghamshire. It was all very accurate and so highly acceptable.

The technique of cloisonné can be likened to the veneering of

Jewelry designed by Pugin for his third wife, Jane Knill, exhibited at the Great Exhibition of 1851, and made by John Hardman and Co. of Birmingham. There are two necklaces with pendants here, two bracelets, two pairs of earrings, two large and two small brooches. The work is plainly taken from Gothic prototypes seen in stained-glass windows or illuminated MSS and seems very flat and two-dimensional. English, 1848. Victoria and Albert Museum, Crown Copyright.

54

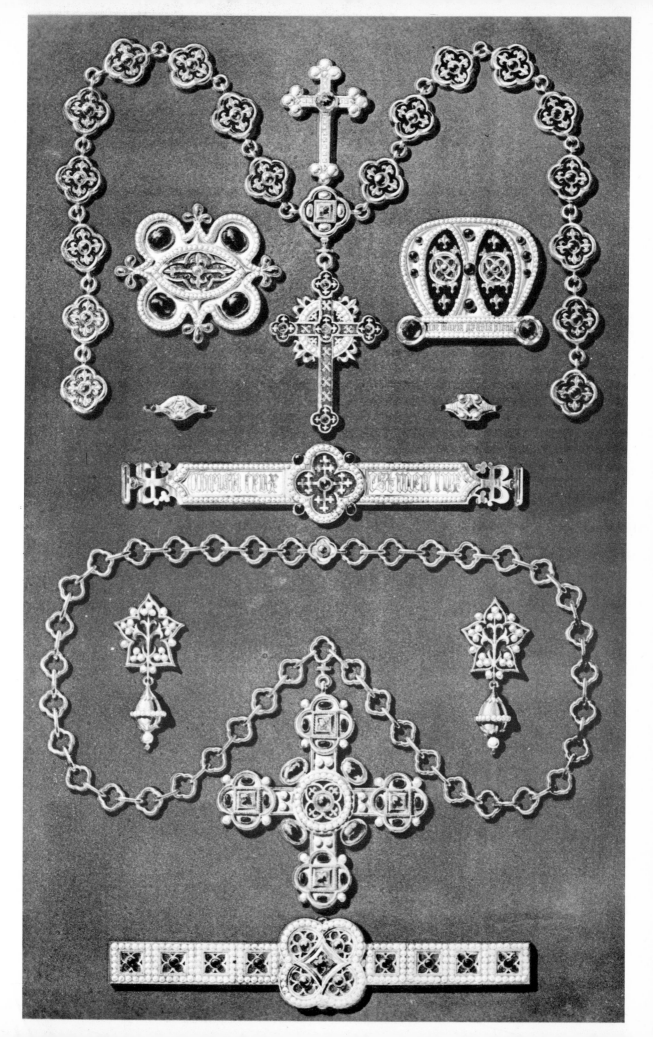

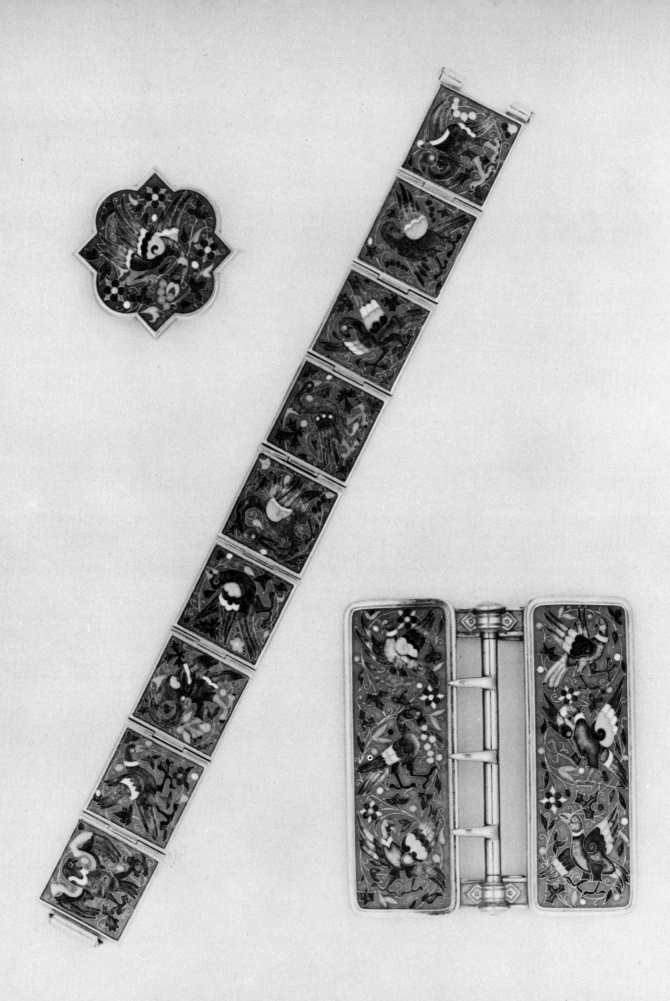

furniture. Let us suppose that a jeweller has made a brooch of gold; he then marks the lines of his design upon the smooth metal. Then he solders into place thin strips of gold, following the lines, making raised cells (or *cloisons*), cuplike compartments which will hold the separate curls or blobs of colour. He then places the coloured enamel powder into each cell and fires the piece, the enamel liquefying and fusing into the cell. When cool it is polished, so that the surface of the hardened enamel is level with the walls of the cells – so gradually the entire pattern is built up with tiny bowls of colour in a tracery of spider-fine lines.

On the other hand, champlevé enamelling is built down into the surface of the article which is being decorated, rather like furniture inlaying. Again the jeweller completes the item and marks his designs on the surface. Then he scoops out the lines of his design, making little shallow compartments in the gold for the enamels. The filling, firing and cooling processes follow as before; and again the piece is finally polished so that the enamels and the metal surfaces are uniform in height.

In encrusted enamelling the surface is not engraved. Instead the enamels are applied to the surface in high relief, a technique much used during the Renaissance period.

A good deal of niello work was used during the Victorian age, for it went well as mourning and commemorative jewelry. It is a very old technique, known from the Bronze Ages, and it is much employed to this day in the East.

It is very similar to champlevé enamelling, but a powder composed of an alloy of silver, copper, sulphur and borax is used instead of powdered glass (enamel). The smith or jeweller engraves his design on the surface of the piece, spreads the alloy over it, fires the piece, allows it to cool and then polishes it so that the black niello design is revealed brilliantly engraved on shining silver or gold. Many a mourning ring was made from black niello on gold, surrounded by 'Black Letter' or 'Gothic' writing.

The impetus for Gothic jewelry did not stem solely from Pugin's work, nor was it limited to Britain. France produced a master of Gothic or medieval style in François-Desiré Froment-Meurice, son of silversmith François Froment, and father of yet another fine goldsmith and jeweller, Emile Froment-Meurice. His early experiments date from around 1840 and his Gothic jewelry shown at the Great Exhibition, especially a bracelet which showed a central section with the life of St Louis (actually made in 1842), looks far more lively than anything made by Pugin.

Architectural details are shown in many items of jewelry both by Pugin, Froment-Meurice, Rudolphi and their followers, and it is possible to see Gothic cusps, mouldings, niches and quatre-foils. The fascinating Berlin ironwork jewelry (which must have been so saddening to wear, however honourably you had donated your gold to your country in a time of stress and received back a replica in iron) shows many graduated pinnacles and designs lightly drawn by a compass, and some tiaras and segmented bracelets of the time did as well.

Now the accent was on originality and accuracy. Gothic jewels, age-old techniques of enamelling, souvenir jewels from foreign lands, they were all the rage, but in a gentle, lady-like way. After the thousands had viewed the astonishing and enormous productions at the Great Exhibition, people in Europe suddenly must have felt that they had been living in a dream-world for years.

A large painted enamel brooch, about 6 cm (2½ in) across, showing the 'Adoration of the Magi', mounted in pinchbeck. Swiss, *c.* 1850. Courtesy of N. Bloom and Son Ltd.

Limoges enamel and pearl circular gold brooch showing a royal portrait after Clouet, signed. French, 1860. Courtesy of N. Bloom and Son Ltd.

A very attractive gold and cloisonné enamel suite comprising a bracelet of nine hinged panels, each decorated with a fabulous bird perched among flowering branches and enamelled in scarlet, buttercup, peacock, aubergine, etc; a belt buckle flanked by similar enamelled work; and a small brooch, morse-shaped, counter-enamelled with a jeweller's conceit and the initials F.F. Almost certainly by Falize. French, *c.* 1860. Courtesy of Sotheby and Co.

4. Balancing the Crinoline

So what was happening to what people wore while they marvelled at the wonders they saw displayed in the Crystal Palace? Reports from Paris described the fashions for that year, against the speed of change which matched the tempo of taste to the whirr and clack of the railway wheels.

A report for February 1851 stated that 'Head dresses for balls are of great variety, in shape, shade and composition. Bunches have superseded the long and falling branches; and, above all, is the interspersing of flowers with ribbons. The ribbon sometimes forms the chief part of the

Fashion plate from *Courier des Dames*, showing party dresses for December 1850. Flounces and tiers of material in the skirt are balanced up by minute pointed waists and a broadened look across the shoulders. Some ladies would wear flowers in their hair, real or colourfully artificial, which would cascade down their bosoms, across their bodies and finally come to a halt at the waist – dancing with them must have felt like dancing with a conservatory. Victoria and Albert Museum, Crown Copyright.

The newest Fashions for December 1859.

head dress, and the flowers fall in clusters on the shoulders: at other times, the ribbons fall as low as the bodice, while the flowers encircle the lace. Wreaths of red transparent gelatine flowers, green leaves, and slight green stems, are much in request. We recommend the gelatine wreaths as being of the only substance combining transparency with solidity; the globes of glass are liable to break, while the gelatine is not damaged by dancing. Wreaths of small white fruit, with foliage of Islay green; the same with golden fruit, and same foliage; wreaths of green roses, with brown leaves; and a host of wreaths, with mixed foliage of green and brown, with drops of gold garnet, or coral, fitted up with great taste, and falling very low, are popular.'

By March the interest had slightly shifted and 'velvet necklaces and bracelets are much in vogue; the shades preferred are coral red, garnet, china rose, and, above all, black velvet, which sets off the whiteness of the skin. These bracelets and necklaces are fastened by a brooch or pin of marcasites or brilliants.'

The richness and sparkle continued through into April when Paris fashions showed that 'Head dress is particularly rich, by no means lacking lively colours, and ornamented with gold, silver, and beads. We only speak here of fancy head dress; for diamonds are always very much admired for a rare and *recherché* parure. Never have they been so well-set as at the present day, both as regards elegance, lightness, and convenience. Thus, each night a lady may change the disposition of her brilliants; today she may form them into a band, like a diadem; tomorrow, a row of pins for the body of her dress; another time she can place them on a velvet necklace, and so forth.'

59

A flower and leaf spray brooch showing a good deal of movement; gold, set with diamonds and a very large spherical Oriental pearl. English, 1860. Courtesy of Collingwood of Conduit Street Ltd.

The variety was enormous. Fancy head dresses were made of blond or coloured lace, silk, gold, or silver; flowers of all kinds, and, above all, foliage of velvet and satin, deep shaded, enriched with white or gold beads, or gold and silver fruit.

For ten years or so before this there had been a lull in fashion, and Victorian ladies had been correspondingly modest in their jewels. The designs suited the young girls, for they were sweet rather than sentimental, and lacked line and direction; prettiness was the general theme where coloured gemstones were mounted in gold. Women's clothes were simple enough with close-fitting bodices and sleeves, the skirt being reasonably full and reaching the ground.

But then the skirt widened until, about 1860, it generally measured a full ten feet around. This meant the sheer weight of the material became far too heavy for women to support (one woman's bridal attire weighed over 100 lbs) so it was decided that it had to have some form of framework. In the beginning there were under-petticoats, lined with horse-hair or corded, plus a straw plait inserted into the hem of the dress; then most women wore an under-petticoat of flannel, then another padded with horsehair, above that one of Indian calico stiffened with cords, then a wheel of thickly plaited horsehair and finally a starched muslin petticoat before the dress perched on top.

When the crinoline frame of light-weight steel wires was invented to do away with all the weight and discomfort, women greeted it as a salvation and the inventor made a fortune in a month. Not only was it light, it was comfortable and, above all, cheap – cheap enough to be worn by all social classes from the dowager duchess down to the cook.

As the skirts were, by now, so wide, they had to be complemented by other exaggerations – the hat, the parasol, the jewels – and one of these was the lowness of the neckline of the evening dresses. These were deep, revealing and open, framed by a bertha (a collar-shaped border to the wide neckline) composed of ribbons, ruches, laces or embroideries and trimmed with flowers and feathers, giving play to any amount of flights of fancy.

Quite the most unique was a bertha made for the Empress Eugénie of France, almost entirely from rubies, sapphires, emeralds, turquoises, amethysts, jacinths, topazes and garnets (the favourite nineteenth-century gemstones) linked together with the Crown Jewels. Certainly the general exposure of the neck and shoulders might have been startling to a newcomer and it is no surprise that a provincial, who was invited to a ball given in the Tuileries in 1855, said in disgust that 'he had never seen such a sight since he was weaned'. However it all made a magnificent background for opulent jewels, flashing and sparkling against bare skin. One of the most beautiful sights to be remembered in the 1850s was the evening when the Empress Eugénie appeared at a ball in a dress of white satin trimmed with one hundred and three tulle flounces, with a collar of diamonds around her throat, more diamonds at her fingers, wrists and ears, and wearing a diamond tiara in her titian hair.

By 1859 fashionable women were sick to death with the size of the crinoline, its inconvenience, the amount of material needed for a skirt and the unnerving way that they could easily knock over anything within a radius of twelve yards. In the autumn of 1859 the Empress took the lead and issued invitations to her guests for Compiegne, adding the significant

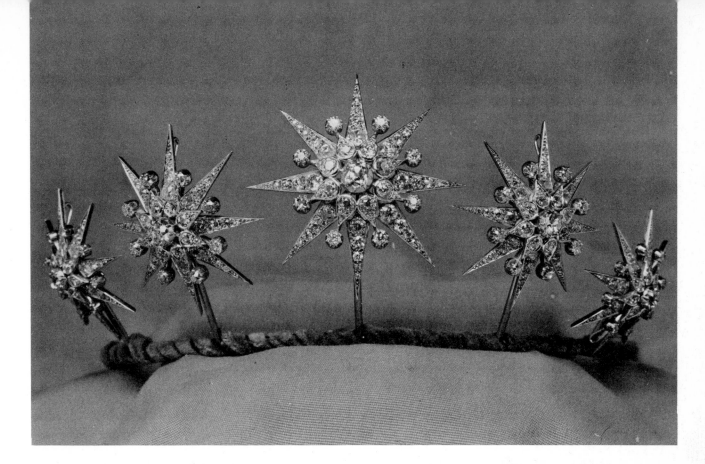

words 'no crinolines'. Queen Victoria followed her lead very promptly and shortly after that the Empress Elizabeth in Vienna said that she, too, had definitely put aside her crinoline. But the provincials and all the other ladies who had caught up with the fashions by then were desperately disappointed and the crinoline took a very long time to die. All it really did was to alter its shape by 1868, turn into the bustle and make women look like elegant ducks.

Ball dresses, the 'grandes toilettes', continued to be most extravagant through the 1860s, and the jewelry matched. In 1864, as an example, a tarlatan dress had 600–700 yards of ruching for trimming; in 1865 tulle dresses, for which thirty-seven yards of material were required, were thickly strewn with small beetles, butterflies, dewdrops, little bells, spangles, mother-of-pearl and so on, and once in 1869 the Empress wore a simple white tulle dress strewn with diamonds, estimated at two million francs in value.

To match the width of the skirt, the low necks and the general air of deliberately abandoned wealth, head dresses were elaborate. When Eugénie married Napoleon in 1853 she brought the Spanish fashion with her for lace mantillas which was enthusiastically taken up. A year later women were powdering their hair with gold and silver dust, and two years after that they decorated their coiffures with Peruvian feather-work. But always there were flowers, real or artificial, singly, in wreaths or in sprays, encircling the head. They could look beautiful and they could also look perfectly hideous.

The jewels worn with the clothes mentioned above are often the jewels catalogued as 'Important' in sale-rooms today because they were rich, fat, colourful and often inventive. For the next two decades there was a good deal of colour in jewelry, through the stones or touches of enamel.

A head ornament or tiara of five diamond stars mounted in silver and gold, which also form separate brooches. The velvet band wound around the bottom piece of metal is to protect the head and covered with velvet which matched the hair. Unfortunately few grand ladies ever changed the velvet as they grew older. English, 1860. Courtesy of Collingwood of Conduit Street Ltd.

A wide gold bangle set with fine Persian turquoises and Oriental pearls. English, c. 1860. Courtesy of Harvey and Gore Ltd.

61

A model wearing earrings and a necklace of fine cast gold scroll-work and foiled aquamarines. English, *c.* 1860. Courtesy of the Central Office of Information.

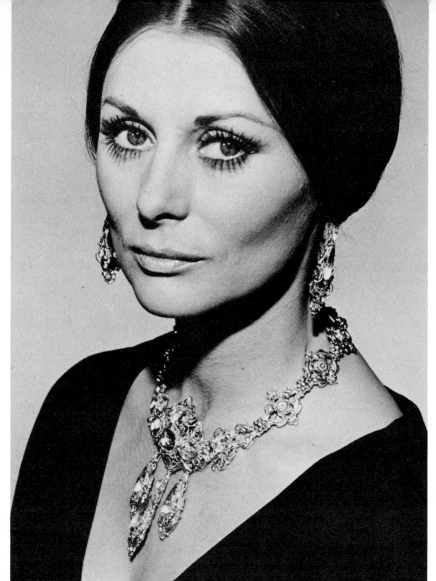

Diamond leaves and flowers balanced up with delicate festoons, mounted in gold (for strength) and silver (for appearance). English, *c.* 1860. Courtesy of Collingwood of Conduit Street Ltd.

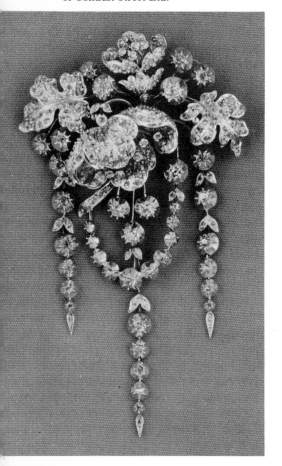

Opaque gems such as turquoise or corals, or faceted stones mounted in silver or bloomed gold like pink or gold topazes, aquamarines, peridots, olivines, amethysts and translucent green chrysoprase were all popular during the Victorian era.

When jewelry was made of metals holding stones (as opposed, for example, to mosaic-ware) the designs concentrated on hearts and ribbon-bows, birds and serpents only; the time for the gimmicks of the 1870s and 1880s was yet to emerge.

Ladies wore elaborate combs to dress their hair, the same long fine gold chains (worn for twenty years past) to hold a miniature portrait or a lorgnette, brooches, rings, bangles above the elbow and bracelets on the wrist. People nowadays are surprised at their lightness, for gold was very economically used.

A typical bracelet of 1850 had a large round or oval centre for its main interest, with tapering sides and a firm snap-clasp. The central section could often be removed and then worn separately as a brooch or part of a pendant fitment, and could have any amount of different decorations – an enamelled one today would cost up to £600 ($1300) without gemstones. A representative oval bracelet was made from gold with a brilliant design of emeralds, diamonds and black enamels on three

different levels. Another showed a portrait miniature and yet another a coiled and twisted serpent of gold and turquoises with ruby eyes.

The tapering sides were generally flexible, made from finely chased and engraved links, constituting some of the most accomplished craftsmanship of all time. One bracelet of this type was exhibited by Messrs S. H. & D. Gass at the 1851 Exhibition 'set with diamonds and carbuncles, with portraits of the Queen and the Prince of Wales, after Thorburn A.R.A. and executed in niello, engraved by J. J. Crew'.

Another type of bracelet showed a strap and buckle design; few wearers nowadays know that this came into vogue because Queen Victoria felt that she could not possibly display even an ankle, far less her calf and knee, so decided to wear her Garter (from the Order) on her arm as a bracelet. This started a new fashion for buckle bracelets, brooches and rings, and there were innumerable variations on the theme.

Rings were often half-hoops lightly set with either rubies or garnets, emeralds or turquoises; or clusters (looking like lazy-daisy stitches) of a small diamond or coloured stone in the centre with small half-pearls surrounding it. In *David Copperfield* at that time, when he reached adolescence and fell in love, he 'measured Dora's finger for a ring that was to be made of forget-me-nots'. The shoulders would have been split, richly chased or engraved, and the total effect inexpensive but charming.

Prince Albert's gift to the Queen (whilst she was still the Princess Victoria) on his first visit to England was a narrow enamel ring set with a

A magnificent diamond openwork bow brooch mounted in silver and gold. Note how some of the stones have been faceted to enhance the general design. English, *c.* 1860. Courtesy of Collingwood of Conduit Street Ltd.

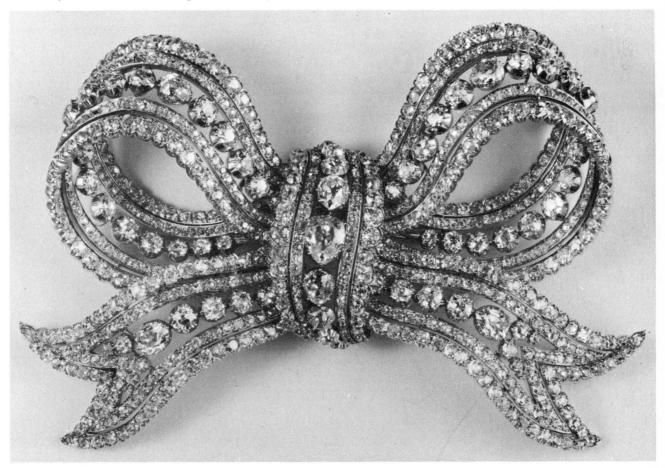

Three massive gold bangles set with various stones and decorated with granular and frosted gold work. The central bangle is similar to the Garter strap and buckle made popular by Queen Victoria as she could not bear anyone to see the Garter below her knee – so she transferred it to her wrist for the sake of modesty. English, *c.* 1860. Courtesy of Cameo Corner Ltd.

tiny diamond, and when they became engaged he gave her a ring in the form of a gold serpent studded with emeralds. Rich and handsome snakes were seen throughout the century, and at this time they were coiling about themselves, often forming a matching necklace and bracelet, or brooch and ring, sometimes made as light hollow tubes, sometimes impressed about the head with small *pavé*-set turquoises.

Another coiled effect was a ribbon of gold or enamels loosely tied together in appearance, with a dripping fringe, knot or tassel (as a direct reference to the French campaigns in Algeria) and should this be a bracelet it would have a central hinge at the back for the wrist to slip through more easily.

Bloomed gold became fashionable as craftsmen became more interested in the novelty. Most authorities call the look of this gold 'like the skin of a peach', and so it is, soft and lacking a shine but gently glowing in the candlelight. The method was to make the article in 18 or 22 carat gold (after 1854 it was permitted, for the first time, to have gold in 9 carat because of the tremendous demand for new jewelry) and then dip it into a boiling mixture of muriatic acid, saltpetre, salt and water. The reason for this was to melt away the alloy (which was mixed into the pure gold) just on the surface, leaving a thin film of the pure metal pitted with tiny holes – like the skin of an orange in miniature.

In the fifties and sixties jewels were worn as profusely as the tier upon tier of ruching on the dresses as you were encouraged to wear absolutely everything you had for special events. If you were an established married woman you probably would own at least one good parure, so that would help you to make a choice for your current ball dress material. A parure of topazes and diamonds would go well with a dress of cream or milk-chocolate brown or 'moss-in-swirling-snow green', and you would accumulate other jewels over the years to tone or match. So you would wear a tiara, perhaps with detachable drops which could be worn at less prestigious events as hairpins and a pendant, or brooches; a pair of earrings which would be long and swinging; a wide necklace which would try to infill the enormous neckline of the dress and often help to cover red patch-marks of nerves or distress at moments of high tension flushing across the neck and breast; possibly a stomacher (a great heavy jewelled plaque placed across the midriff, a hangover from Georgian times which dowagers were loath to discard) with as many stones as could be comfortably arranged together with enamels for the leaves, diamonds for the flowers and the central stone of each the same as the rest of the parure. You would always wear one Very Important brooch to match and almost certainly a bangle or bracelet – the bangle is fixed, a bracelet is flexible. It would be taken for granted you would wear at least one bracelet on each wrist, possibly more, and finger rings would glister aplenty. Your wedding ring would always be worn, however old-fashioned the design, and new ones at this time were extremely wide and rich, made from gold, chased with a design of true lovers' knots and hearts and flowers, and inscribed within, giving the date of the wedding and the names of the bride and groom. You never took it off deliberately and many women were eventually buried with it in a double grave with their husbands. Occasionally they had to be professionally cut off when a lady, in middle age, having been as slender as a gazelle in her youth, had guzzled herself to twice the weight and her precious wedding ring was

A typical piece of thoroughly sentimental jewelry, but exquisitely made; a diamond-set double heart and tied-ribbon brooch pendant. English, c. 1860. Courtesy of Harvey and Gore Ltd.

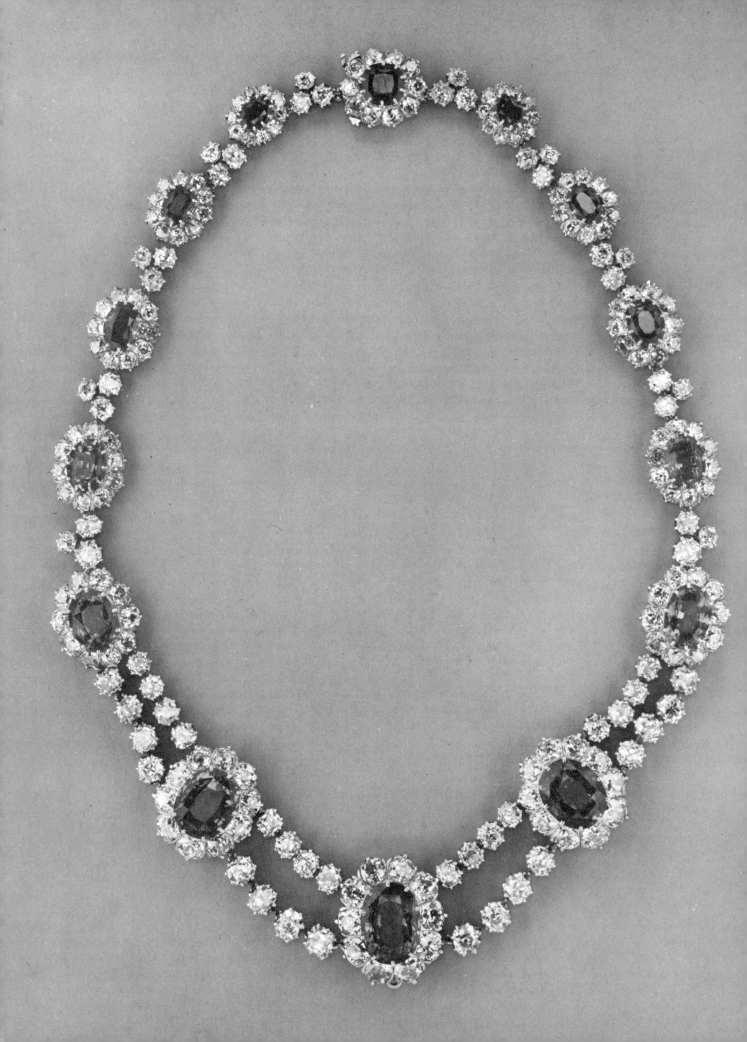

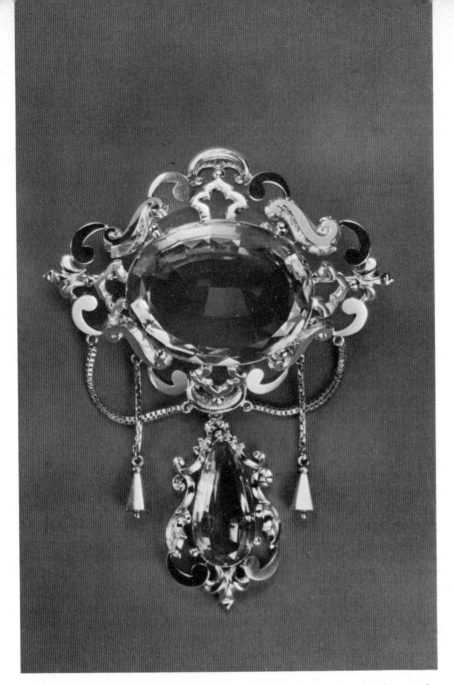

An elaborately scrolled gold brooch set with a central citrine. The angles of the scrolls are carefully set to catch the maximum of light and the two citrines, beautifully faceted, have no metal backs to hold them safely – such was the confidence of the gem-setter by the mid-Victorian age. English, *c.* 1860. Courtesy of Cameo Corner Ltd.

stopping the flow of blood to her finger. If you were sentimental enough, and very many were, you then had the original gold snippets melted down and recast, with plenty of new gold, into another ring.

Heavy settings and naturalistic designs predominated such as in brooches showing very grainy tree-stumps with either oak- or ivy-leaves entwining them, with the new addition of animal forms: foxes, cats, lions and so on (many copied from Stubbs' paintings extremely accurately) which were in either silver or gold, chased or enamelled. Flying insects came into fashion as well, led by the bee with its body as an oval cat's or tiger's eye, its wings of small diamonds, its head of enamels and its eyes of tiny furious rubies. It was a question of colour, colour, colour all the way with a plethora of knot and tassel designs, huge bows, chased gold which might be coloured four ways, turquoises, carved ivories, very large faceted stones in the new colours of yellow, green and pink, general blowsiness and bloomed gold.

Opposite Sapphire and diamond cluster necklace, the sapphires graduating in size from the snap-clasp to the central section; the diamonds must have come from Brazil. London or Paris, 1860. By courtesy of Collingwood of Conduit Street Ltd.

67

A pair of forget-me-not brooches made of frosted and polished gold and set with small turquoises and diamonds. English, *c.* 1850. Courtesy of Cameo Corner Ltd.

A small brooch showing a brilliantly painted cat's head under an Essex crystal, surrounded by bright blue enamels and diamonds. English, *c.* 1860. Courtesy of Cameo Corner Ltd.

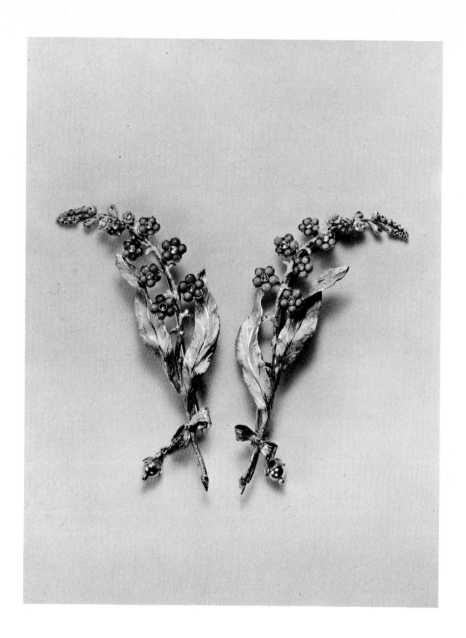

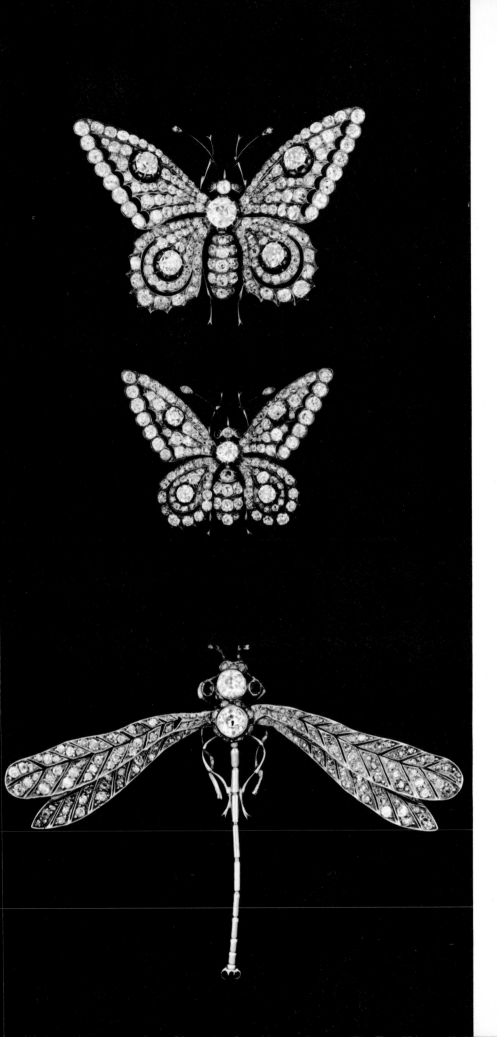

A beating of wings with two Victorian butterflies and an Edwardian dragonfly, all in diamonds and with ruby eyes. The butterflies have fittings so they could be worn in the hair and come together in the same matching case. English, *c.* 1860 and *c.* 1900. Courtesy of Sotheby and Co.

5. Eclecticism

The years from the Great Exhibition to the time Art Nouveau began to catch on in the early eighties saw an eclecticism of styles. The Gothic waned in popularity, but never died out. With their still essentially Romantic taste the people of Europe and North America looked to the Middle Ages, and to other ages from the past for inspiration.

While the immensely popular Empress Eugénie set a colourful fashion in Paris until 1871, in Britain, and to some extent the USA, everything was conducted according to precedence and sentimentality and the pleasures of being harrowed by grief were rampant. Queen Victoria's protracted mourning for the Prince Consort, together with her interest in funerals and memorials greatly endeared her to the more sentimental of her subjects, even if it exasperated her statesmen and her unmarried daughters. Art, they felt, needed no pioneering; art, of no matter what kind, was regarded as being frivolous if not positively sinful, and *objets d'art* must be made to serve a useful purpose. No wonder the painters and sculptors felt they were living in a wilderness and turned privately to experimentation – anything – in order to arouse interest and to please themselves. But in the third quarter of the century jewelry design was stagnant. There was no modern style, and everything was made 'in the style of', but with the greatest of care and from a most painstakingly scholarly approach. In the beginning it was generally austere and correct to the last dot of granulation, then later, with a sense of freedom, the method of making it slipped into a mixture of styles and techniques – often becoming extremely pretty – after all, one did not want to be severely classical for ever.

During Victoria's reign the population of England grew and grew out of all recognition: hamlets expanded into villages, villages into towns and towns into cities. As they did the High Street was naturally developed and tradesmen jostled for good positions. The butcher, baker and candlestick-maker from the olden days, but now the upholsterer, the milliner and the jeweller as well were all represented. The days of having your jewels expressly made for you were not entirely gone, for tradesmen were always prepared to go up to 'the big house' when asked, but now the ordinary man in the street was able to walk into a shop and buy across the counter.

Fashion plate from *Le Fallet*, 1860, showing some evening dresses. Some beautiful fabrics were used at this time such as crystallized gauze, tarlatans sewn with gold and silver stars, tulles of every sweet-pea shade with embroidered garlands of flowers and printed muslins stiff and sparkingly fresh. But oh! how they burned! The worst occasion was the burning of Santiago Cathedral in 1864 when the flimsy draperies for a Feast Day caught alight, dropped onto the ladies below in their yards of muslins and tulles and burnt 2000 women to death. Victoria and Albert Museum, Crown Copyright.

These new jewelry shops owed a deep debt to the scholarly eclecticism of designers of note, but they hardly dared strike out in any new direction and experiment with new trends in art. Most of their mid-Victorian paying customers, whether English or American, were quite indifferent to science, art or modern 'improvements'. 'What was good enough for my father is good enough for me' was their motto, and their lives were almost patriarchal in their simplicity.

The only new type of design which seems to have been taken from a living example was the 'Algerian style', which became popular during the French campaign in North Africa; Moorish pendants in arabesques and acorns, simply wrought fishes and stars, fine gold fringes, chains and tassels; they all had an especial appeal at the height of the period of Romanticism, the 1860s and 1870s.

Styles peculiar to England in the seventies were the Celtic and the 'Holbeins', the Celtic being a follow-on to those seen and made popular at the Great Exhibition and the 'Holbeins' being adaptions of those jewels designed by Holbein and made for the flamboyant King Henry VIII during the sixteenth century. They both fitted in well, demonstrating pride in the past and adding to a fancy dress appearance for the

71

moderately scholarly lady. The rest of Europe was generally more
interested in the distant past, especially when archeological digs took
place in or near their own land (see next chapter).

Although jewelry worn in remembrance has been known since before
the Roman conquest, mourning jewelry gained great currency in Britain
after Prince Albert's death in 1861. Queen Victoria dropped out of the
fashion scene like a stone, wearing the deepest mourning for several years.
Many an admirer remained in mourning with the Queen for the rest of
their lives and even the appearance of the ordinary Victorian lady now
was subtly altered; the curls, rosebud mouth and innocent eyes of the
demure Victorian miss were forgotten. Heavy wings of hair now
shadowed mournful eyes and full lips were exaggeratedly sculptured;
mysticism and sensuality were developed in portraiture, especially by
Rossetti and his trio of regular sitters, whom he dressed in trailing robes.
Doom and gloom hit the English fashion world, led by Victoria as she
wept copiously both in public and in private, hugging her sorrow to her,
reluctant to let its mantle go.

Victorian mourning jewelry centred on black enamels set on gold,
finely worked jet or tiny strands of hair curled or woven under glass. In
view of the amount available for sale today it seemed as though every
woman in Europe (especially England) had at least one mourning piece,
but most have been carefully hoarded until the past thirty or forty years
when everyone had forgotten whose death a certain ring had
commemorated and exchanged it in an antique shop for something a bit
more cheerful.

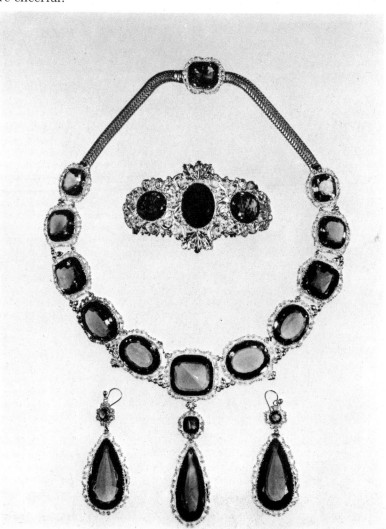

A model wearing earrings, necklace and bangle of huge foiled amethysts and diamonds. These could have been worn for six months as 'half mourning' jewels. Courtesy of the Central Office of Information.

Many of these mourning jewels were worn together with a band of black velvet, passed around the neck and crossed in front of the throat, held by an amethyst, a cluster of pearls or an onyx centred with a diamond; or with a black velvet wrist-band brooched with a pointed oval medallion, pearl-rimmed or picked out with deep enamels. Equally the velvet ribbon might have suspended a cross entwined with an anchor, a star and a heart, standing for 'Faith, Hope and Charity', pathetic and almost hopeless.

With the passion for mourning jewels jet became highly popular. Jet had been worn since Roman days intermittently and really came to the fore during the period of mourning for King William IV. Then in December 1851 Paris fashions favoured 'shawls of black velvet, ornaments of jet, and lace shawls with jet embroidered on them'. However, after 1861 jet came into vogue as never before. Jet, onyx and

74

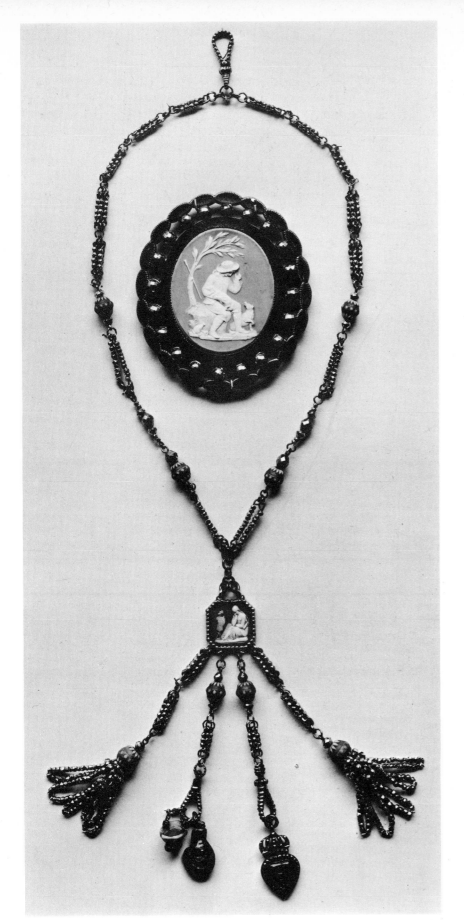

Jet and cut-steels jewelry. The brooch (by Wedgwood) has a jasper plaque and cut-steel border; the chatelaine has a small jasper plaque by Wedgwood and is framed with jet. Strung jet beads form the drops. English, early nineteenth century. Victoria and Albert Museum, Crown Copyright.

A large mourning cross. This has banded agates set in polished and frosted gold with three small pearls at the terminals. It could be worn over one's funereal black clothes and look extremely handsome. Possibly French, c. 1860. Courtesy of N. Bloom and Son Ltd.

black glass – all three were extensively used and, to the casual observer, looked very much alike. Onyx was normally framed and polished, black glass is synonymous with 'French jet' and ordinary jet, lightweight and without the hard bright glitter of glass, came mostly from Whitby.

Break open a piece of English jet and its interior would intrigue you, for the room would immediately smell slightly of oil and the striations of the material would show clearly that it was fossilized driftwood. Like coal it is a hard substance formed by the decaying of vegetation over hundreds and hundreds of years. The wood has lain for centuries in stagnant water, often sea-water, gradually rotting and finally flattened by enormous pressure; the deeper it is found the harder it is.

The best English jet is found in the cliffs by Whitby on the north-east coast of England, generally in wedge-shaped horizontal seams which are from one to six inches in thickness (25mm – 150mm).

During the nineteenth century the Whitby jet industry rose like a firework and as rapidly burst, sparkled and died out. There was no real method in the way they worked or sold their products, no co-ordination between miners, dealers and workers. Some producers had quite large factories, others ran a one-man business, all looking very much alike in their uniform of grimy blue smocks and filthy but cheerful faces. The work was exceptionally dirty, rather like working with coal and coal-dust all day, for the jet had to be carried in, ground down, carved and polished.

They made carved beads for necklaces, polished or floral, or even more elaborate for rosaries; cameo-rings; brooches of every shape and size (because jet is so light it does not drag the material, so some were absolutely enormous); bracelets and earrings; ornaments for their hair and delicate falling fringes. Jet had many advantages, the main one being its lightness which meant that larger items might be worn than those made from metals – some swaying earrings might easily be suspended from lobe to shoulder without causing any great distress and huge bracelets felt no more than a whisper on the wrist. Jet was dark, too, and glittery, relatively cheap, and splendid for the craftsman as opposed to the artist. In time some magnificent constructions were created, with carved foliage festooned with carved fruit, on which perched the most delicately fashioned birds, butterflies and insects. Some excellent sculptors were employed in Whitby, too, and probably the best things which came from the Whitby workshops were small jet busts of serious politicians and personalities.

At the height of Whitby's success, in 1870, the French and the Spanish produced their own brand of jet which was hard, easy to fracture black glass – and even less expensive. This piracy, together with the changes in fashions and the boredom with mourning styles during the 1880s, catapulted the Whitby jet industry into relative oblivion again.

Another favourite way of remembering the dead was to enshrine a lock of the departed's hair in a piece of jewelry. This was not a new fashion, for hair jewelry had caught the imagination of the Empire and Regency ladies. It continued to attract Victorian ladies to such an extent that various pattern-books were publicized from which they could choose the designs that appealed to them. A particularly fine example, published in 1864 towards the very end of the vogue, was the catalogue by William Halford and Charles Young. This contained 'A Great Variety of Copper-

Plate Engravings of Devices and Patterns in Hair; suitable for Mourning Jewellery, Brooches, Rings, Guards, Alberts, Necklets, Lockets, Bracelets, Miniatures, Studs, Links, Earrings & etc etc'. There were 164 patterns in all. Hair jewelry is essentially feminine, and the phrase 'Whose hair I wear, I loved most dear' probably sums it up as well as any.

One may divide hair jewelry into two basic groups; the classical and the frankly sentimental. The latter, unless desperately personal, generally lacks both beauty and intrinsic value, and it is never worth acquiring or keeping; but the former can have some historical value, some indications of style and intricate craftsmanship, and is worth keeping for that. Both were produced in quantity during the Regency and the High Victorian age from about 1790–1870, and then mercifully died out.

The better quality jewels incorporate a Neo-classical scene: a miniature pastoral play, where hair is used to create the leaves of a weeping willow, a stiff little poplar on the skyline, or the feathers of a swooping pair of bluebirds. Much is borrowed from Goethe's 'Charlotte at the tomb of Werther', so almost always visible is a box-like tomb, a classical column or a Grecian urn (presumably marking the resting-place of the loved one's remains, whether bone or ash) and generally there is a lake as well, or a little stream.

Heaven, or at least its entrance, was always kept in view; and somewhere, somehow, the deceased's initials had to be worked in, perhaps as a gold monogram, together with the date of passing on. Oceans of grief were conjured up with scenes of disconsolate widows, lonely children and showers of tiny little seed-pearl tears. It was a peculiarly English invention, but was much admired and copied in both France and America, even after England had exhausted the fashion.

A typical scene is number 16 from the Halford and Young catalogue. This is a design for a brooch two inches wide by one and a half inches deep (about 50 mm by 35 mm) oblong in shape but with rounded corners. In the centre is a classical column on a square plinth topped by two hearts pierced by one long arrow; above this is a swallow swooping down from the sun's rays and holding a wedding band in its beak. All this takes place in the usual country scene with trees within a park, a country house in the background; all created in a minute space which is stuffed with details of importance to the owner.

Materials of varying types would have been used for its creation, but not gemstones of high value; seed pearls apart, the maker would need ivory for the column and gold for the ring and the arrow, together with the use of curling hair. Once completed it was covered with a piece of glass or an Essex crystal, and then given a protective gold backing to keep it secure and to shut out any damp – always a final destroyer. Finally the reverse would be inscribed with any further details the owner desired.

This scene did at least attempt to be artistic as well as sentimental. It is when a mourning jewel consists simply of a plaited background of hair – generally going grey or at least 'pepper and salt', a small curl, a loop, a circle, or even a quatrefoil of hair, set in gold with perhaps black enamel on the frame – that it becomes of no importance today. This is a genteel method of keeping a relic, and fortunately they chose hair rather than some of the other grisly relics enjoyed by the medievals, but it is still a part of the human body and not nearly as acceptable as the eighteenth-

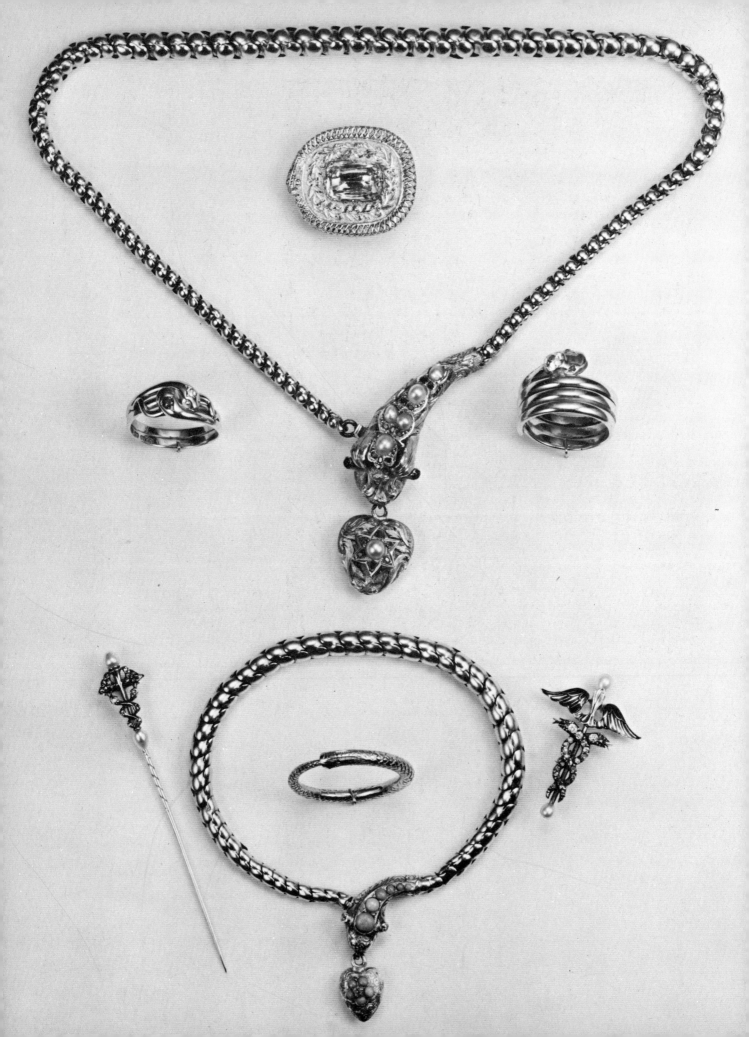

Opposite A selection based on the snake motif which wriggled and writhed throughout the entire century. *Top* articulated snake necklace, impressed with pearls and diamonds on its head and dangling a small locket from its fangs. *Centre top* an oval brooch with a central citrine and framed by a carved gold snake. *Centre right* a gold snake ring with a diamond in its head. *Bottom right* a caduceus cravat pin, taken from an ancient Greek or Roman herald's wand, especially that of Mercury, and usually represented with two serpents twined round it. *Centre bottom* a snake-shaped bracelet but with turquoises set in its head and heart-shaped pendant. Within the bracelet an Ourobouros ring (a snake biting its own tail). *Bottom left* another caduceus cravat-pin. *Centre left* twin snakes writhing around each other to form a ring. All periods, English. Courtesy of Cameo Corner Ltd.

A model of today wearing the heavy-lidded pre-Raphaelite look and showing a selection of Victorian rings and bracelets to give an idea of their general size. English. Courtesy of the Central Office of Information.

century notion of a painted miniature within a ring or brooch.

Sometimes hair jewelry is collectable for its historic associations, such as a tie-pin in private hands showing a snake curling over and onto itself, with a central small section of plaited hair and the names and title of Lord Byron engraved in black upon the enamelled skin of the snake. Worth today £50 ($100) it was picked up for a fraction of that several years ago (the owner of the antique stall had not bothered to read the inscription).

Naturally whilst they were about it, and both ideas and hair seemed so plentiful, they eventually began to make hair jewelry just to show off how clever they were in the craft and with no mourning connotations at all.

The Halford and Young catalogue shows an endless variety of brooches and pendants in the most curious shapes: tightly plaited and woven hair is twisted into harps, bows, arrows, quivers and a quagmire of wriggling snakes. Indeed the snake is a perennial motif in jewelry

A wide gold bangle set with fine Persian turquoises, diamonds and Oriental pearls. English or French, *c.* 1860. Courtesy of Harvey and Gore Ltd.

throughout the entire Victorian period, slithering and sliding up arms and round necks, as used in Classical times and reminiscent of Cleopatra's asp and Medusa's curly head. Jewelry of hair was generally plaited over a hard core which kept it stiff; the Halford and Young snakes twist into knots, bite their own tails, and even, in one case manage to dangle a small gold locket from their fangs at the same time.

Coiled snakes, created from hair mounted upon multitudes of springs, writhe up a slender arm – in the Art Nouveau they sometimes undulated right above the elbow too – their heads being made of gold studded with small gems (generally turquoises, known to have come from the wicked Middle East, together with the snakes) and set with evil little ruby eyes. Towards the end of its popularity there was a descriptive passage in *La Belle Assemblée* for 1858 which sums up the general interest in hair:

> 'Our artist converts the relic into an ornament for all times and places – expands it into a broad ribbon as a bracelet and fastens it with a forget-me-not in turquoises and brilliants, weaves it into chains for the neck, the flaçon, or the fan: makes it into a medallion of leaves and flowers; and of these last the most beautiful specimens I have seen have been formed of the saintly white hair of age. This he converts into orange-flowers, white roses, chrysanthemums and, most charming of all, clusters of lily of the valley.'

Where else could one go from there?

For jewels in more common use the favourite colours were now sombre; the popular stones were amethysts, emeralds, sapphires, carbuncles, agate, jasper, cornelian, haematites and Scottish granite. Balmoral had been purchased by Victoria and Albert in 1852 and, apart from the tartans she adored, Victoria enjoyed wearing Scottish jewelry such as four-petalled flowers in granite mounted in silver, which is still worn a great deal today as souvenir jewelry.

Another stone which became very popular during the latter third of the nineteenth century was the alexandrite. It was reasonably cheap in

those days but recently its value has soared sky-high. The alexandrite is a form of chrysoberyl (its properties are completely unlike those of a beryl, with which it must not be confused) and was first discovered in the Urals in 1831, being named after the Crown Prince Alexander, who was later crowned the star-crossed Czar. What is so attractive about the alexandrite is the way it changes colour. It has a definite split personality for the stone absorbs both red and green light with equal ease so the finest specimens change their colour from a deep grass-green in daylight to a strawberry-red in candle or electric-light, the colours being evenly balanced within its formation. Some, not so evenly balanced, turn from a deep amethyst to a brilliant aquamarine, which can be even more attractive.

A word of warning to present-day collectors; alexandrites were genuine in Victorian times but recently it has been found how to make them synthetically (and cheaply) and even though a jewel might be Victorian in its setting a false alexandrite might have been inserted and a very high price asked. Therefore one ought always to insist that an alexandrite is officially tested before buying.

During the third quarter of the nineteenth century rock crystal became popular, carved into heart-shapes and sometimes framed with diamonds. Rock crystal is the purest form of quartz when it is absolutely colourless. It has been used since time began – some people used to say it was pre-historic frozen water which would never melt, which shows a rich imagination – and during the sixteenth and seventeenth centuries massive and useless rock crystal objects were made, engraved and decorated with gold, gemstones and pearls. Most museums have a piece or two of great value, probably the Kunsthistorisches Museum in Vienna or the Pitti Palace in Florence have the best displays.

Another form of quartz which wears well, polishes well, holds its colour and is the only purple stone of note is the amethyst. It was very popular in Victoria's day, partly because far more were available after the rich South American deposits were discovered in Uruguay and Brazil in 1760. One of the most obvious reasons the amethyst was worn was its relationship with religion. The Bishops' rings, their symbols of dignity, have always been made from an amethyst since AD 610 when Pope Innocent III decreed it should be so. Equally the stones could be worn as 'half-mourning' with their settings of gold and borders of tearful pearls.

By the 1870s direction via the Royal families had gone with the wind. Victoria could not have cared less about setting any example in dress and after the Franco-Prussian War of 1870–71 Eugénie had disappeared too. Without a Court it was difficult to know whom to follow as an example. There remained the *nouveaux riches* and the ladies of the stage – no wonder that Joan Evans, in her scholarly *History of Jewellery 1100–1870* complains of 'pettiness and silliness' invading the designs of jewels, and any books on fashion speak of 'a mélange of styles, lacking direction, which came about through too great a degree of freedom; each individual choosing form, colour and fashion best suited to their personal taste'.

The picture painted by Joan Evans certainly is startling – let us hope that it was not often seen – of 'gold earrings designed for daytime wear with such subjects as sitting hens, stable lanterns, barrows, windmills, lamps and watering cans', fore-runners of some of the extreme costume

A diamond scroll brooch set with emeralds; there are three drops which give the rather static design some movement, two of flowers and one of a cabochon emerald. English, *c.* 1880. Courtesy of Collingwood of Conduit Street Ltd.

81

Fashion plate from *The Milliner and Dressmaker* showing evening dresses for 1870. it was about this time that the crinoline was partially altered, the attention was brought around to the back and women turned into elegant ducks. This was also the time for satins and brocades, deep and rich colours, all of which were off-set with magnificent parures of matching pieces of jewelry. Nothing could be too large or too extravagant and it all looked marvellously theatrical in the fluttering candlelight or the soft hiss of gaslight. Victoria and Albert Museum, Crown Copyright.

jewelry of the twentieth century and showing quite clearly how some designs had become completely out of hand.

On the other hand there was some quite obvious and amusing jewelry made to show the latest hobby, generally some form of sport. Made from gold and often encrusted with diamonds there were brisk whips, horses, hounds, caps, foxes' masks and brushes; and equally there was a buzz of insects, birds, beetles and peacocks – some displaying a tiny emerald in every feather of its fan-like tail. Craftsmanship and invention could not have been surpassed but pure design could hit rock-bottom.

On the erudite aspect of jewelry there were some absolutely magnificent pieces being made by some renowned jewellers and designers, pieces which are nowadays sold for a great deal of money in salerooms. New owners do not buy them for their gemstone content, nor did their original owners, but purely for their design.

The greatest of the designers of the first half of the nineteenth century was Fortunato Pio Castellani (see following chapter), together with his sons; and they influenced such men as Giacinto Mellilo of Naples, Eugène Fontenay of France together with Robert Phillips and the

82

Giuliano family of London. On the other hand there were also the great traditional jewellers of France such as the Bapst family; Massin, who eventually headed the Rouvenat firm and refused offers to work for Tiffany; Fossin, foreman for Nitot, and Boucheron – all skilful craftsmen who made up more conventional jewels for they found that they sold and sold. Very few people can fault the craftsmanship of the great firms of this period, and there is an overwhelming amount of jewelry to prove the point, yet many designs were either rather finer copies of the popular jewels of the eighteenth century or adaptations of archeological finds, and it is this latter category that most interests collectors today.

A gold brooch of a dragonfly set with diamond wings, a series of rubies for its body and small green garnets for its eyes. English, *c.* 1870. Courtesy of Cameo Corner Ltd.

6. Treasures from the Ground

Two different forms of inspiration were taken from the earth that were to have considerable influence upon mid- and late-nineteenth-century jewelry. One was in the form of materials – major discoveries of gold and diamonds – the other, inspiration from the past, in the shape of archeological discoveries of classical and pre-classical jewelry.

Gold and Diamonds

An important discovery was made in California in 1848. Gold! Gold was the most important metal during the 1860s, replacing silver in popularity and preceding a later fashion for platinum. Because of the finds in California it was far more plentiful from the fifties on, which made it cheaper, and jewellers treated it in as many ways as they could.

The effect of the Californian discoveries was cataclysmic. Apart from supplying the Western world with so much more actual metal it changed the face of Western America. In February 1848 there was a total of two thousand people living in the entire state of California, by the end of the following year there were 53,000.

All men who were able flocked to the diggings to prospect for gold. 'Go West, young man, go West!' was the theme, and even in Hamburg in Germany extra vessels were fitted up on which, for one hundred and thirty thalers, men could take their passage to the land where gold was said to be lying about on the streets. Thousands only paid for the one-way passage, few of them dreamed of returning, for everyone would do *anything* to lay their hands on gold – or its equivalent, an insurance policy.

Once they got to New York many remained there to make their fortunes in the city rather than travel further to California, for they found the pace and general atmosphere so stimulating, so different from the old countries, quickening the blood and sharpening the sense. However, the majority of the men went on West to dig, to live like crazed hermits, passionately hoping for the find of them all, secreting small nuggets in their pockets and with the creases in their fingers sometimes stained yellow with gold-dust. Very soon sufficient was coming from the goldfields to be used commercially, and in the London Great Exhibition Messrs Ball, Thompson and Black of New York exhibited a very handsome tea-service made from California gold.

84

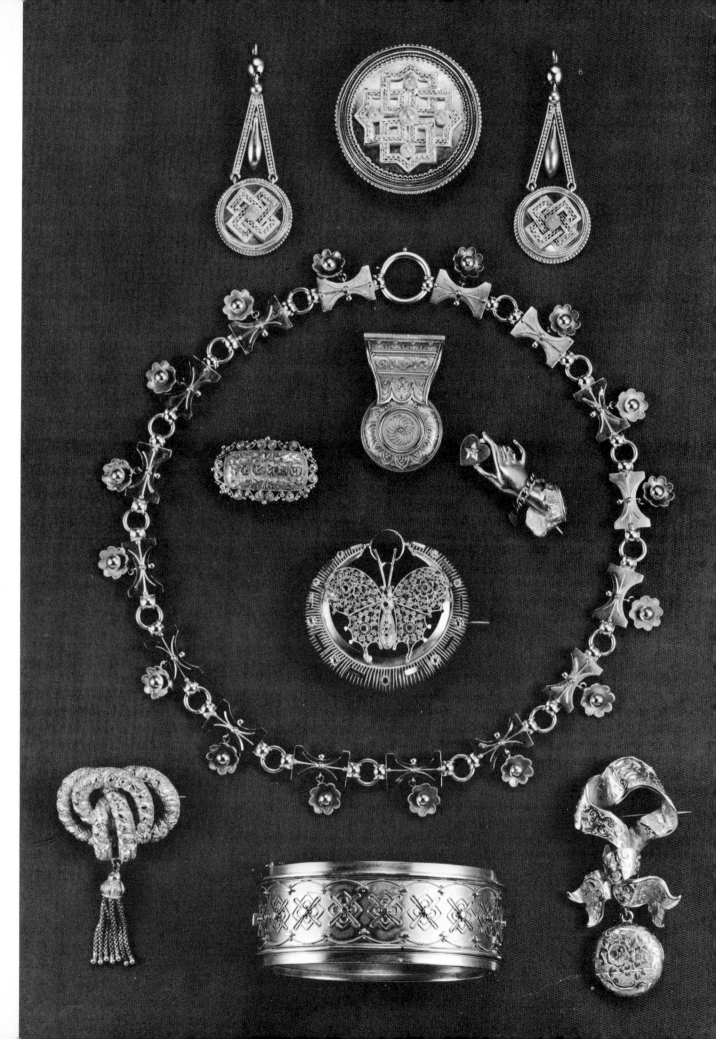

A group of four thin gold bangles set with *top* sapphires and diamonds, *second row* Oriental pearls, *third row* turquoises and Oriental pearls and *bottom row* turquoises and diamonds. English, *c.* 1870. Courtesy of Harvey and Gore.

Gold was discovered in Australia three years after the Californian find – in October 1851. A Mr E. H. Hargreaves, who had been prospecting for gold in California in 1848, returned to New South Wales and noticed similarities in the terrain, so set about to find gold in his native country. Quite soon he was joined by others and within the month a spectacular lump of gold was found, weighing almost four pounds. Then another of eight pounds was discovered and the sensible government promptly awarded Mr Hargreaves £500, with an appointment of £350 a year and an allowance for two horses in order to find gold in his own country. It is ironic that he had to travel so far only to find gold at home, but with his experience in California he knew just exactly what he had to look for; and while they found gold they also, to their amazement, found rubies – which began the trend for searching for minerals in Australia, culminating in the discovery of huge opal fields around 1870. Today Australia is one of the richest sources in the world for minerals.

86

But it was in America that the mining of gold had the greatest effect. It coincided with a growing artistic self-confidence, marked by the establishment of the National Academy of Design under its first president, Samuel F. B. Morse – whose distinction as a painter has been somewhat overshadowed by his fame as the inventor of the telegraph – by New York's 1853 Exhibition, and by the Foundation of St Patrick's Cathedral in New York in 1858.

Up until the 1860s diamonds had been available, but they were rare enough and very expensive. They came from Brazil rather than the traditional trading place for them – India. The Indian diamond mines had just about been worked out and coincidentally, as they petered out, so diamonds were first found in Brazil in the gold-mining area of Minas Gerais in 1725, reputedly by one Bernado de Fonseca Lobo. The Portuguese Government made a fortune from the diamond mines, but only for a short time, for about one hundred years, before they, too, began to falter and die away. Again, as a pure coincidence, they were found in South Africa.

Five hundred miles inland from the Cape of Good Hope, near the source of the Orange River, was once the land of the Hottentots, later occupied by their descendants the Griquas, who in turn were pushed out by the Boers, in endless search for somewhere safe and productive to settle.

In 1859 a Hottentot shepherd boy was playing with a friend, Erasmus Jacobs, when they saw a bright stone on the ground. Erasmus brought it home to play with his sisters and it was left on the ground outside the house. Schalk van Niekerk, a farmer and trader, called upon Mrs Jacobs one day and was given the glittering stone because of his interest in it. He thought it might be a diamond, and, having read a book about precious stones, he experimented by trying to cut a pane of glass in the Jacobs' house. (This marked pane is now in the Colesberg Museum.) It slowly but surely was passed from hand to hand, traders and amateur gemmologists passed judgement on its merits, until it eventually arrived (in an envelope by post cart) on the desk of Dr Atherstone in Grahamstown. He authenticated it as a diamond after tests, stating that it was $21\frac{1}{4}$ carats and therefore worth £500. It was bought by the Cape Governor, Sir Philip Wodehouse, and then sent to Messrs Hunt and Roskell, the Crown Jewellers in London, and christened the Eureka Diamond. Schalk van Niekerk received £350, which he honourably split down the line with Mrs Jacobs, but it was by no means the last of his adventures.

Three years later he was offered another diamond by another Griqua shepherd boy named Booi, all of $83\frac{1}{2}$ carats. He accepted it and gave the boy everything he had on him at the moment: his horse, ten oxen and a wagon he 'had just hauled up from Cape Town; and even 500 fat-tailed sheep belonging to his father-in-law', all of which Booi thought uncommonly fair of van Niekerk. He, in turn, peddled the diamond around and was eventually offered the staggering sum of £11,300 from a group of traders, which he accepted in a flash, who promptly sold it again for £25,000 in London. Everyone was completely satisfied.

Now fine quality large diamonds of apparently inexhaustible numbers became available from South Africa. Members of the jewelry trade all

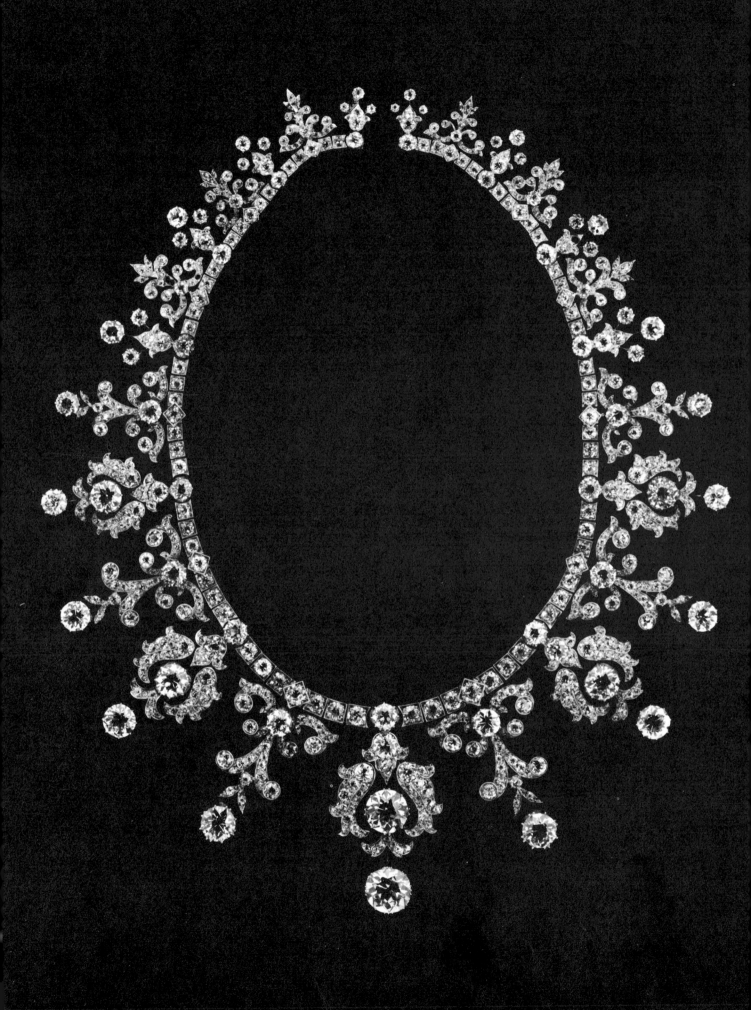

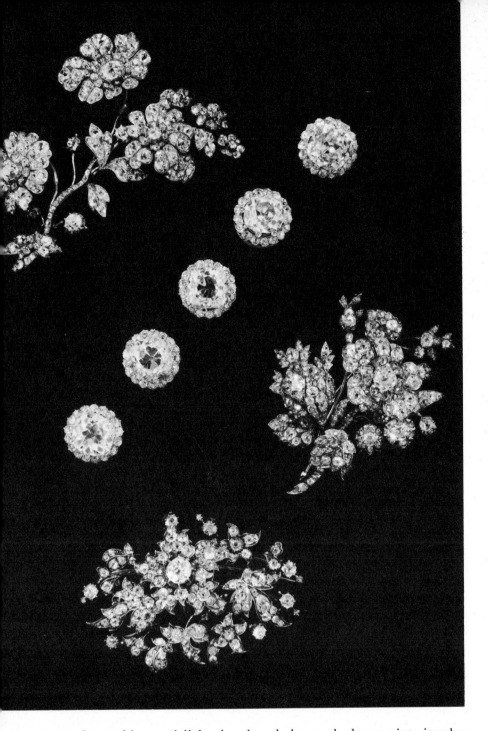

over the world were delighted and a whole new look came into jewelry design. The rich had their diamonds, large, massed and beautifully mounted; the not-so-rich made do with large faceted stones of a far cheaper type (topazes, aquamarines, amethysts and so on) set with diamond chips, just to show they had some anyway. Some other women seemed to cheat (or perhaps their husbands were mean) by having new pieces of jewelry made with a mixture of new diamonds from South Africa, cut with the brilliant cut, all mixed up with old diamonds inherited from the eighteenth century still with the rose cut. It was a very good idea; diamonds don't die, the whole point about them is their brilliance when cut. The rose-cut did not release their fire and colour nearly as well as the brilliant cut, but they were diamonds all the same,

89

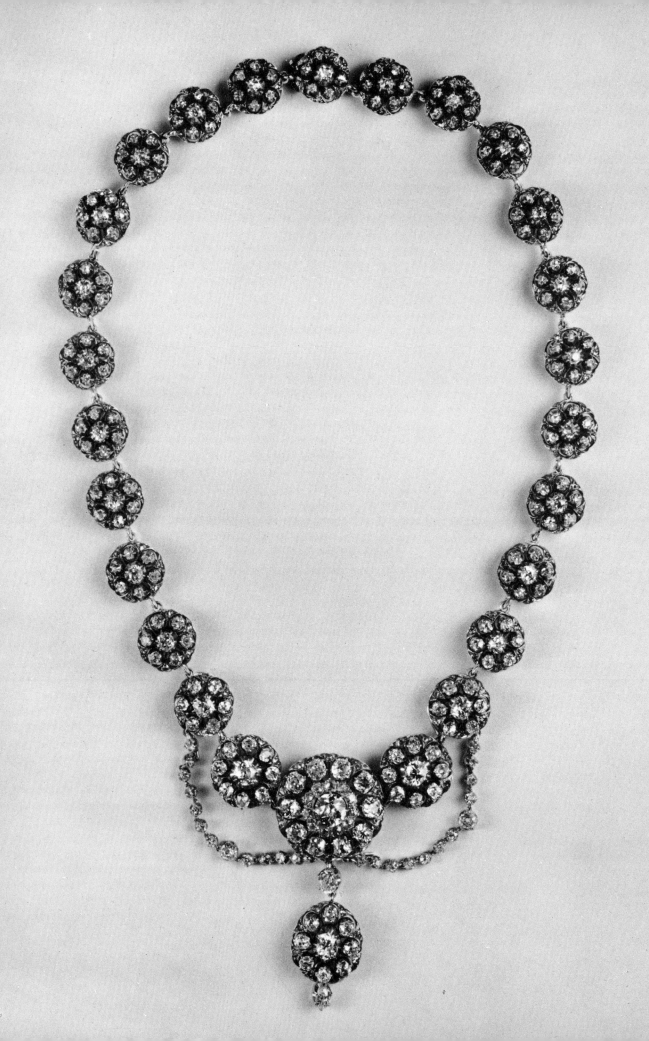

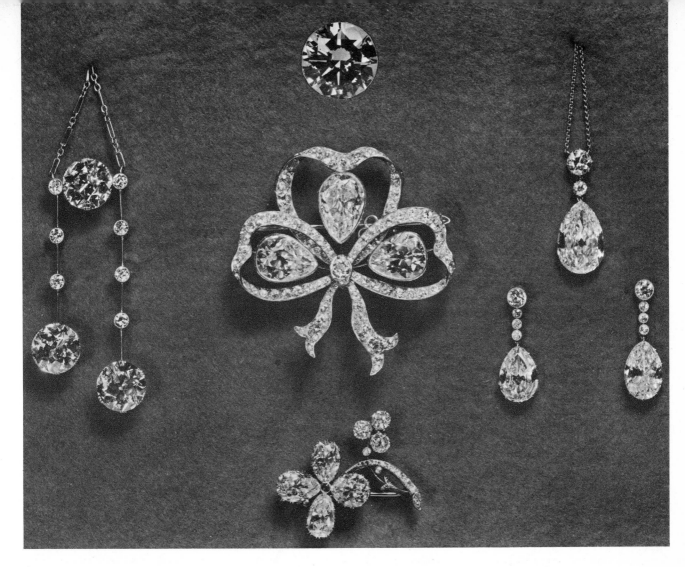

and, unless you came right up with a magnifying glass to the owner you could hardly tell which were old and which were new – and a mass of diamonds certainly *did* impress.

Now that diamonds were again in plentiful supply it was absolutely necessary to see that they were decently cut and set. In the past the lapidary had worked with hand-operated tools at his work-bench, grinding away slowly but surely with a hand- or foot-operated drill. The tools and abrasives for cutting diamonds had been almost unaltered from the fifteenth century but now, at last, it became possible to have power-operated tools and the time taken to cut a diamond on a rapidly revolving wheel or disc cut the working time to a tenth.

As the diamonds were better cut and more readily available it was decided that they should be better displayed in more invisible settings. Up until now there was a tendency in England to bury the diamond deep into a bed of thick gold, just to make sure the precious stone would not be lost; now the backs of the settings were being opened up far more – the 'monture illusion' – made from either silver or gold (and in twenty years' time in platinum). Designs continued to be as large as possible and often floral, with most exact copies of bull-rushes or tulips or roses with their leaves and stalks and buds all copied from nature. However, as the designs *were* so large, and cost a good deal, the Victorians wanted real value for their money, so many large branches of diamond roses and

A selection of diamond jewelry showing very large and lustrous stones from South Africa. *Top* an unset brilliant-cut stone. *Centre* a bow brooch set with three huge pear-shaped diamonds. *Top right* a triple diamond pendant on a fine platinum chain. *Centre right* a pair of diamond earrings with almost invisible settings. *Centre bottom* a flower and leaf diamond brooch. *Centre left* a diamond pendant hanging from a very fine gold chain and showing knife-edge work between the beautifully matched stones. English or French, last quarter of the nineteenth century. Courtesy of Cameo Corner Ltd.

Opposite A necklace of diamond clusters mounted in silver and gold with a festoon centre. Note the graduation in size and the two links at right-angles between each cluster which is a feature of the best eighteenth century work. In the nineteenth century there were often further links in order to economize on diamonds. English, *c.* 1880. Courtesy of Collingwood of Conduit Street Ltd.

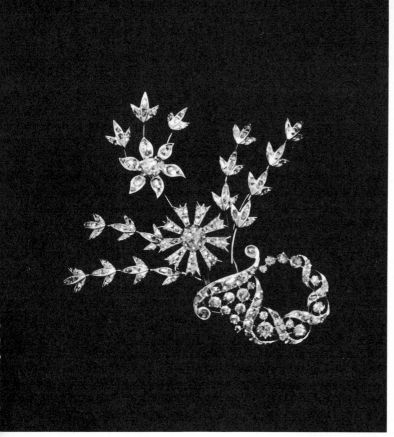

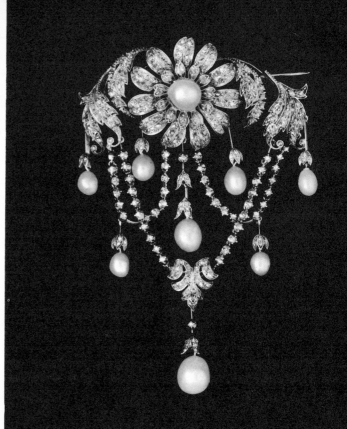

Top Left A brooch showing a diamond cornucopia showering diamond flowers and leaves, very delicately set with knife-edge work. English, *c.* 1860. Courtesy of N. Bloom & Son Ltd.

Top right A very rich yet delicate diamond and pearl brooch showing a central flower, curving leaves, festoons and 'garrya elliptica' drops. The Oriental pearls are beautifully graduated in size to balance the whole composition. English, *c.* 1860. Courtesy of N. Bloom and Son Ltd.

A very lovely pearl and diamond bracelet; the cluster central section can be removed and worn separately as a brooch. Mounted in silver and gold. English, *c.* 1880. Courtesy of Collingwood of Conduit Street Ltd.

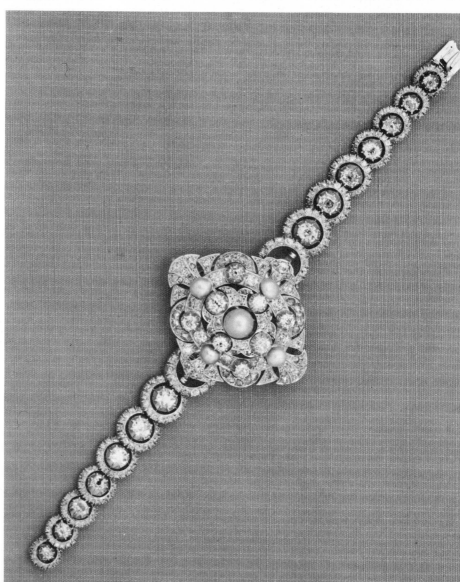

leaves were made to be detachable. In this way two roses might be removed to turn into two brooches, two leaves to two earrings and the remainder of the buds, leaves and stalks might be joined together with minute little hooks or box-joints with screws to make a necklace or two bracelets.

The older and more conservative families felt that it was bad taste to display too much diamond jewelry during the daylight hours (it all went on at night) but this did not deter several well-known personalities, amongst them the fabulous American, Diamond Jim Brady, who thrived on showing off his great wealth. Joan Younger Dickinson writes in her fascinating book *Diamonds*: 'the man who was probably the greatest diamond collector of all time, "Diamond Jim" Brady . . . had a different set of monogrammed jewelry for each day in the month – diamonds one day, emeralds the next, turquoises, rubies, sapphires, cat's eye – thirty-one different sets of studs, cuff-links, belt-buckles, scarf-pins, tie-clips, watch-fobs, and chains. His most famous was his bizarre "transportation set" studded with a total of 2,548 diamonds. Each piece was a different rail-road car: a tank car, a caboose etc.' Diamond Jim was certainly not influenced by the experts on etiquette who ruled that it was more seemly for men to wear their diamonds on their cigarette cases rather than their shirt-fronts, but he did not go as far as some 'old-timers' who had diamonds set as sparklers in the middle of each tooth 'granting, thereby, a guaranteed, built-in smile'.

Diamonds were for everyone and their use depended entirely upon the money that was available and how confident you were about spending it. One day, according to the mineralogist Emily Hahn, Lord Randolph Churchill, father of the great Sir Winston, stood staring down into the great Kimberley dig and said sentimentally 'All for the vanity of women' which was capped by a sharp reply by a lady in his party 'And the depravity of men!' Both were right.

Archeological Digs

Amongst the general unimaginativeness of High Victorian jewelry, collectors are today most interested in that which was inspired by archeological digs. The forerunner of styles derived from the past is the 'Egyptian style', which stemmed from the extensive and well-organized digs in Egypt after Napoleon's conquests of 1798. (These excavations have scarcely come to an end almost two hundred years later. Much the same thing has occurred with the excavations of Herculaneum and Pompeii, where Roman and Greek jewels have been found, for they are digging and sifting still.) No-one could have featured more prominently than Napoleon and his ladies in the promotion of the Imperial habit of wearing a crown or diadem; they took them up with Republican verve, wearing them in the Roman way, and insisting in the incorporation of the classical techniques of working gold and adding cameos, both hardstone and shell.

Then there were the Greek finds of jewels from the then remote islands of Crete and Rhodes (later on to be sorted most expertly by Sir Arthur Evans), together with the marvellously inspired writings of Sir Austen Henry Layard *Nineveh and its Remains* (1848) describes how wonderful artefacts were discovered in the ancient capital of Assyria.

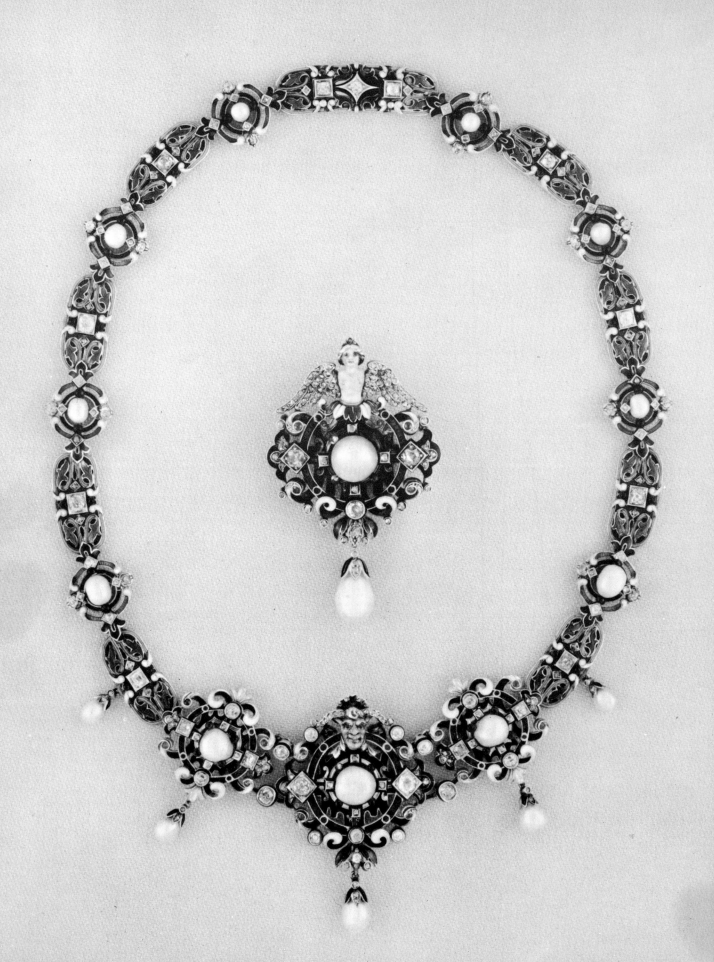

Romantic stories cluster around these finds, such as the tale of Heinrich Schliemann (1822–1890) who, fired by the legends of Troy told to him by his poor Lutheran pastor father, eventually in 1868 gathered equipment to make an expedition to Asia Minor to discover Troy for himself. He dug down on the grassy site where he believed the fabled city had stood, in quite the most amateur but enthusiastic manner, completely missed the Homeric Troy (its remains lay hidden in the upper strata) and uncovered a city of immense antiquity whose treasure of over 9000 pieces of gold jewelry and gold and silver plate he named 'The Treasure of Priam' after the king who had ruled during the Trojan Wars. The huge hoard of jewels included bracelets, earrings, beads, diadems and pectorals, the largest made of nearly a hundred gold chains edged with tiny scales, and featured chainwork and gold filigree, very sophisticated and feminine in design.

Schliemann wanted, naturally, to go on digging, but the Ottoman Government made difficulties (they felt they should have had a greater share of the treasure), so he sailed across to Mycenae in Greece, where there were some ruins so old that Pausanias, a traveller of the second century AD, mentioned them in his guide to the Greek sights. He began digging there too – and here one must remember how erudite a man Schliemann was; his only vice seems to have been endless cups of hot sweet tea – and in 1876 uncovered the shaft graves. Here was found a vast treasure of gold, silver, bronze and ivory, including diadems, pectorals, hairpins, bracelets, pendants, signet-rings and finger rings, and a few earrings – many of them embossed with beast and flower motifs. Quite naturally all Europe went wild with delight at the sight but it must be remembered that news took time to filter through before they could be copied. And copied they were, brilliantly, in the newly dug gold from California and Australia, and worn all over Europe.

In 1827 a few tombs were opened at Corneto in Italy and some remarkable wall-paintings discovered, then part of the cemetery was found of the ancient City of Vulci, followed by a tomb at Caere. This was discovered intact by the archpriest Regolini and a General Galassi in 1836, now known as the Regolini-Galassi tomb, at Cerveteri (Caere), and which yielded the greatest selection of Etruscan jewelry ever discovered at that time. After that there was the discovery of the Campana tomb at Veii in 1842 and in 1850 the Grotta dei Rilievi, all with sumptuous jewelry and metalwork, some showing a marked oriental influence.

Their situation, within the loop of the Tiber as it flowed south-west to the sea, in the strip of land stretching from Elba down to Rome, was most important for a great archeologist-turned-jeweller, Fortunato Pio Castellani.

Castellani (1793–1865) entered his father's goldsmith's workshop in Rome in 1814 and became so adept in his craft and so serious in his approach to the past that he was present in an advisory capacity when some of these tombs were opened. Immediately he was fired with enthusiasm to reproduce jewels in exactly the same designs and techniques as the far-off Etruscans had used. This was easier said than done, for there were no written instructions on how to achieve the fineness of their granulation and so much had to be done by sheer experimentation.

Opposite A very attractive and colourful antique necklace and pendant brooch made in the nineteenth-century Renaissance taste. The front is in a design of blue and white scrolls and crimson annular motifs, set with rubies, diamonds and baroque pearl drops. English or French, *c.* 1860. Courtesy of Sotheby and Co.

95

Naturally Castellani had read Pliny's and Theophilus' classical texts on working gold; equally carefully he had read the recipes of the master-goldsmith of the Renaissance, Benvenuto Cellini, and he had studied the fine metal-work and filigree of Genoa, Malta and India. Instead of calling jewelry of the past 'antique', copying it and selling it for a fortune as so many others were doing, Castellani carefully distinguished between Etruscan, Greek and Roman jewels, for he wished to be taken seriously and not as an archeological faker. He managed this so well that his three sons, who were all practising jewellers, were very highly thought of in their turn by various Governments later on. Alessandro, for instance, advised the Greek and Roman Department of the British Museum on the acquisition of classical antiquities; Augusto was the founder of the Collezione Castellani, a fabulous collection which rivalled the Campana collection; and Gugliemo conducted the negotiations between the Papal government and the representatives of Napoleon III when the Louvre acquired the Campana collection in 1860.

Castellani experimented on and on until he had perfected his techniques. He was ably assisted by the fact that he came across several families, about which he had heard whispered in Rome, who lived in a remote mountainous village of St Angelo in Vado and who appeared to be working in the ancient style. Lock, stock and barrel he transferred them to Rome to work with him, continually using his large personal collection of authentic pieces as an inspiration to them all, virtually working gold in miniature.

The Etruscans had used minute beads of granules of gold to decorate and enrich the surface, achieving a fineness in their granulation and filigree that was almost, but not quite, impossible to recapture.

Castellani's work, both Greek and Etruscan, was marvellously classical and cold; he had worked on their techniques for so long that when he made jewelry in the image of theirs it was precise, erudite, small, surprising and perfect. A long stretch of time lay between him and those early craftsmen, giving his work dignity and distance. His adaptations of classical jewels were small, exact and intricate. He seemed to piece them together like jig-saw puzzles from a thousand tiny sections, working in small areas of gold and rarely leaving any large space of undecorated metal.

Gold was almost always the basis of the jewel, with granulated gold or filigree decoration, a sparing use of enamels, small stones such as cornelians cut *en cabochon* (being of the right historical period) and occasionally pearls.

Nothing was ever either vulgar or really large, especially when he produced the Roman mosaic jewels for which Italy has always been famed. But he made another type of jewel as well with a very strong political bias – 'peasant' jewelry of both gold and silver and enormous in size. He did this because he wanted it known where his political sympathies lay; everyone who had a political conscience was fighting for freedom in nineteenth-century Italy, and he fought as hard as the next man. It resulted in an extremely unpleasant time for him and his family. No work was done in his workshop in Rome between 1848–1858, so Fortunato retired in 1851 and handed over his business to his sons. Castellani also made adaptations of Renaissance jewels which were not nearly as successful as his Greek and Etruscan work. Perhaps he was too

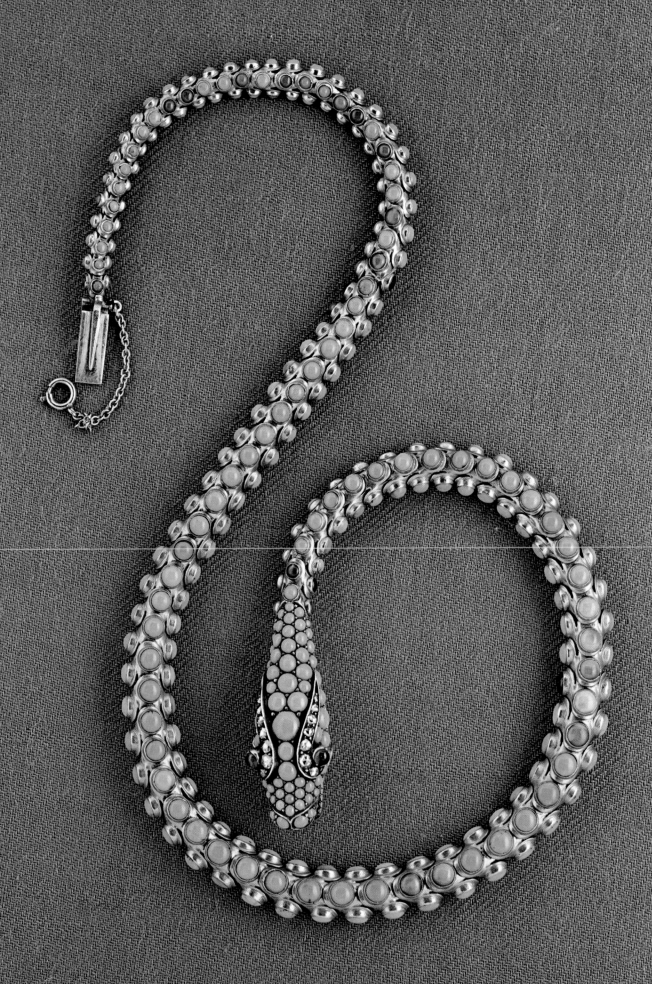

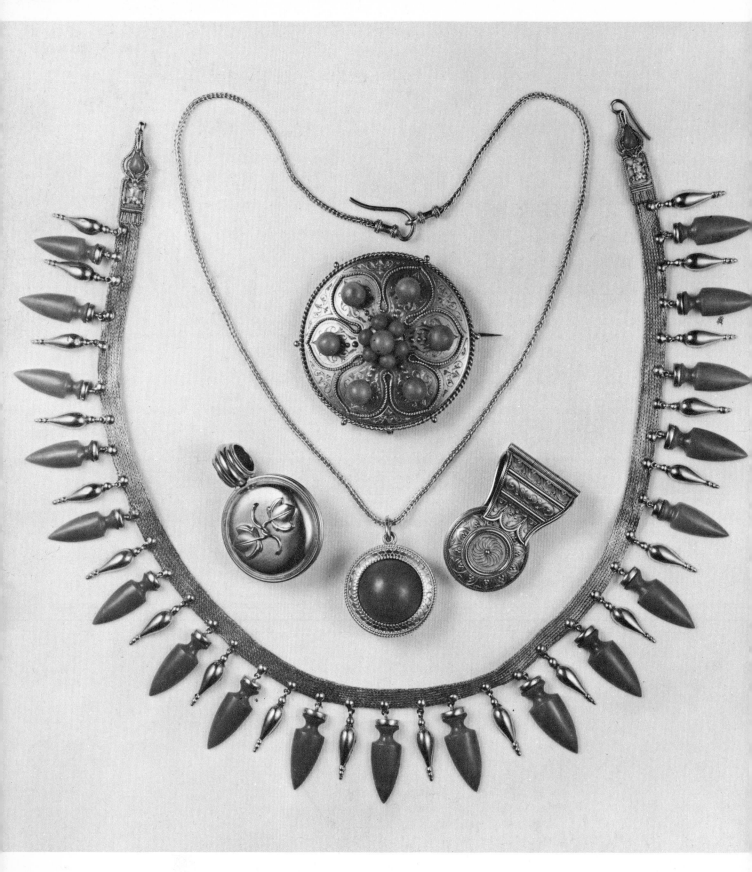

close to them. He was so determined that they should be perfect that he missed out that one ingredient, personality, that one expects from fifteenth- and sixteenth-century jewels. The Renaissance designer knew the person for whom he was designing the jewel and even, perhaps, the occasion on which the jewel was to be worn. Jewelry was caught on the wing, so to speak, brilliant, original and completely personal fantasies made as fast as life was lived. Castellani, on the other hand, was using his brains rather than his emotions. He was making jewels for an ideal, not for a patron; the magic quality was lacking, and it showed.

His reputation during his lifetime was unequalled and it is the same today. To acquire a piece marked by two C's in monogram (used by father and sons) would mark a red-letter day for any collection.

Another man whose name seems always to be linked with Castellani was Carlo Giuliano, although his work was really quite different. What they had in common was that they rarely included valuable gems in their work. Their interest in the antique and the classical meant that they used polished rather than faceted gemstones, chosen from the limited range of cornelian, onyx, cat's eye, lapis lazuli, chrysoprase and pearls – and naturally both worked with gold.

Giuliano was born in Naples and, during the 1860s, when there were disturbances in Italy, it is said that Robert Phillips persuaded him to work in England. He died there, in 1895, in London, having had businesses in both Frith Street and Piccadilly, leaving at least two sons and maybe some brothers and nephews to carry on his business.

What Carlo Giuliano managed to do was to adapt the classical techniques and designs to suit the Victorian lady. He was not nearly as severe as Castellani had been with his Etruscan work, nor as correct, but he was working later in the century when the exuberant crinoline was giving way to the bustle and bolder, more striking jewelry was in vogue.

Unlike Castellani, Giuliano combined Etruscan techniques with Renaissance individuality and always had his customer in mind. There was no working in limbo for him, for his was truly personal service.

His work was exceptionally light, delicate and feminine. He used gold as a base, but plenty of enamels, too, and white enamels at that. Each jewel was made up of dozens of tiny sections, no more than 7 mm across (a quarter of an inch), contrasting in colour and treatment, linked into a single piece of jewelry but existing as independent creations within it. These tiny sections might be infinitesimal spaces of coloured enamel, or

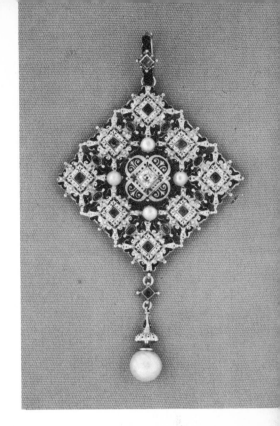

A pendant-brooch in the Renaissance taste, colourfully set with small rubies and sapphires amongst the black and white enamels. Possibly by Giuliano (but not marked). English, *c.* 1880. Courtesy of Cameo Corner Ltd.

Opposite A selection of gold and corals. A fine 'archeological' necklace by Castellani, with gold and carved coral – note the embossed frogs by the clasp, almost a trade-mark of Castellani's. Two bractate pendants in gold, one with ivy leaves, the other with granulations by Castellani. A fine gold chain with a coral-set pendant (possibly made to protect a child). Central disc brooch of gold also set with corals. Mainly Italian, *c.* 1850–80. Courtesy of Cameo Corner Ltd.

Cloak clasp adapted for use as two brooches. Gold, rubies, pearls and enamels surrounding lapis lazuli. 5 cm (1¾ in). Carlo Giuliano, *c.* 1860. Courtesy of N. Bloom and Son Ltd.

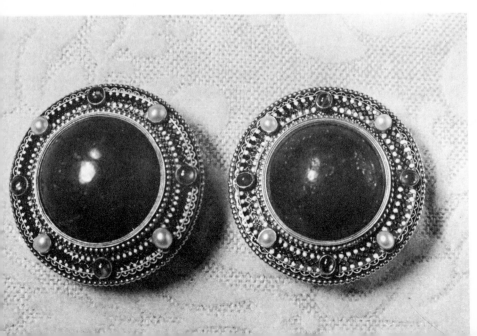

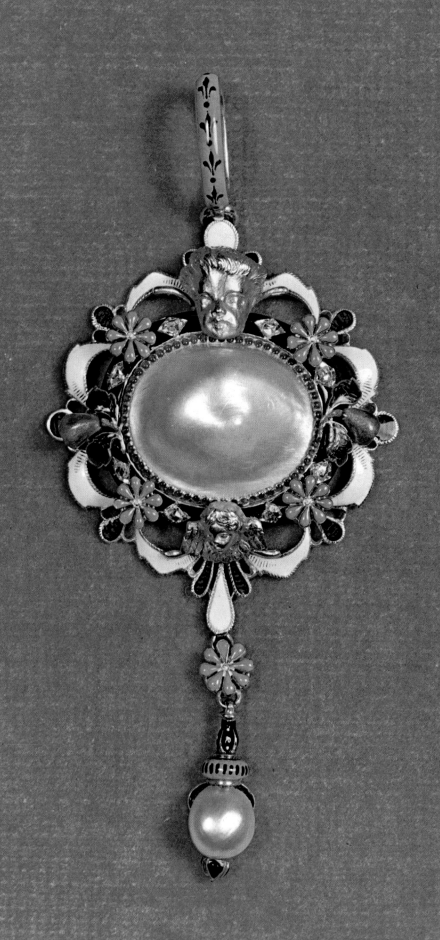

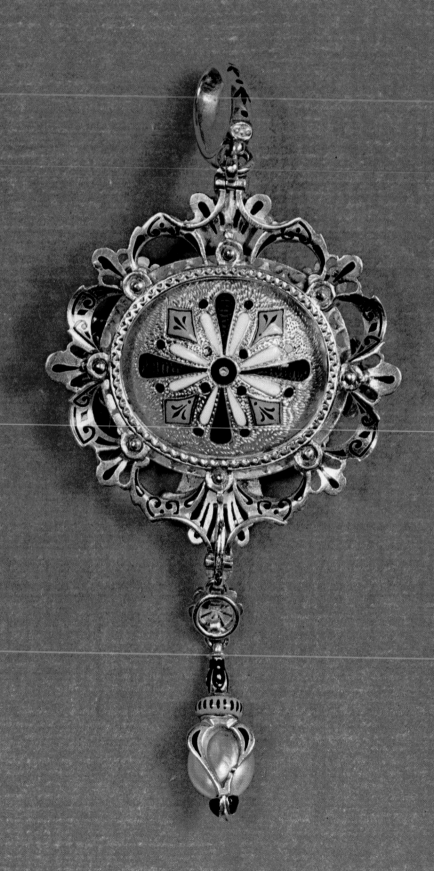

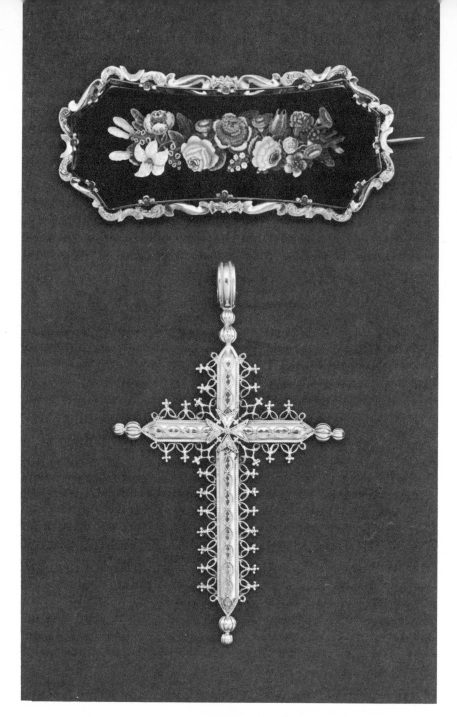

translucent stones polished *en cabochon*. At that point he would drift away from classical traditions by inserting a faceted diamond in a central position, providing a focal point which was lacking in Castellani's jewels but which the Victorian lady expected. Several members of the Giuliano family are known to have worked in London, Carlo and a second Carlo, Arthur, Frederico and Ferdinando and Carlo's senior assistant Pasquale Novissimo. Some remaining members of the family still live in England.

Working very much in the style of Giuliano was Carlo Doria (his mark is a stylised fleur-de-lys and the monogram C.D.) who again was a gifted Italian, inspired by Castellani, and encouraged to come to England by Robert Phillips. Robert Phillips himself (he died in 1881) was an early English pioneer of Castellani-like 'archeological' jewelry and

exhibited widely in various Exhibitions (1851, 1862, etc). But he was perhaps more famed for the assistance he gave to the poor workers of coral in Italy and Sicily, to the extent that the King of Naples decorated him for his help.

The archeological jewelry of the nineteenth century was a real break-through for the craft, especially for the work done in granulated gold, and shows a tendency at last for jewels to separate themselves from the design of the clothes. Classical designs went very well with the Neo-classical types of dress early in the century, but most of the real 'finds' were not until well into the century when dress had acquired an identity of its own, away from the Greek 'simplicity'. Now people were buying the work of those such as the designers mentioned above for the jewels themselves, for their historical content, for their craftsmanship, because there were a talking piece. As so much was brought to the Louvre in Paris after the French had the concession to dig out Pompeii more thoroughly from 1806–14, it is understandable that the French had the opportunity to study classical work at first hand and realize that women were prepared to buy jewelry, for the first time for many weary years, because of its own intrinsic design. It was immensely encouraging to the trade and led the way for French designers to go 'way out on a limb' at the time of the Art Nouveau. Conventional jewelry would always be made and bought like so many beans across the counter, but the products of the great designers working on archeological reproductions started a whole new trend.

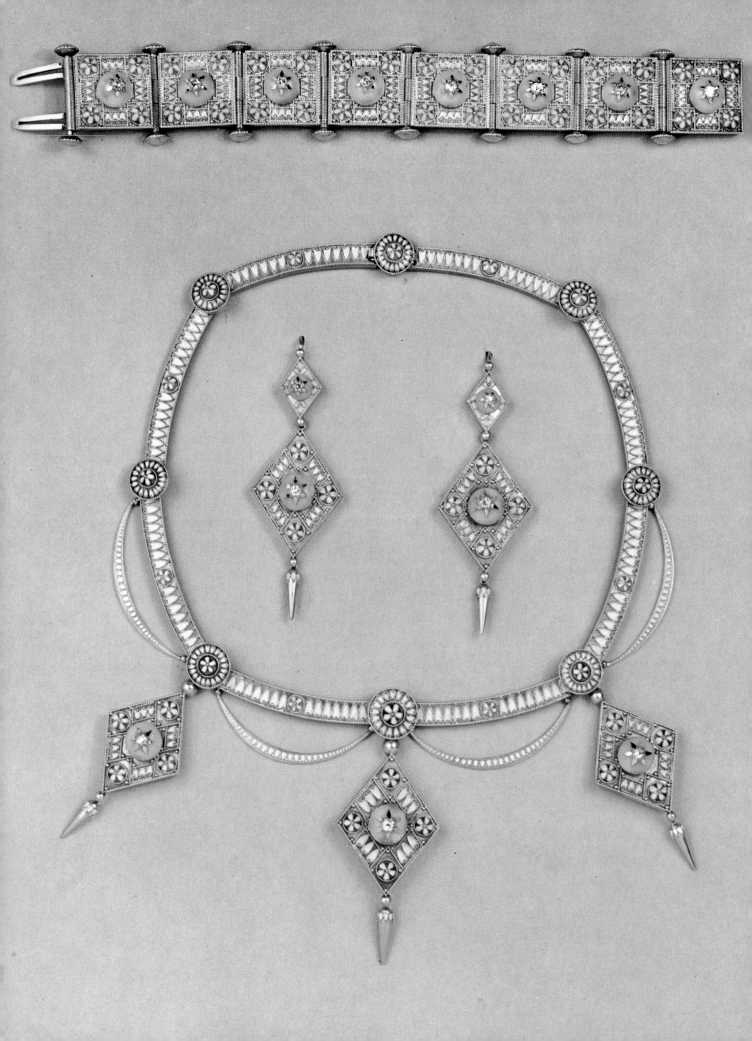

Left A fine suite comprising a necklace, bracelet and pair of earrings of gold enamel, coral and diamonds. Although unsigned it is very much in the 'Classical antique' style of Castellani, *c.* 1865. Probably Italian. Courtesy of Harvey and Gore.

A charming gold, enamel and pearl bracelet by Carlo Giuliano in London. Made sometime (most probably early on) between 1861 when he established a business in Frith Street and 1895, when he died. From the Hope Collection, by courtesy of the Countess of Rosse.

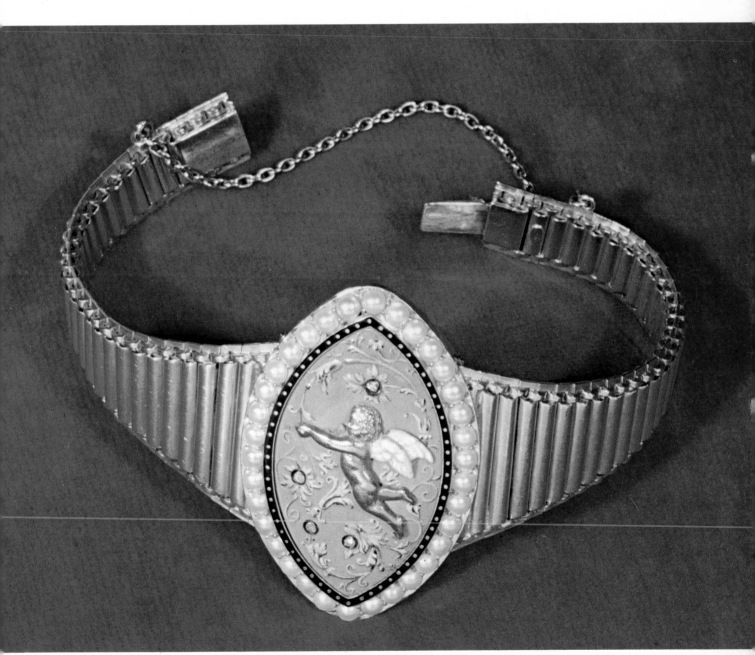

7. Charles Lewis Tiffany and Jewelry in the USA

Fuelled by growing prosperity, tastes and fashions in the USA were running parallel to those of Europe by the sixties. New York's St Patrick's Cathedral, designed by James Renwick, built to endure 'as long as any human work can last' (its cornerstone was laid in 1858) was a high spot in the Gothic architectural revival. After Greek forms had dominated American architecture for decades, the Gothic revival became a part of the new Romantic period in which Moorish temples, Italian villas and Swiss chalets all had their place. In jewelry American styles echoed the same archeological or historical styles as those in Europe and became just as fanciful.

A woodcut of Tiffany's diamond room at their store on Union Square published in 1879. The legend says that Mrs Brown is completely overcome by the dazzling array of brilliants. Courtesy of Tiffany and Co.

In America art was 'out' as business was 'in', and so it was in much of Europe. With the Civil War behind, the quarrels over slavery and free soil that had divided the nation for decades were nearing an end. By 1875 business was booming, the North was prosperous and the South reviving. Railroads were thrusting into new territory and settlers in large numbers were moving into the empty lands of the West. People were proud of their country, with good reason, and as a result the nation commemorated its first century of existence with a Centennial Exhibition in Philadelphia on 10 May 1876. Ten years in the planning, it was the biggest thing of its kind ever held in America.

This was no amusement park. Visitors were quite content to wander slowly amongst the assembled wonders of science, invention and the arts. Although they invited no less than fifty different countries to exhibit there, the Exhibition was mainly a demonstration to the world that the United States had become one of the great industrialized nations.

Displayed were farm machines, pocket watches, machine-loomed fabrics, printing presses, mass-produced furniture, incredibly ornate soda-fountain dispensers – all the great and small products of the burgeoning machine age. The spirit of enterprise in the USA is exemplified by the story of Charles Tiffany, founder of the New York jewelry store. No better illustration of his business acumen, which was to make the store famous, could be found than the story of his reaction to the laying of the first Atlantic telegraph cable in 1858.

After several years of failure Cyrus Field managed to lay the cable unbroken and found he had a further twenty miles of it in hand. Charles Tiffany happened to be in Europe at that time (he had been selling jewels to the Empress Eugénie) and shrewdly decided to buy the lot and cash in on all the excitement. He had the cable cut into four-inch lengths, each fastened with a brass ferrule, and sold them with 'a copyrighted facsimile certificate of Cyrus W. Field Esq, guaranteeing that the piece was indeed cut from the original cable'. Other parts were made into paperweights, cane and umbrella handles, seals, watch-charms and 'coils for ornamenting parlors and offices'. It was one of the most successful promotions of all time, with police called to hold back the crowds. Charles Tiffany, Yankee Puritan, had achieved yet another landmark on his well-publicized journey to solid-based success.

The story of jewelry in America at this time is really the story of this man and the inspired way in which he built up his store. Little jewelry was made in America, but much was imported, and the best came from Tiffany's.

Charles Lewis Tiffany was born on 15 February 1812 and eventually moved from his family home and business in Connecticut to New York. He and a friend, John P. Young, decided to 'go it alone' and start a 'fancy goods' business, anticipating the mid-nineteenth-century craze for

Overleaf left Some exceptionally delicate jewelry of the Victorian period which would have been just as costly to buy then as now. During the first half of the twentieth century Victorian jewelry was out of favour and the prices dropped, now, however, they have risen to a sensible level again.
Top row gold and enamelled openwork brooch. Pansy ('*pensées*' for 'thoughts') brooch in gold and a ruby. Half-mourning brooch of amethysts and pearls – 'for tears'. Shaded enamel, gold and pearl leaf brooch. *Second row* diamond and ruby cushioned flower brooch. Twin hearts of enamelled gold with pendant drops; hearts have been in fashion since the fourteenth century, so this is a conscious reference to the Gothic. *Guilloché* enamelled green oval brooch centred with a diamond rose and framed with pearls and diamonds. A ring-brooch of pearls and diamonds, four sets of three, on the Renaissance ideals of mixing threes and fours, adding or multiplying them. *Third row* an enamelled mauve flower-brooch for half-mourning. A gold and pearl leaf brooch. A delicately enamelled pendant drop in the style of the sixteenth century. A heavy brooch of five amethysts and fine gold whorls. *Fourth row* a ruby heart interlocked with a diamond one, probably made for a wedding. A clover-leaf brooch set with three differently coloured pink pearls. A diamond trellis-work basket of flowers. A very delicate diamond, ruby and pearl ring-brooch. *Fifth row* a Wedgwood cameo brooch showing Queen Elizabeth I in profile surrounded by pearls. Three Belleek lilies of the valley set with gold. A pearl and diamond horse-shoe brooch. A gold and enamelled brooch of three coats of arms, possibly made as a wedding gift. Courtesy of N. Bloom & Sons Ltd.

A flexible gold bracelet of 'S' shaped links with diamonds and blue enamel plaques within rope-like frames. French hallmarks can be seen on the tongue of the clasp. French, *c.* 1840. Courtesy of Harvey and Gore Ltd.

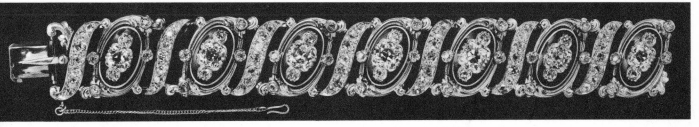

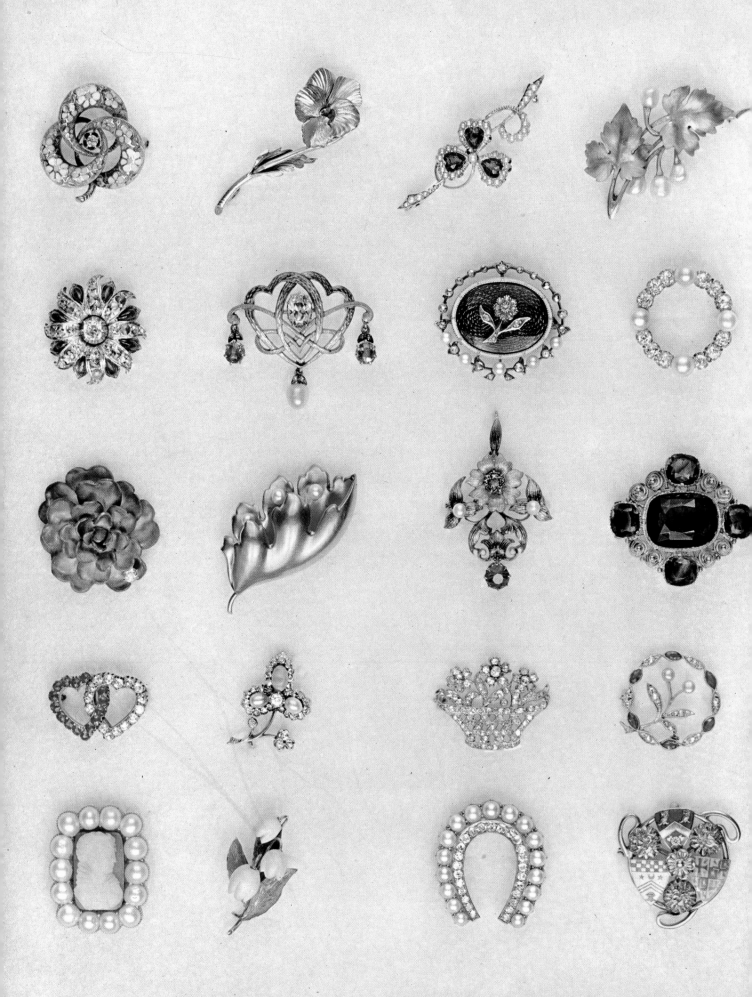

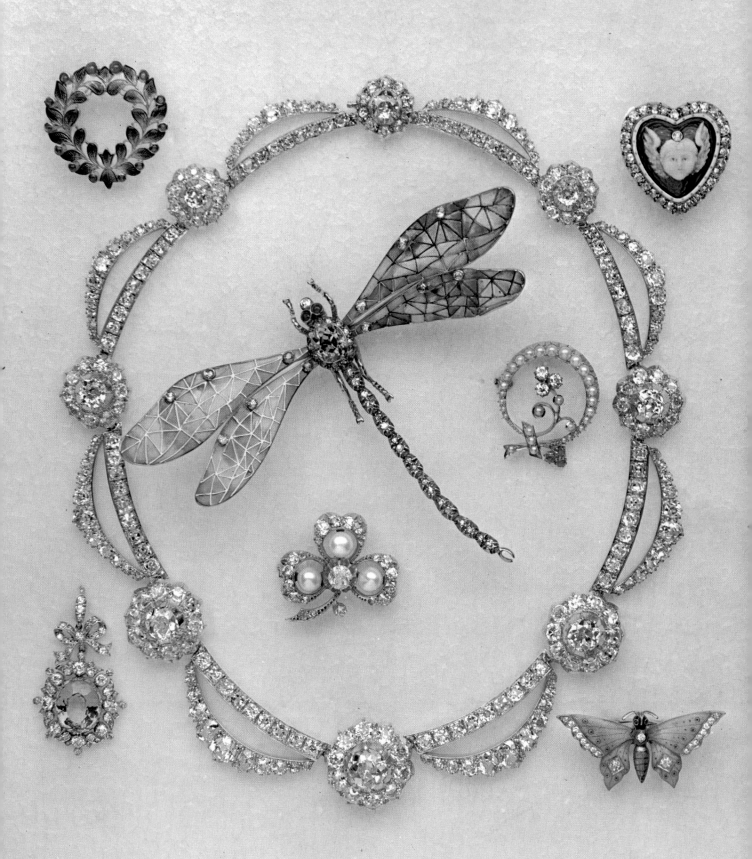

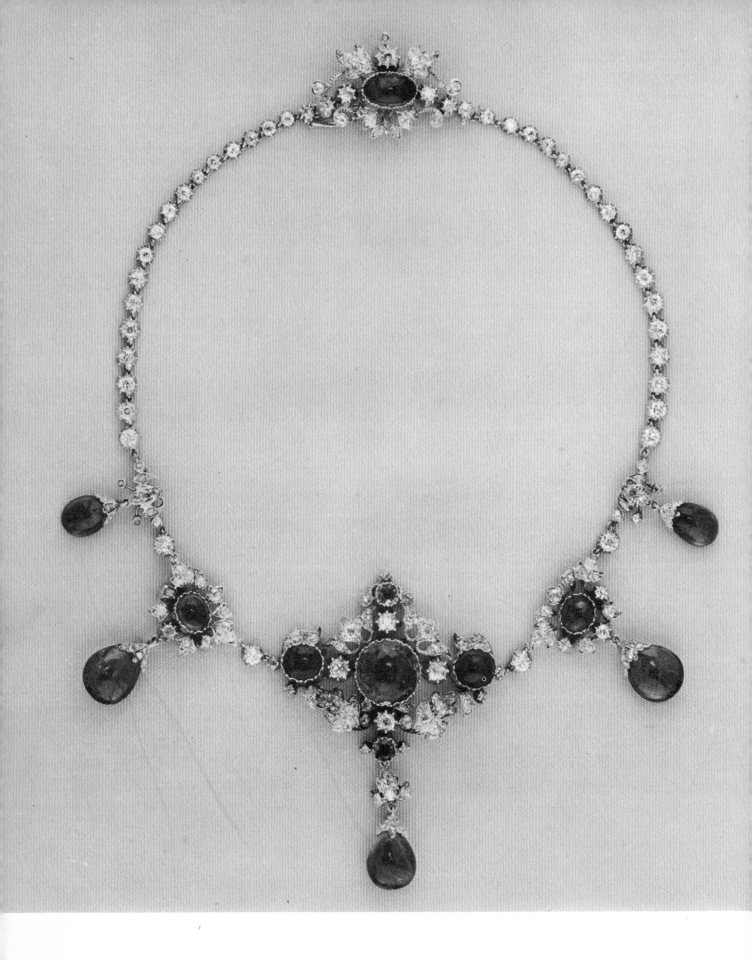

gadgets and curiosities. Their store which opened on Broadway in 1837, sold a multitude of curious objects from umbrellas to lacquer-ware, with their main-stay being stationery. Almost all the goods were imported in those early years and the two young men worked like Trojans to keep their little shop going. Tiffany had a distinct feel for quality and a penchant for the Orient, but their store was certainly not known either for quality or for silver and jewelry as it is now.

The first time either of them thought about selling jewelry was in 1839 when they bought some imported German stock of paste costume jewelry which sold like wildfire. Real gems were very unusual in America at that time; you were considered pretty well-to-do if you could wear a cameo set in gold, or a garnet, or a small turquoise, and these rather coarse pastes looked very much like diamonds to those who had never seen one.

As the store gradually progressed another partner was included, J. L. Ellis, and the three men took the revolutionary step of sending John Young abroad to Europe to scout out the fancy goods market. Tiffany had a magnetic touch with publicity stunts and their small business started to gain fame by being advertised as 'the only store in New York with a representative abroad'.

In Paris John Young was riveted by the sophisticated lines available and brought back with him well-designed paste jewelry, amongst many other things, which again sold immediately it was on show in the store – and Charles Lewis Tiffany decided that the firm should in future only deal in quality goods. After 1845 they stopped selling pastes and only sold jewelry made by the goldsmiths of Paris, London and Rome. They also concentrated on watches and clocks, bronzes and silverware, and had to move to larger premises, while sensibly continuing with all the profitable fancy goods lines from tongue-scrapers to Swiss osier-work. The 1848 Revolution in France provided the impetus to specialize in jewelry. John Young and his assistant were in Paris on the very first day, when the price of diamonds plummeted 50 per cent in twenty-four hours. Young bought every diamond he could lay his hands upon, had some hair-raising adventures, 'acquired' Marie Antoinette's girdle (called a 'zone' in Victorian times), and returned in a blaze of carefully engineered publicity to New York. There Charles Lewis, who had never lifted a finger but was friendly with all the press, neatly turned the tables on Young and had himself dubbed 'The King of Diamonds'.

Money was scarce in France and beginning to flow in all directions in America, especially because of the California Gold Rush. Charles Lewis Tiffany became an expert Public Relations Officer and often teamed up with the famous P. T. Barnum for advertising purposes, such as for the wedding of two of Barnum's midgets, General Tom Thumb and Lavinia Warren, for whom Tiffany made (and naturally displayed in their shop-window for weeks afterwards) a silver horse and carriage. Charles Tiffany had been selling imported English silverware for several years for the *nouveaux riches*, together with mountains of massive sporting trophies, but then in 1844 a new tariff of 30 percent had been levied on imported goods – which made Tiffany think again. He decided to commission John C. Moore (a well-respected silversmith with a well-organized business) to work for him exclusively. Where he showed originality was to insist that the silver should be of the same sterling quality (925 out of 1000 pure) as used in England – a far higher level than most American silver. This was

Page 109 A charming group of late Victorian brooches and necklace. The 'colourless-look' came in after the introduction of electric light so fashion-trends were towards pearls and diamonds, moonstones and pale opals. Sentimental and naturalistic motifs were seen throughout the century, such as the diamond-framed enamelled heart locket and the *plique-à-jour* dragonfly and butterfly. Courtesy of N. Bloom & Son, Ltd.

Opposite A diamond and cabochon emerald necklace, the central section can be detached and worn as a brooch. The emeralds are treated in the European fashion and not speared right through as in the East. London or Paris, *c.* 1880. Courtesy of Collingwood of Conduit Street Ltd.

An ivory pendant enclosed in crystal and framed with gold, showing a woodland scene with deer. About 5 cm (2 in) across, probably made in Northern France, *c.* 1860. Courtesy of N. Bloom and Son Ltd.

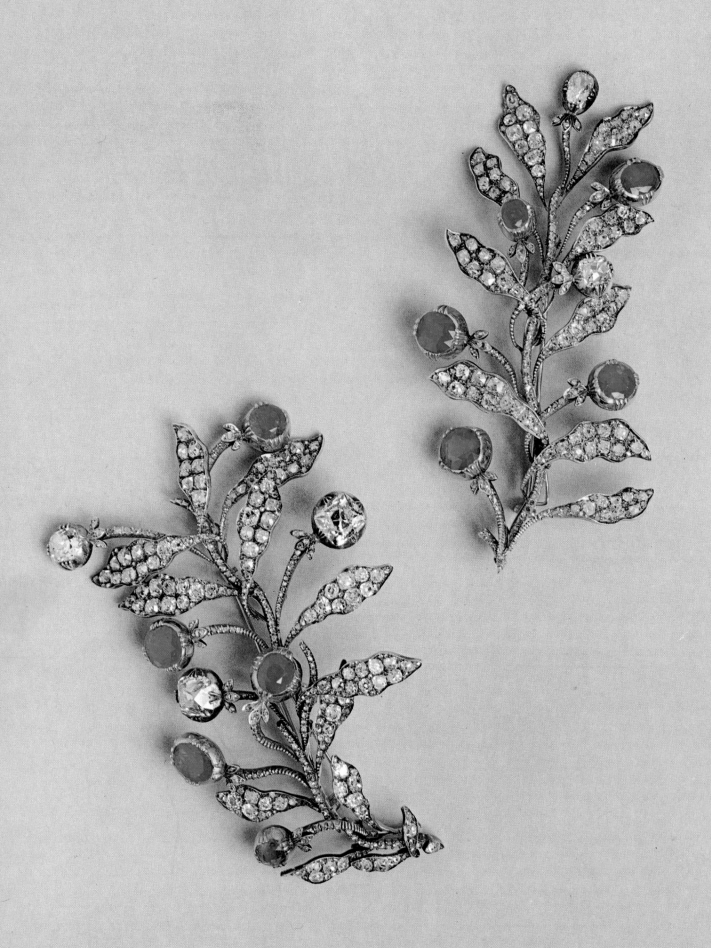

suitably publicized and now the firm of Tiffany, Young and Ellis was all set for the very big league.

Coincidentally the two older men, Young and Ellis, decided to retire, which they did in the most amicable fashion in 1853, leaving the company under one inspired leader and with its final name 'Tiffany and Co'. Suddenly the till money was running into thousands rather than hundreds; the Astors, the Belmonts, the Vanderbilts were regular visitors, buying silver and jewels, diamonds and pearls. Ropes of oriental pearls were selling at that time for three hundred thousand dollars apiece (it was fashionable to wear three ropes at a time) and the scintillating Mrs George Gould had Tiffany make a necklace for her which cost over a million dollars.

The Civil War called a temporary halt to ostentatious diamond sales but Tiffany had his hands full supplying soldiers with badges, gold braid and swords; and at the end of the war he provided commemorative swords to be presented to popular soldiers by their home towns. Charles Lewis did so well with every section of his store that in 1868 the company went public, with Charles as the major share-holder and elected president, and in November 1870 a new store was opened to amaze the world. The *New York Times* reported it as 'A Jewel Palace . . . the largest of its kind in the world'. Every day the newspapers described different parts of the building: the crystal chandeliers, the gas-bulbs, the decor, the unheard-of luxury of a 'Ladies', the elevator (not quite the first, but almost unknown), the jewels for sale valued at over two million dollars, silver valued at a million and a half, and floor above floor of bronzes and clocks and jewelled fantasies.

In 1872 Charles Lewis Tiffany was very badly duped in 'the great Arizona Diamond Swindle' in which real uncut diamonds were brought from South Africa and planted in unknown country, and decided that an infallible expert gemmologist should be on his pay-roll to prevent it happening again. In 1877 George Frederick Kunz joined the company, aged twenty-one, a keen mineralogist from the age of eleven. Naturally in his work for Tiffany's he had to deal with some of the finest conventional stones in the world, diamonds, rubies, sapphires and emeralds, but his personal delight lay in the new colours, rare specimens and yet-to-be-made-popular 'semi-precious' stones.

Kunz was an amazing man. Through his enthusiasm lesser-known stones became almost as popular as diamonds, and he managed to find them all in the United States. He travelled indefatigably, nosing out every new specimen, appearing to hear every whisper of a find. Tourmalines from Maine, emeralds in North Carolina, sapphires in Montana, freshwater pearls in Arkansas and Wisconsin, topazes and garnets in Utah and an unknown spodumene in California of a particularly lovely lilac colour which was named after him – kunzite.

In 1887 the French Crown Jewels were put up for auction in Paris and the Empress Eugénie's favourite pieces were seen again. There was the famous vine-leaf ornament with its wreath of more than 3,000 larger and smaller diamonds, which fetched 1,172,000 francs; there was the comb composed of 208 large diamonds, bought for 642,900 francs, and the girdle of pearls, sapphires, rubies and emeralds, linked together with 2,400 diamonds, which realized 166,000 francs.

All the pieces, according to the *Illustrated London News*, were exquisite;

A spray of laurel mounted in gold and silver, composed of twenty-two diamond leaves, in which five single stones weigh approximately 30 carats, and set with ten Burma rubies weighing approximately 20 carats. This historic jewel from the collection of the Empress Josephine became the property of her son, Prince Eugène de Beauharnais, Viceroy of Italy and the future Duke of Leuchtenberg de Beauharnais, in whose family it remained until some twenty-five years ago. It is seen here divided into two brooches. Courtesy of Wartski.

The original red leather case for the Empress Josephine's brooch, emblazoned with the Imperial cypher in gold; the lid-lining is stamped with the supplier's name: Ouizille Lemoine, 7 Rue Duphot, Paris. The Attestation bearing the Leuchtenberg Seal accompanies the spray. Courtesy of Wartski.

Right A magnificent and enormous
necklace, with matching earrings, made
by Tiffany and Co. of New York. In 1887
Tiffany bought a selection of the French
Crown Jewels which included, from the
written description, a necklace like this.
He also bought the collection of rose-cut
Indian diamonds of the late Henry Philip
Hope – whether he added the diamonds
to the original French necklace or created
a copy is speculative, but the settings
show alterations. The total length is
81 cm (32 ins). Courtesy of N. Bloom &
Son Ltd.

A detail of the necklace clasp, showing
the superb enamelling in the French
Renaissance style, and the clever way
that the huge diamonds are set into
scrolled borders of brilliant-cut
diamonds. American, *c.* 1888. Courtesy of
N. Bloom & Son Ltd.

jewelry designed and made by Bapst, Krammer and Lemmonier. In the past, as a rule, the Empress had preferred to display their dazzle on a white tulle dress, with which she would also wear her diadems, such as the Russian tiara of 1200 diamonds, which fetched 180,000 francs – or the Greek scroll one. But these events had all passed into the realms of dreams, no longer romantic reality but dry-as-dust history.

Tiffany's were at the sale. There was a total of sixty-nine lots and Tiffany bought twenty-four of them, spending approximately 500,000 dollars. They acquired four out of the famous seven Mazarin diamonds, a huge briolette of diamonds, a sapphire and diamond comb and two diamond and ruby bracelets – as well as a belt and buckle privately after the sale. George Kunz felt that the year 1887 was a memorable one for the firm. They had acquired the 'French Crown Jewels'; four of the largest diamonds to come out of Africa that year and a number of gems from the great collection made by Henry Philip Hope (in 1850) which was sold all over the world by his heir. At the end of the year, in spite of the amount of jewels they had sold, the vaults at Tiffany's still contained forty million dollars in precious stones.

It was, however, all made with conventional designs, with a great accent on acquiring 'the biggest diamond, the most beautiful pearl or the most costly parure' – nothing was new.

So the business spread at Tiffany's, with all the usual lines of superb quality decorative arts now allied to silver and jewelry, some imported but much of it being made in New York by their own craftsmen. There were watches, chains, rings, fobs and seals for the gentlemen and all the same types of jewels fashionable in Europe for the ladies. The settings were rich and heavy, mostly of gold, with naturalistic designs; brooches, stomachers, earrings, bangles, bracelets, lockets and now charm-bracelets as well, set with as strongly coloured stones as possible and studded with diamonds.

Many a splendid pendant brooch was being made with carbuncles (cabochon garnets) and diamonds, wickedly rich and dark. Much use was made of exotic turquoises, surrounded by diamonds, or *pavé*-set to form a spray of convolvulus flowers (an example may be seen in the Victoria and Albert Museum) and there were many pieces of jewelry made of enamelled gold, coloured dark blue, emerald green or rich ruby red. But on the whole people wanted diamonds and, after 1860, they got them.

8. Art Nouveau

From 1853 onwards power-operated machines brought mass-production to jewelry, and anything which had the magic words 'machine made' was a special attraction and bound to sell. Naturally, as with furniture design, the machines imposed certain conditions and disciplines undreamed-of by the hand-craftsman. When light metal was being stamped into moulds, for instance, the easiest designs to carry out were scrolls and foliage rather than the light, pretty settings of earlier years.

The factory centres were mainly in Birmingham and Sheffield and it is true that they employed individual designers, but rarely named them, because the novelty of the machine was of greater importance.

Once the metal backgrounds were created by the hundreds they were sent elsewhere, generally to retail shops who bought by the dozen for a special price, for the stones to be set in by hand and then finished. By the 1870s and 1880s machine production was so much taken for granted (and more exciting designs made every week) that advertisements no longer bothered to mention the fact.

In 1878 Mrs Haweiis commented in *The Art of Beauty*: 'Many a woman imagines that her friends will have a higher opinion of her wealth and wisdom by being able to count twenty machine-made lockets and chains in her jewel-case, than if they never see her wearing anything but one diamond brooch, or one really fine cameo, or one precious ring.' What could break this charmed circle of spiritless or constricted designs carried out by machines? The answer was – not a person, or a thing – but a philosophy. Japanese art arrived.

What, one might think, was so surprising in that fact? Nowadays we are swamped with Japanese cameras, Japanese cars, machines of all types – so what was new? The answer lies in history, particularly the seventeenth century. There had been a civil uprising against brutality and misrule in Japan in which many of the Christian population, who had been converted by Westerners, had unfortunately joined, so Japan closed her doors to both incomers and to outgoers in 1637.

The rule was cast-iron, insurgents hoping for help were slaughtered, trade delegations were suppressed, only the peace-loving Dutch were permitted to retain a trading post on one of the off-shore islands. The nation became at peace. At peace to smooth out their internal

relationships, at peace to learn to live within their own resources, at peace to develop their own art forms without any outside influences. However, at the end of the eighteenth century and the beginning of the nineteenth various foreign ships began to shadow Japan's shores until, in 1853, under the threat of an American mission commanded by Commodore Matthew Perry, Japan was forced to sign a treaty which, with subsequent negotiations, brought to an end her isolation and her comparative lack of material possessions. Catapulted into competition with other nations if she were to retain any shred of independence, she was now forced to trade.

What intrigued the West was the type of small artistic curio emerging from Japan, sent along with their trading ships just to see whether they had any commercial appeal. Europe had been familiar for a long time with the normal blue and white earthenware and porcelain coming from China, but of modern Japanese artefacts they knew nothing at all. What they saw caused an upheaval in the art world.

England, America and Russia were occupied with wars and similar disturbances at this time, but France – temporarily at peace – jumped in with offers of vast sums of money to help build ships and shipyards, docks, iron-foundries and mines. In exchange Japan exported to them the only things they really had – aspects of their arts. Prints, embroidered textiles, pottery, lacquer-work, inros, netsukes and carvings in a variety of other materials. As soon as these artefacts appeared in Paris enthusiastic connoisseurs and dealers went racing out to Japan to see for themselves and to buy up their own consignments. In those days most wealthy collectors depended upon *bona fide* dealers who were overjoyed to discover these new forms of income.

First Paris, then all France and then all of Europe became fired with the totally new phenomenon of Japanese art and artefacts. In the art world, by the 1870s, the rehashing of past European styles had become boring and decadent in the eyes of the avant garde. So the French, in their normal manner, took the best from another country, extracted the essence and then refined it for themselves.

At this time colour became the dominant element in art. The 'holy' colours used by Pugin and his followers had been rich, dark and opaque, with a dense, flat look; the ruby-red of a sanctuary light, the deep sapphire-blue of a stained-glass Madonna's robe, the dark-green of an altar-frontal, all fitting in with the Neo-Gothic look where lighting came from some mysterious but external source, falling on and revealing the object. Now, however, Europeans could see how the Japanese artists created colours which fused in an entirely natural-looking way and which were, moreover, translucent – now the light seemed to be filtered *through* colours in a beautiful and tantalizing way.

Japanese blues fused gently and smoothly into greens, yellows into reds, golds into silvers, and all were irradiated with light, as if a luminosity existed deep within an object and shone effortlessly out. Most inanimate objects shimmered and gleamed, showing that they had a real inner life of their own, possessing that soul which all Japanese knew to be present in all things.

In the decorative arts, and especially in jewelry, the mysterious shifting colours persisted, as did the mysterious inner silvery sheen – silvery because it was generally a moony translucence rather than a golden glow.

An Art Nouveau gold pendant, modelled in two tones of gold, showing a maiden's head with flowing hair intertwined with leaves and wearing a head-band of rose-cut diamonds; and with dragonfly wings, with a pendant baroque pearl. 3.8 cm (1½ in), French gold poinçon, with gold chain and detachable brooch fitting. *c.* 1900. Courtesy of Sotheby and Co.

117

An Art Nouveau pendant-brooch of two dragonflies embracing, with *plique-à-jour* enamelling for their green wings, a central oval opal and a pendant opal drop. French, *c.* 1900 Courtesy of N. Bloom and Son Ltd.

Pretty Art Nouveau pendant-brooch, with a fitting for a hairpin, of two irises in painted and shaded enamels, eight diamonds and two pearls. *c.* 1900, French. Courtesy of N. Bloom and Son Ltd.

The heavy golds quickly went out of fashion and silver came back; it was even interwoven with textiles. Some anodized metals were used (meaning metals which were treated electro-chemically to thicken the protective coating that forms on exposure to air) with some dyes added to give an attractive shot-silk colour with a silvery sheen.

Instead of the heavy onyx, dark marbles and mahogany that had previously been used for lamp-standards and sculpture plinths, artists tried out most successfully the use of pale marbles, chunks of rock crystal or glass made to represent dripping ice. When they used gold at all they did so sparingly, perhaps merely to highlight some shift of accent in an object in order to emphasize the quickening feeling of perpetual movement.

Whereas 'Chinese learning' can be rather neatly defined, 'Japanese spirit' is wholly elusive. According to Professor Edward Seidensticker 'the first phrase applies to a philosophical tradition, either Buddhist or Confucian, and to advanced scholarship in fields like medicine and philology. The second is much vaguer – a touch, a feeling, an intuitive assertion.' Distilling the essence of Japanese art becomes almost impossible but an intense love of nature and an ability to create new fusings of colour are basic elements upon which they built their themes.

The Japanese revered the natural world with an absolute empathy unknown in Western art. They felt themselves a part of it rather than apart from it, therefore they never needed to give repetitive patternings when designing a flowered scene. A single bloom was enough, very unlike the practice in Victorian England and the repetitions of William Morris and his friends. Instead of attempting to portray an exact and objective scene, the Japanese artist showed, perhaps, a single significant image; it was a refinement that yet remained accurate and full of life.

Art Nouveau floral designs for jewels featured everyday plants and flowers, because the Japanese have always stressed that there is no real hierarchy in plant-life, that all is equal in Nature. Especially popular were those which had coiling tendrils, delicately pointed petals, and tongue-shaped leaves. They used the hedgerow vetch, bunched or trailing chrysanthemums, the phallic iris, the sinuous convolvulus, the hide-and-seek marsh-orchids or silvery moon-lit honesty, whose French name is *la lunaire* – plants and flowers with endless clinging tendrils and the soft secretive droop of leaf or bloom.

These flowers were rarely seen in Western European and American decorative arts. People had been far more used to roses and lilies and faced with a nasturtium or a poppy as a 'serious' flower they were bemused. Equally the choice of insects in designs they found unsettling and rather frightening: diamond-winged wasps, dragonflies with *plique-à-jour* enamelled wings and hurrying ants were all very often featured in Art Nouveau jewels, together with writhing snakes or licketysplit lizards. After decades of being safe and conventional these aspects of nature which were beginning to encroach into their lives seemed something definitely to avoid for the majority of people, yet the real avant garde reached out with open arms and added this new type of jewelry to their other experiments.

It stands to reason that it was in France that Art Nouveau jewelry found its finest expression because the designers could assimilate the Japanese art which was pouring in at first hand and they had there a

buying public eager to acquire their bejewelled fantasies. Yet it is essential to remember that the French avant-garde designers adapted Japanese ideas to suit the exotic French lady of the stage, not for them the endless pattern-making of the Arts and Crafts movement in England. They set out to shock, to titillate, to attract the experimenters in sex and drugs and Symbolist poetry. They made intense jewels for the few – but important – people who dealt in excesses and who were proud to wear Art Nouveau jewelry because it drew attention to themselves. Some of it was as flamboyant as the wild can-can, some as sinister as the whispers of the underworld of crime, most of it would have been rejected by the Japanese as ugly or absurd and the conventionally minded of each nation were afraid of it. But in France it soared as a style for it was the right flavour for the dramatic mixture of women of stage and society who were not afraid to live their lives to the full and in public.

The designers were led by René Lalique (1860–1945) who found international fame when he was taken up by Sarah Bernhardt to make the jewels she wore upon the stage. As a result his supremely beautiful pieces were deliberately dramatic and theatrical; he used motifs drawn from nature, flowing nudes, sensuous, luminous, full of sexual images – women being swallowed, spiked, stung – deliberate, cruel, completely unreligious, always surprising and never repeated. As was said in the Grafton Gallery's catalogue in 1903, when Lalique gave his first one-man exhibition in London, 'there is, at times, something almost sinister in this wondrous beauty and exquisiteness; in this super subtle fancy that disdains the common earth and seeks to tear out the heart of nature's beauty – but also her never-ending pain and struggle'.

Lalique incorporated into his flowered jewels the sculptured heads of girls with dreamy faces, hooded eyes and flowing hair unloosed like a broken wave upon their shoulders, often tangling with birds about their necks. They have a strange, unknown and curiously sinister air as if they were being willingly propelled by a force unknown to themselves. It was also said about these great French jewellers and their sculptured nudes of young girls, 'one is led involuntarily to think of mysterious rites, of priestesses of some strange worship that is beauty – but not godliness – of a strange type of perfection, gladdening the eyes but grieving the heart'.

Lalique had many followers, men such as Eugène Feulliatre, Georges Fouquet, Eugène Grasset, Lucien Gaillard, Paul and Henri Vever and several others creating brilliant work; there are many beautiful photographs of their work in Graham Hughes's book *Modern Jewelry* and some superb and hitherto unseen designs in Charlotte Gere's book *Victorian Jewellery Design*. One also finds Philippe Wolfers in Brussels, working for the court there and becoming almost equally famous, and finally Georg Jensen in Denmark carrying on the movement successfully but in a completely different idiom.

British Art Nouveau jewelry was better known as 'artistic' jewelry and ought not to be confused with the Arts and Crafts movement. Although to a certain extent they touched now and then in principle (the hand-made work, the individual jewel and some techniques) there was far more emphasis on the linear qualities than any sensual or erotic feeling. The Celtic Revival influence was very important and so was the fact that the most important designer-craftsmen worked as individuals rather than a

school, but on the whole there were very few Art Nouveau jewellers who could match up to the French in Britain except, perhaps, C. R. Ashbee.

Far too much importance is placed on the Arts and Crafts movement in some jewelry books, blowing out of all proportion the importance of the style in Britain at that time. The movement as a whole was important for design in the decorative arts generally and also for the hand-craftsman or woman, but in jewelry one finds the least attractive aspects and extremely small quantities of jewelry were actually made. Arts and Crafts were a protest against the machine and trade in general, but much of it was badly made in dull silver with a few dull stones; the jewels did not sell, for they were too expensive, and much was made by sheer amateurs. However there were some people who stood head and shoulders above the others and amongst them were Henry Wilson, Arthur Gaskin, Sir Alfred Gilbert and Alexander Fisher.

The Arts and Crafts Society was founded in 1886 and the Guild of Handicraft in 1888 and they both evolved out of the thinking of the Pre-Raphaelite Brotherhood and William Morris. The sad thing about Art Nouveau jewels in England is that they were so desperately dull when they should have been fun or naughty or both. Unhappily it was an unwillingness to acknowledge sex which prevented the British jewellers from creating anything really memorable. They were all quite ready to make beautiful under-stated hand-made jewels with a motif from nature but that was just about as far as they could go. The Victorians were too inhibited and the customers lacked the courage either to buy a sexual fantasy or to wear it.

The jewels they made were in complete contrast, however, to the elaborate gold and flashing diamond commercial products worn by the wife of a wealthy man. They were designed and made by the same artist craftsman, on proper Morris principles, in a deliberate effort to restore the medieval system with its emphasis on craftsmanship and a conscious rejection of machinery. It is quite noticeable how French designers used a marvellous medley of stones – often including diamonds – for their exciting and highly original pieces and the British shrouded their work in modesty, paying more attention to the working of the metal and the use of painted enamels. The French considered the glamorous woman who would wear the jewel and on what occasion; the British were far, far happier designing jewels and silver for the Church. These were sexless, rich with religious symbolism, yet still dramatic; a morse or cloak-clasp made in silver or gold and studded with cabochon gemstones had to have a certain impact if it were to shine out through the 'censer-made mists' and flickering candlelight, and British artists of the time seemed to have breathed more happily when working in a religious atmosphere. Their jewels for everyday wear were pale and 'good class' – even today, about 100 years later, there are many people in Britian who feel it 'wouldn't be done' to wear even faintly erotic jewelry.

However, several jewellers of note emerged in Britain. Amongst these Sir Alfred Gilbert (1854 – 1934) created some fine work but never liked to be publicly associated with the Art Nouveau movement. His training as both a sculptor and a metalworker, together with an early stay in Paris gave him considerable advantages. A badge and chain for the Mayor of Preston is one of his most famous pieces, carried out in silver-gilt, enamels and moonstones and rich with endless convolutions.

Charles Robert Ashbee (1863–1942) made some exquisite work, of which several pieces are permanently on view at the Victoria and Albert Museum in London so that they can be studied from a few inches away. His ideals led him to found the Guild and School of Handicraft, not only working for himself but encouraging many others and giving them practical help. He worked in both gold and silver, rarely using faceted gemstones. The luminous moonstone attracted him and blister pearls, jade and turquoises; he concentrated on designs of the abstract – or flowers in abstract – with sensuous and soft low-relief sculpture which always looks fresh and spontaneous. One of his most famous jewels is the peacock (to be seen in the above museum) which hangs from the most delicate hand-made gold chain in five slender threads. The bird is in gold, its tail spread behind with golden branches of feathers and small blister

Moonstone jewelry showing necklaces and pendants. The stones came from Ceylon and were generally set in fine silver to keep the moony translucence. English, late nineteenth century. Courtesy of Cameo Corner Ltd.

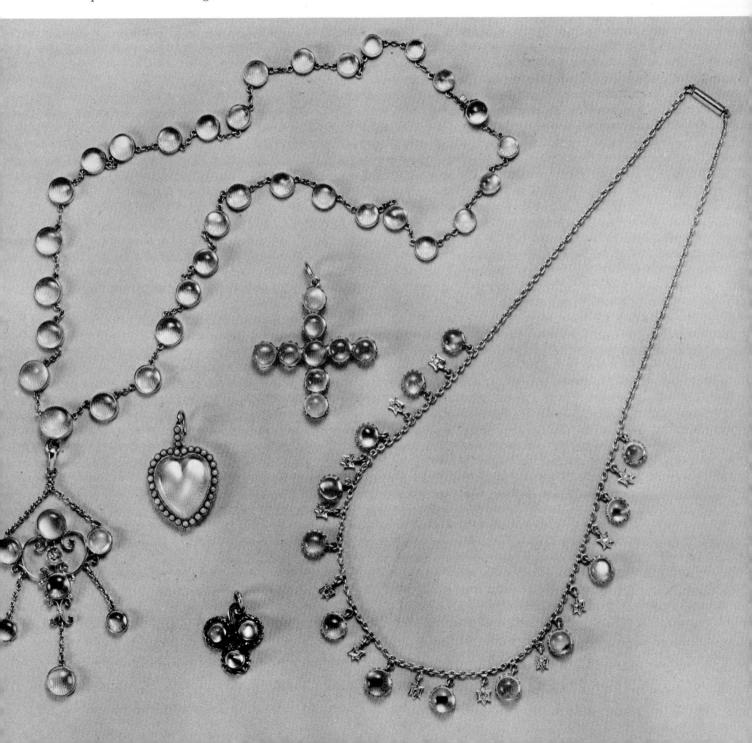

pearls for the 'eyes'; then lacily the patterning continues in silver with rose-cut diamonds pin-pointing each section, letting the light filter through, just as it seems to filter through the 'nest' the peacock sits upon with an 'egg' of a larger blister pearl. To balance the composition three more lengths of golden chain hang below, tipped with yet further elongated tiny pearls. The design appears static until one realizes that every part is different and hand made, uneven yet balanced, and the finishing touch is the way that the peacock abruptly turns its proud head, crowned with tiny diamonds, to one side, away from the viewer. The peacock was often used as a motif for Art Nouveau jewelry. So beautiful and harsh a bird, with its cruel speech and splendid tail, was as exaggerated as any fantasy of nature – a robin would never have done.

Alexander Fisher (1864–1936) was one of the most famous and able enamellists in Britain, having had the advantage of living and studying in France. His work was exhibited at the Royal Academy, the Arts and Crafts Society and several International Exhibitions; one of the ugliest masterpieces in the enamellist's craft is his huge enamelled girdle (seen at the Victoria and Albert Museum too) showing scenes from Wagnerian operas. Amongst his many distinguished pupils were Nelson Dawson (1859–1942) and Arthur Gaskin (1862–1928), who both taught their own wives, Edith and Georgina respectively.

These artists, amongst others, helped themselves and helped each other, but it was Henry Wilson who helped everyone because he actually wrote a book to explain it all, *Silverwork and Jewellery*, in 1902.

Henry Wilson (1864–1934) was immensely practical. He left nothing out, giving every possible direction (and the reason behind it) and he gave dozens of detailed diagrams. At the same time he encouraged the creative instinct in his pupils: 'If the student will study methods, materials, and natural forms, perfect his skills in handiwork, feed his imagination on old work, attend faithfully to his instincts, his personality can safely be left to take care of itself. It will infallibly find expression.'

Wilson ended a brilliant career as architect, silversmith, sculptor and jeweller by being elected president of the Arts and Crafts Exhibition Society for 1915–22. In the true tradition of the English Art Nouveau he made gentle jewels for women and blazingly exciting and original jewels and plate for the Church. But the most influential person in England in the Art Nouveau movement was neither artist nor sculptor, silversmith or jeweller – but a shop-keeper.

Arthur Liberty (1843–1917) was trained behind the counter, having migrated from his native Chesham in Buckinghamshire via Nottingham to London. There he eventually joined Messrs Farmer and Rogers in Regent Street and became manager of their Oriental Warehouse, an extension of the main store. They sold *objets d'art* – Japanese prints and lacquers, porcelain, bronzes, silks, fans and bric-à-brac, many bought in after the 1862 Exhibition. Some of his more interesting customers were the Pre-Raphaelite brotherhood of artists, several of whom painted exquisite Art Nouveau jewelry into their compositions – men such as Dante Gabriel Rosetti, William Holman Hunt, John Everett Millais and James McNeill Whistler. They used to wander into his shop (from 1875 Liberty owned his own at 218A Regent Street) and discussed with him the nuances of Japanese art, especially the American Whistler, who had trained in Paris and eventually became known as 'the Japanese artist'.

An Art Nouveau gold brooch of irregular oval form showing a maiden dreaming on ramparts. 3.8 cm (1½ in), English, *c.* 1900. Courtesy of Sotheby and Co.

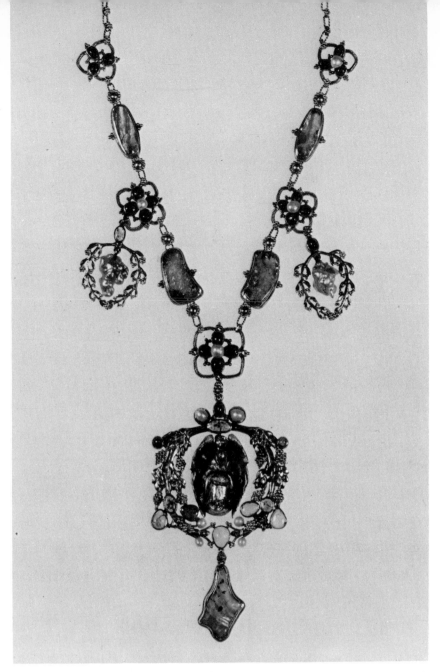

An enamelled necklace by Henry Wilson, decorated with pearls, opals and cabochon emeralds, centering a sculpted seated figure of an angel. English, c. 1895. Courtesy of Sotheby and Co.

As time went by the quality of the beautiful silks from the Orient began to change and Liberty felt that British dyers and weavers could emulate their better work – rather than having to continue importing rather coarse examples – and so the 'Liberty fabrics' were born. The same applied to his feelings about jewelry. He switched from selling pieces from abroad to commissioning native-born workers in England, calling his range of jewelry 'Cymric'. The designers had to submit their ideas to be made up by various commercial firms in and around Birmingham and a certain amount of mass-production became inevitable.

Liberty only sold quality goods, individually designed and to his own very high personal standard. Now the problem was: were the many artists and craftsmen to have their name attached to each object – silver, silk, lamp, jewel or glass – or were they all to be sold under the one name? He considered this latter project to be the most sensible course, everything was now from 'Liberty and Co', and the move was so

successful that as far away as Italy the Art Nouveau is still known as *Stile Liberty*.

It was cruelly hard for the designers, whose names were rarely mentioned. During the past decade or so several of their names have come to the fore, especially at the Archibald Knox Exhibition and the Liberty Centenary Exhibition of 1975 (Arthur Gaskin, Jessie King, Oliver Baker and others), but their fame is decidedly posthumous and most of them died in relative poverty.

The giants of the jewelry movement have been mentioned over and over again in the plethora of books about the period as a whole, yet there are others whose work appears equally able. In England there were five women who managed to create more daring designs than their male counterparts; Frances McNair, Winifred Hodgkinson, Kate Allen and the McLeish sisters. In Germany there was the work of Robert Koch and the flowing lines of the designs of Theodor van Gosen. In Austria Franz Hauptmann seems to have understood the movement in his bones, but it is always to France that one returns.

Under the auspices of M. Meier-Graefe and his 'La Maison Moderne' some glorious pieces emerged, especially from the hand of Colonna and Marcel Bing. Yet for a personal choice some of the purity and sculpture in the glorious jewels of Jules Desbois seem to anticipate the best jewels of today by almost one hunded years.

Enamelling and the use of a higgledy-piggledy collection of stones, cheap and expensive, together with valuable ivory and cheap horn, bundled together in the most deliberately unconventional way, mark the two main features of Art Nouveau materials.

The usual and conventional forms of enamelling had been used up to now, especially since Pugin, but now they decided, especially in France, purely for effect and sophistication of technique, to use *plique-à-jour*. This is

Top silver and enamelled buckle in the Liberty style, the circular areas hand-hammered overlaid with geometrical designs; each side enamelled with twin rectangles of deep blue and green. 10.25 cm (4 in). *Right* a 'Cymric' silver belt buckle of abstract pierced entrelac design. 7.6 cm (3 in) Liberty & Co. Hallmarked Birmingham 1901. *Left* an Art Nouveau gold brooch of irregular oval form, the border of blue-green enamel. 5.4 cm (2¼ in) English, *c.* 1900. Courtesy of Sotheby and Co.

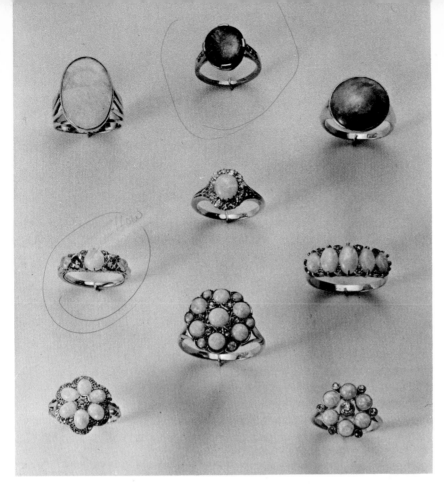

where the enamels are set, like gemstones, in a metal framework which has no backing; thus they are held like fragments of glass in a stained-glass window, translucent and glowing – yet no religious motives ever affected the French designs! This beautiful but very difficult technique meant that now a jewel could be permeated with light and iridescence and colour could flow from one shade to another with scarcely a golden whisper in between. It looked entirely new and quite impossible to do.

In the beginning the colours for enamelling were reasonably dark, shades of turquoise blues and greens, for instance, and berry browns shot with black or golden tones, or elephant greys merging into purples, but as the phase of the Art Nouveau rapidly gained speed, so the colouring grew lighter and lighter and the whole format of enamelling, stones and colours can most clearly be followed through the escalation of Lalique's work. As the movement developed gold gave way as a metal to silver, sapphires to moonstones, rubies to blister pearls, deep enamels to plain glass; there was copper, ivory, horn and a sprinkling of diamonds – and one of the most favourite stones was the opal.

The opal had everything most beloved by these artists; a fusing of colours, teasing depths of light, an inner luminescence and a gemmological structure which taxed the best of gemsetters.

Opals had been well written up in their time, with details of their formation and their general characteristics. Ancient books state that the value set upon this stone was quite extraordinarily high, quoting that Nonius, a Roman senator, preferred banishment to parting with his favourite opal, which had been coveted by Mark Antony.

In mid-Victorian times a letter-writer to the *Illustrated London News* reported that Hungary was the principal source but 'lately, however,

some very fine specimens of this substance have been discovered in the Faroe Islands; and most beautiful ones, sometimes quite transparent, are obtained near Gracias a Dias, in the province of Honduras, in America'.

Opal is a mineral consisting of amorphous silica and varying quantities of water. At least sixteen types are known, a few of which are collectively known as 'precious opal', holding such a brilliant kaleidoscope of colour that it looks as if there is a living fire in its heart . . . and the novelty which appealed at this time was the fact that no two gems are absolutely and exactly the same.

Another stone much worn by the Aesthetes of the time was amber, partly because of its historical associations, partly because the beads they wore could be of so many colours and partly because they lacked the sparkle which 'rich' jewels like diamonds gave off, so the contrast appealed to the unconventional mind.

Amber was loved for the warmth in the hand, the smoothness against the skin and the varieties of colours in its depths; opaque or translucent, creamy-yellow to dark sherry brown, sometimes with a prehistoric pine-needle or tiny insect or fly trapped in the resin whilst it was still semi-liquid – for amber is the solidified resin from a now extinct species of pine-tree.

A third curiosity of the time was the use of *piqué* jewelry, used for the sake of the craft and the novelty rather than any specific value or design. The background material generally used was tortoiseshell (that of the hawk's bill turtle found round the coast of Brazil) although at times ivory was employed instead.

The technique was to heat the shell over fine quality smokeless charcoal and cut and shape it into small crosses or pendants, butterfly or star brooches, leaf-shaped necklaces or rather Spanish-looking pendant earrings, all of which were light in weight.

When they cooled down they kept their shape, but before that happened the surface of the object was dotted all over with a design, then a tiny drill worked minute holes into that surface and equally miniscule

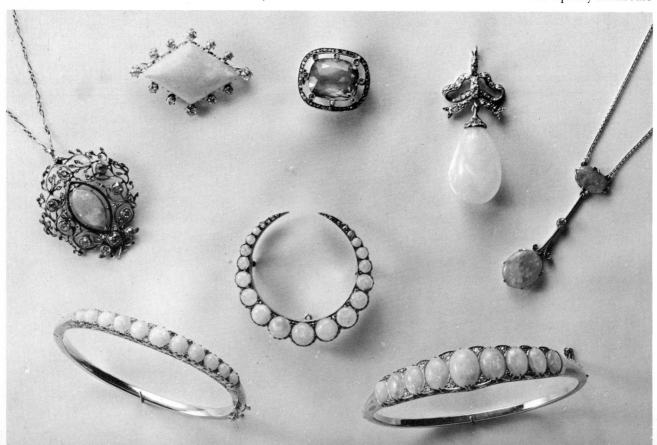

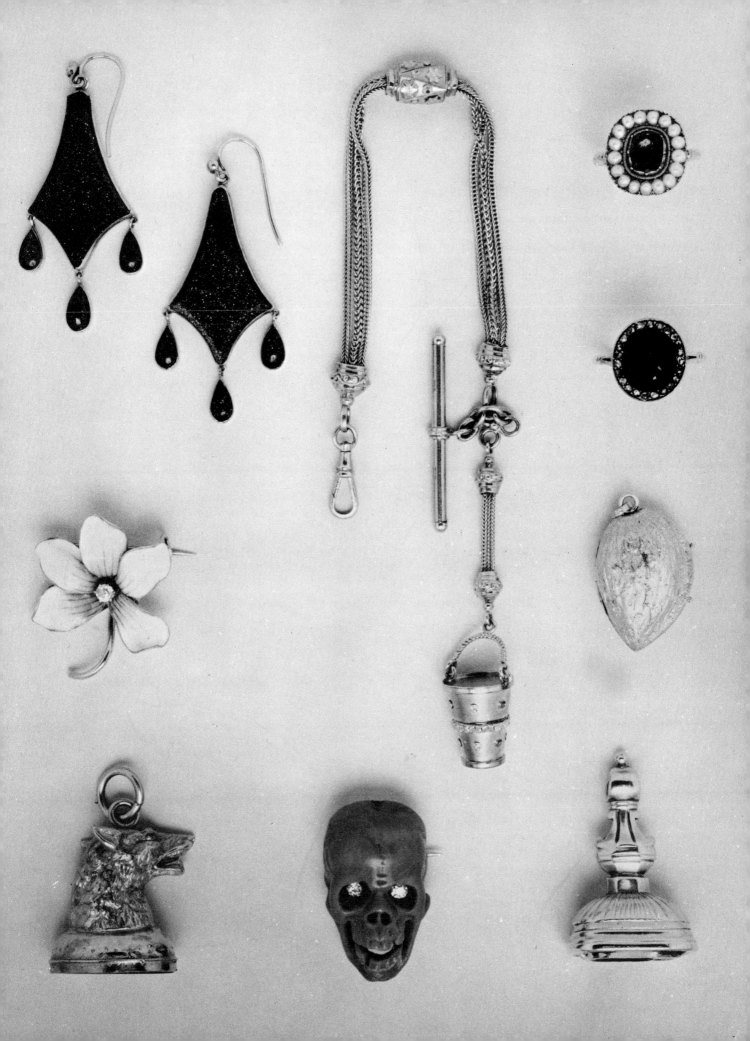

rods of either pure gold or pure silver were inserted, just a fraction of a millimetre, into the hot shell. When the shell cooled down it not only kept its shape but also contracted a little, gripping the gold or silver pinpricks in place with no help of any adhesive.

The craft was an old one, dating from sixteenth-century Naples, and used to decorate all manner of useful objects: handles of knives, forks and spoons or the butts of guns; étuis, bodkin cases, patch boxes, snuff boxes and fan sticks. The craft reached great heights in the seventeenth and eighteenth centuries, again in the 1820s, and finally in the 1870s machines were employed for *piqué* work turning out some extremely superior examples. It was all over, however, by the time of Queen Victoria's death, and today is a collector's item.

Both amber and *piqué* appealed to the women with less money to spend as the wearing of jewelry became more general across the social classes. For the same reason larger, cheaper gemstones were being set with small diamond or pearl rims, such as garnets or agates or even shell-cameos (which have never really lost their popularity). Equally, simple gold jewelry was being worn, with or without gemstones at all, such as broad gold hoop rings or even 'gypsy' rings, which is a type of setting in which a gold ring has a diamond mounted in the centre, but below the level of the surrounding gold, with engraved lines radiating from the stone, however tiny, to make it look like a star with its rays.

Another star effect was to have a star shape of tiny pearls in the centre of a brooch, generally of matt or textured gold, oval in shape, occasionally with earrings to match.

Finally, in order to save money on metals as expensive as gold, there were three processes used which were both economical and perfect for mass-production. Pinchbeck, rolled gold and electro-gilding.

Christopher Pinchbeck (1670–1732) invented a metal which would be a perfect substitute for gold used for watch cases, except for the fact that the jewellers took it up rather than the watch-makers. Pinchbeck consists of 83 parts of copper to 17 parts of zinc; it is durable and lasting and looks exactly like gold except it is far lighter and far less costly. An enormous amount of jewelry was made in pinchbeck during the late eighteenth and most of the nineteenth centuries and many a person is still fooled today as to which is which.

In 1817 rolled gold was invented, very much on the principles of Sheffield plate. Under great heat and pressure a block of gold is fused on to a larger block of base metal to make an open sandwich, which is then rolled out repeatedly between highly polished rollers, the sandwich becoming even thinner and thinner, until sheets of the required gauge are achieved. It was this rolling process which gave rolled gold its name. Rolled gold was made as sheeting or tubing and cost a fraction of the price of real gold – and it was as light as pinchbeck.

Thirdly, a patent was taken out by G. R. Elkington in 1840 for electro-gilding, by which infinitely fine coatings of gold were applied onto almost anything in the form of a made-up piece of jewelry through an electrical process. This made jewelry even cheaper, especially as the gold could be so thin upon the jewel that it stood up to no wear at all and might easily peel off. However, for a short time it looked lovely, and in all three cases it brought jewelry into the possession of those women who might otherwise never have owned anything at all bar their wedding rings.

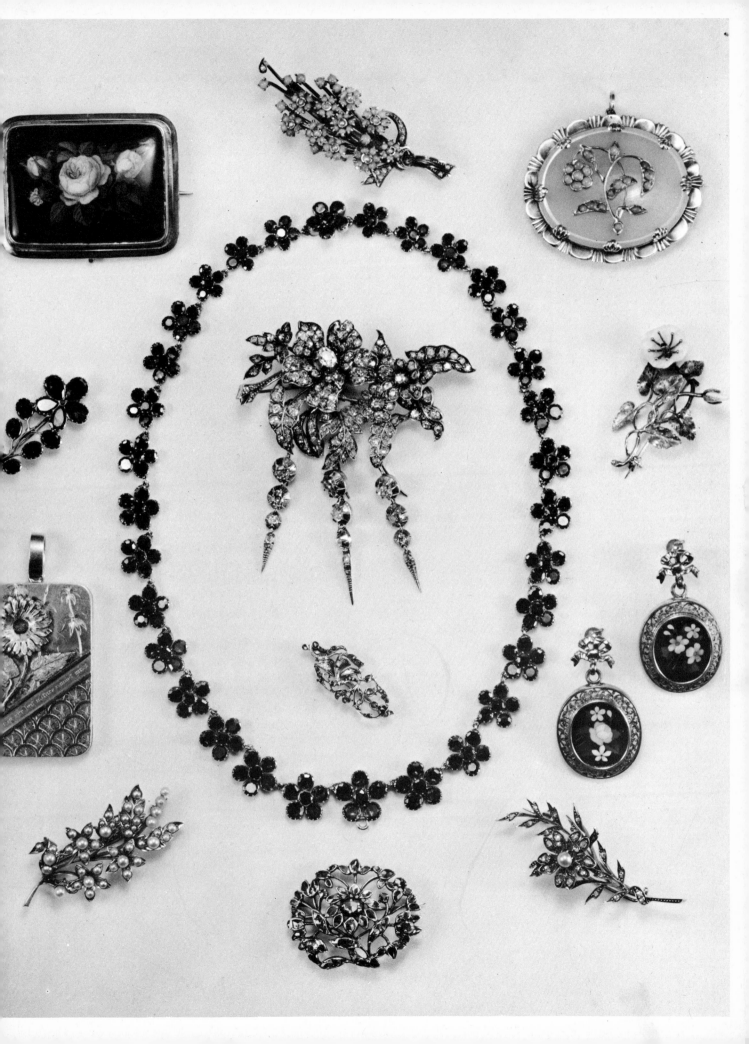

9. The Years of Opulence

The last decade of the century was the real period of the new rich. In America almost 4500 dollar millionaires flaunted their wealth with great ostentation. This was the time that the costly houses on Fifth Avenue were built in New York, on Nob's Hill in San Francisco, on Chicago's Lane Front and Summit Avenue in St Paul.

Fashion plate from *L'Art et la Mode*, 1890. At this time clothes began to shimmer and tantalize, a deliberate tease, with one type of fabric slithering over a differently textured one rustling below. Fortunately ladies were always allowed to show their necks and shoulders during the evenings, which meant they could wear a mass of jewelry; much of it now was in the archeological style but – in England – adapted to the English taste. Victoria and Albert Museum, Crown Copyright.

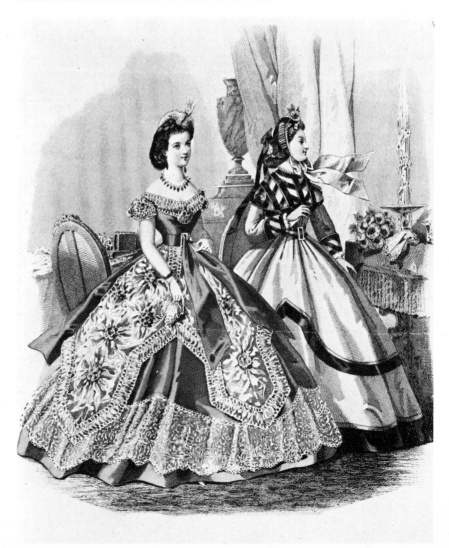

At the other end of the scale it was also the time that Frank W. Woolworth was expanding his chain of red and gold fronted stores and Aaron Montgomery Ward was circulating his mail-order catalogues. There was a huge tide of immigrants, there were beer-gardens and German bands, strawberry festivals and bicycles made for two. Above all there was the Gibson girl, drawn by Charles Gibson (Nancy Astor's brother-in-law), whose zenith was in the Gay Nineties. A recent commentator wrote 'he struck an early blow for female liberation – for his girl the swooning and vapours of the Victorian maid were passé; she needed freedom to walk and to bicycle, and she got it by loosening her clothes'.

High society enjoyed itself in a grand manner, with extravagant balls and a fascination with the stage. Priorities were shown by the front page of the *New York Times* of 11 February 1897, whose lead story was a report of a ball at the Waldorf Hotel, followed by the announcement of the birth of an heir to the Marlboroughs, then, in smaller type, reports of bloodshed in the Pennsylvania mine-fields, panic in the oil market and tales of unscrupulous boss rule in Philadelphia. This was the era of the title, of wealth and of very great beauty in women. On both sides of the Atlantic they could be lovely, and they dressed accordingly.

In Europe there were pockets of great wealth, too, because each country was expanding and colonizing as fast as it could – France, Britain, Germany and Belgium. In the Far East, Africa and any set of islands they thought that they could exploit for their own profits, were occupied under the guise of 'helping them'. Money seemed to flow in from all sides, from gold or copra, minerals or sisal, and many a newly rich man (who was, after all, prepared to take great risks) considered that his money might be as well spent in large pieces of jewelry as in other dubious shares. Yet investing perhaps £5000 in a piece of jewelry meant large, expensive stones and buying what is now termed An Important Piece.

So wives benefited as much as the mistresses and jewelry travelled across the borders of many countries as the eminent money-spinners strolled across the social scene. The friends surrounding Edward VII, the Kaiser, Leopold II of Belgium and Nicholas II of Russia were extremely rich and just as much at home in one capital as another. Gifts were exchanged far more than they are today; diplomatic gifts, 'thank you' presents to the hostess of the night before, bejewelled frivolities for each lady at a private dinner-party – all in all great wealth was fairly fluid, and the most binding of gifts was jewelry.

The last fifteen years of the nineteenth century were almost colourless in dress and in jewels, and it was one of the most feminine eras of all time.

At the close of the seventies the fashion for tight dresses and closeness of fit had reached a pitch beyond which it was impossible to go. It was said on good authority, for instance, that the beautiful, wilful and vain Empress Elizabeth of Austria had her riding habit sewn on over her bare skin, and various brides had their wedding dresses so tight that they could neither eat nor sit at their own wedding receptions. So everything became gradually looser and to cover the alterations in style draperies took the place of trimmings, the dominant fabric now being pure silk. It was a subtle material, rich as a background, easy to cut and drape, swelling gently on the bias and taking the palest of pretty dyes with ease. Some of

these lovely dresses can still be seen in especially good museums, showing the softest mauves, blush-rose pinks, rain-cloud greys and edible Devonshire creams. They were overlaid with the most lovely of laces at times, or sweetened with contrasting ribbons.

The dresses were subtle in other ways as well. They concealed more than they revealed but they were all a deliberate tease, very often the undergarments being of far more attractive fabrics than the dresses themselves. Skirts became very long, so long, in fact, that the length of the skirt forced its wearer to lift it as she walked in the streets or up and down steps, showing glimpses of the undergarments beneath.

The dresses were very slim-fitting to the knee, so naturally the petticoats followed the same lines and then they both flared out to a considerable width. As all the movement was below that soft, smooth thigh then all the attention was paid to the moving fabrics. The dress might be quite drab in colouring but the petticoat beneath was designed to catch all the attention. The softer and airier the petticoat the more alluring the garment became.

Despite the changes in dress fashion, the majority of the public at the end of the century, in both Britain and America, bought quality jewelry of rather conservative taste. The stones they favoured were almost colourless, rather like the textiles, and the settings were at their most subtle.

There are several features which mark the jewels of this period. Firstly the designer's name is almost always unknown (the opposite being true of the Art Nouveau fantasies) and the jewel was bought across the counter in some very grand and glamorous shop. No longer did you have the jeweller come to you, to take your orders and to design something round the stones you already owned; now you took the lady of your choice, wife or mistress, to look through the discreet plate-glass windows of shops in Bond Street or Regent Street or Fifth Avenue. Having made your choice of shop you would enter the thickly carpeted showroom and then stay, perhaps, for several hours until just the right choice was made, placed into its own velvet-lined leather-covered case, with the name of the shop inside, stamped in gold on the satin under the lid, and the object charged to the gentleman's account. Neither the designer's name was mentioned, nor the recipient's. There are a multitude of lovely jewels about which one cannot write in detail today simply because of the tantalizing reason for their giving – and the better shops are still patronized purely because of their monumental tact. Anonymous was the receiver, anonymous the designer and anonymously international was the design. It gradually became more and more difficult to tell if the jewel was made in France, England or America . . . and the standards became very high. A diamond brooch with the letter of your first name, perhaps a 'W', set in finest gold could look just the same from any of those countries, especially as many a jeweller in – say – Philadelphia was able to buy sheets of jewelry designs from artists in Paris to use in the States.

A very great deal of attention was still paid to the head, your type of coiffure, the tilt of your head and the placing of your jewels. Hair pins were most often featured (sometimes worn by day upon a hat) with a jewelled motif of either a feather (and every single frond would have been jointed and set 'knife-edge' style) or of an insect such as a bee or a dragonfly or a flower. Several of these diamond-set pins or aigrettes could

be worn at the same time, perhaps complementing some small diamond-set lace-pins scattered across the bosom.

One small brooch enjoyed at that period was the 'honeymoon' brooch, a purely personal and private gift from husband to wife, given at the first moment they were alone, possibly in the carriage as they drove away from their marriage ceremonies. It would be small, made from gold, very delicately set and showing any amount of variety on the theme of a crescent moon and a bee, true-lovers' knots, hearts and flowers. There are some absolutely beautiful ones about today, given for sentiment, not for show, treasured over the years and always kept in their own velvet-lined cases.

With such care taken over the coiffures – the Alexandra look, with the tight little ringlets, the sculptured, controlled look – a woman's ears were visible and her neck seemed elongated with the depth of the décolletage. This resulted in the wearing of earrings most of the time; quiet little pearl ones during the day but beautifully made drops at night. They could still have a single pearl, but on this occasion it would be pear-shaped, and set at the point of an articulated swing of diamonds, the settings almost invisible. The method used to keep the settings looking like 'frozen lace' was three-fold. The galleries were kept very high, and no longer were stones virtually imbedded into the metal but a claw-setting would lift the stone aloft into the air and the metal seemed to disappear. Secondly, each sculptured element of the design would be attached to the one above by a single ring, allowing maximum movement, especially if there were several, and lastly the knife-edge technique meant that the metal used would be flattened to razor-thinness and then laid on its side, so that only the finest hairline of gold would be seen between each diamond, making it look as though they were suspended in the air like magic. Observed sideways-on the real width of the metal could be seen properly, but viewers rarely examine an earring, when worn, from the side or the back.

Earrings might also be made at this time of one single stone, a large one, perhaps an amethyst, faceted into a pear-drop shape, and then surrounded with small brilliant-cut diamonds, hung by one near-invisible ring from a single, larger diamond above and then looped through the ear with a fine gold fitment. It was made much on the line of a section of the old Georgian briolette, but was more finely made and looked less like a chandelier.

Another form was that of small, bell-shaped flowers, graduating in size, one fitting neatly beneath the other and each swinging from its own single ring inside. A head dressed in as static a way as that of the Princess of Wales, later to be Queen Alexandra, with her swan-like but rigid neck imprisoned in circle upon circle of pearls, would need desperately to have *some* movement from the ears.

Necklaces differed by day and by night as well. If you could afford them you wore either precious pearls or heirloom diamonds in the evenings. If you could not you wore a piece of velvet to tone with your gown and pinned your prettiest or most expensive brooch to that and wore it as a choker.

It was the neat, tight, slim look that counted.

Some of the most wonderful pearls in history were strung at that time, spherical, large, matching in shape and colour – and the colour tones ranged imperceptibly from pink through creams to grey. Up to about

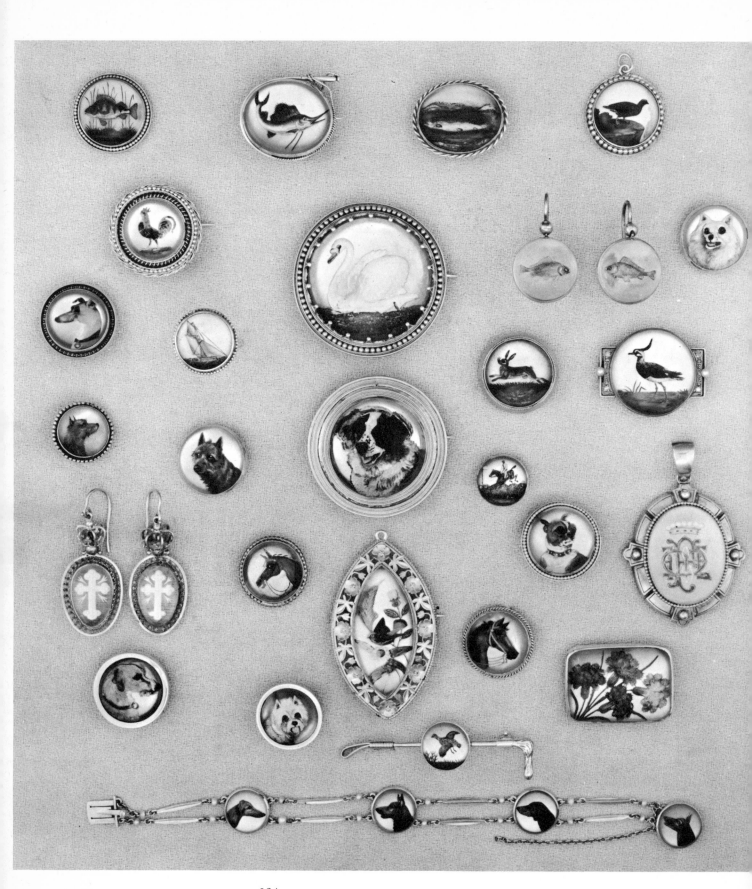

twelve strands were worn on one clasp, with supporting struts placed in three mathematically spaced places, to hold them all up evenly; and the clasp itself was often set with smaller pearls, or diamonds with rubies, emeralds or sapphires.

Again, if you could afford them, you wore further pearl necklaces graduating below the choker, as many as you had, to infill the décolletage, until it looked as though you were wearing a complete child's bib.

At times people interspersed the pearl necklaces with ones of single rows of diamonds, to make a change. Some of the old portraits and photographs of Princess Alexandra and the members of her court show the spirit of the age, the last real period when you were not only happy to show off your family treasures or your husband's accumulated wealth, but you were positively expected to do so.

You also embroidered the edge of your neckline with brooches, using the fabric to support as many of those as you had, too. There is a photograph of Lady Carew in 1886 wearing no less than ten quite different diamond brooches arranged around her low neckline, most of them totally unrelated in design (the smallest by the shoulders, the largest at the cleavage point) but several of them featured stars.

The stars, the sun and the moon were often seen at this time. Huge bursts of flashing diamonds, in celestial shapes, could have a double use, that of either brooch or pendant; you rarely had them all the same size so that you might ring the changes on your clothes to get differing effects.

If you were not wealthy, but still had enough money for diamonds, you wore small brooches scattered across the lace on your hat or veil, and on your scarf or the draping upon your dress. A great many of them were tiny jewelled novelties such as bats, lizards, frogs, owls, butterflies or even tiny tortoises, shimmering and glinting amongst your clothes with many a sharp point of light caught by an emerald eye or a ruby talon. They were really the fore-runners of the costume jewelry worn today, but far more precious and better made.

Other women, not quite so modest, wore complete scenes in their diamond brooches, showing the hunt with horses and hounds, or the race-course with horses and jockeys. This was nothing like the older and more beautiful archeological jewelry; it was bang up to date, and it was not nearly as good class.

Louis Comfort Tiffany

In the 1880s Victorian America suffered from over-furnishing and over-decoration. Housewives, armed with some of the many books on how to decorate in 'elevated taste', turned their parlours into jungles of horsehair sofas, ostrich feathers, asparagus ferns, Japanese screens, statues on pedestals, arrangements of dried flowers, draped silk shawls, embroidered antimacassars and a hundred other tricks. Luckily help was on the way in the person of Charles Tiffany's son, Louis Comfort Tiffany.

Louis Comfort Tiffany, born in 1848, wanted to become an artist, not a shop-keeper like his father, even if he was destined to serve the richest people in the world. In 1867 he exhibited his first painting at the National Academy of Design and promptly went over to the Mecca of painting at that time, Paris.

A collection of late-nineteenth century carved crystals, stick-pins, brooches, bracelets, etc., showing mainly animals or birds. The pair of goldfish (upper right) is perhaps the most interesting as they are complete spheres appearing like goldfish bowls. English. Courtesy of Harvey and Gore Ltd.

135

A beautifully mounted diamond-set
cockerel brooch with a ruby comb.
Brooches with a fox's mask or an owl on
a branch were made in the same manner
at this time, the last quarter of the
nineteenth century, English. Courtesy of
Harvey and Gore Ltd.

He was right in time to see the very best of the Japanese arts coming
into the metropolis, and he also studied (along with others) Islamic art
from North Africa and the Near East; in fact his interest in Moorish
decoration led him to visit both Spain and North Africa. Like the Arts
and Crafts designers in England he felt that fine art should be at one with
the crafts and vice versa. This being so Louis Comfort Tiffany went into
the decorating business and became a wild success.

When Vice-President Chester A. Arthur became President on the
death of James Garfield in 1881 he refused to move into the White House
until it had been completely redecorated. A widower and a dandy, he
hired Louis Comfort Tiffany as his decorator. The blue of the Blue Room
was changed to a robin's egg shade; he did the East Room, the Red Room
and the State Dining Rooms as well, and Tiffany's masterpiece, a floor-
to-ceiling screen of opalescent glass embellished with 'a motif of eagles
and flags, interlaced in the new Arabian method' was installed in the
front hall. It was a revelation.

He painted successfully and showed at many exhibitions, but it became
increasingly clear that he wanted to work in other mediums as well.
Although he specialized in glass, his work included jewelry too.

By the look of the designs which are left Louis Comfort Tiffany's jewels
were inspired by the very best traditions. They sold to some very
influential patrons but not to the middle class, because they just wanted
diamonds and yet more diamonds.

Some of the pieces were glorious; his biography described a few of the
more exotic items:

'A dragonfly hatpin is enamelled and set with opals in a platinum base.
A marine motif, half crab, half octopus, with the writhing feet slit in
two, is arranged as a brooch, and set with opals, sapphires and rubies.
A girdle of silver, ornamented with enamels, has berries formed of
opals . . . a decoration for the head is a branch of blackberries, the
berries clusters of dark garnets. Another design is the dandelion full-
blown with seeds [reminiscent of one by Fabergé at the same time] . . .
and the peacock necklace, the main piece of which is a mosaic of opals,
amethysts and sapphires. The back of the big centerpiece has a
decoration of flamingos and the lowest point of the pendant below is a
single large ruby, selected, not for its cost, but for the shade of its red.'

Louis Tiffany's work introduced the Art Nouveau to America, but it
never became as popular as it did in Europe. His influence, perhaps, lay
more in breaking the charmed circle of convention and making people
realize that there was more to a jewel than its price and glitter.

Carl Fabergé

At the same time as Tiffany was producing his elegant designs in America
Europe saw the work of a man whose jewels and fantasies were to gain
world-wide fame – Peter Carl Fabergé.

Born in St Petersburg in 1846, Carl Fabergé (as he is better known)
travelled widely around Europe in his youth. What he learnt there made
him an amalgam of East and West, who provided Russia with her own
essentially Russian brand of Art Nouveau. He set out to make objects of

little intrinsic value but of enormous beauty and inventiveness (the first of which he exhibited at the Pan-Russian Exhibition of 1882) which captivated the international rich. They also captivated the Czar and Czarina of Russia who quickly gave him the Royal Warrant to make their jewelry, silver and *objets d'art*. Not many people are prepared to buy things which cost a good deal of money unless they have some use, be it jewel or paperweight at the very least. So Fabergé concentrated upon giving his customers their money's worth and his recipe for so doing was through impeccable craftsmanship.

He made every object quite perfectly, mostly custom-made, nearly always without a duplicate: tiny, jewelled, enamelled and enchanting. He made cases for cigarettes and cases for matches, so slim that they slid into the jacket pocket of a beautifully tailored dandy without a ripple, the thumb-pieces opening up without breaking a nail, the hinges so smooth they never snagged a satin lining. He made many an object which had to be outlined with straight lines come to life merely by using some not very expensive, but beautifully marked, indigenous Russian gemstone (they have them all there) where the structure of the stone gave a modelled or sculptured appearance.

He made things for the desk, things for the table or vitrine, everyday objects like bell-pushes which suddenly turn, like the frog at midnight, into a surprise. One of these is a bell-push which happens to be a supply curved dark-green nephrite fish with its mouth opened into a golden 'O' and its eyes bulging moonstones, surrounded by rose-cut diamonds. Press the eyes together and, miles away in the servants' quarters, a bell rang.

Fabergé made animals in miniature. They were rounded, friendly, full of character; the hardstones used were always quite right and sometimes altering slightly in colour which added to the scene – a sleepy fieldmouse might be made of jade with slightly muddy paws where the jade was gradually turning brown, or a sturdy obsidian hippopotamus opened its mouth in a huge yawn, showing an interior of rhodonite and characteristic ivory teeth.

He also made models of the people of Russia, cossacks and peasants, houseboys and street sweepers, using every imaginable hardstone blending into each other, and marked, when they were, under the right boot. But psychologically some of the most attractive things he ever made were his vases of flowers, given as Christmas gifts to remind snow-bound Russians that spring was not all that far away.

One of the most charming flowers of this type is available to be seen in the Luton Hoo collection of Lady Zia Wernher. It is a sprig of gypsophila put into a small nephrite vase, with tiny flowers made from rosecut diamonds set in gold. It moves in the breeze and is quite exquisite. All sorts of botanical types were made: buttercups, enamelled brilliantly yellow, bright enough to reflect under the chin; forget-me-nots inlaid with tiny turquoises; strawberries made from purpurine and carved jade leaves and a host of other plants. They all came with their own vase or containers, so cleverly made that each in turn looks as though it is filled daily with fresh water, the flowers perfect enough to smell, the fruit luscious enough to taste.

But Christmas was not the main religious festival of Russia; that came at Easter. This was the real time of present-giving and joy. Fabergé was quite ready for both.

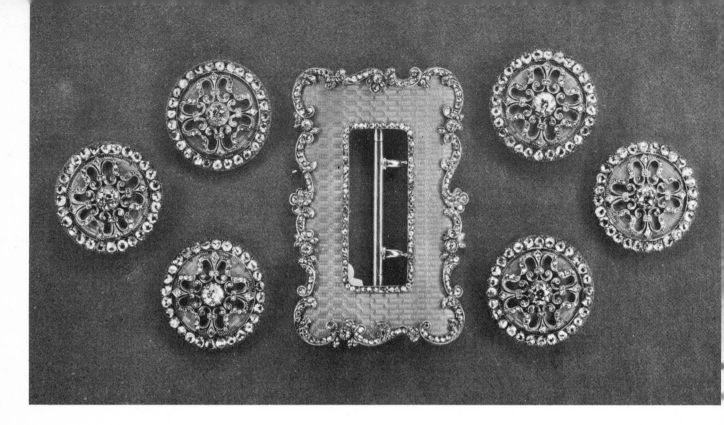

A belt buckle and six buttons made by
Carl Fabergé in gold with enamels and
diamonds; their delicacy takes them
away from being merely practical objects
and turns them into pieces of jewelry.
Russian, c. 1890. Courtesy of Wartski.

Very soon, because of the surge of business, his workshop multiplied
with craftsmen, sketching, carving, setting the gold feet for birds,
positioning the eye of an elephant, adding the bands of enamel and
rosecut diamonds to stamp-holders, shaping the holly wood boxes with
their cream velvet linings, machine-turning the almost Op Art effects of
the engraved designs on the cigarette cases to take the multitude of
colours of enamels they had perfected, working under the several work
masters as a team and all imbued with the spirit of Carl Fabergé himself.
There was almost nothing they could not make, to be of use or to adorn,
and one thing that Fabergé made synonymous with his own name was the
surprise Easter egg.

His Easter eggs came in a multiplicity of techniques and sizes. On the
whole they were relatively small, to be worn upon a chain or a flexible
bracelet as a form of charm, symbolic of rebirth. They were created either
from some form of hardstone such as greenish-grey chalcedony set with
rubies, light-blue beryls sparkling with diamonds, aventurine-quartz
with bands of enamel, obsidian, lapis lazuli, nephrite and jade and milky
agates set with sapphires; or they were made from gold and enamelled
with one of the hundred or more colours of his palate, generally onto an
engraved base.

Now there was fiery orange enamel, or lime-green, snow-cloud-grey
shot with lavender or candy-floss pink, sometimes embellished with a
sprinkle of small faceted stones, more often left alone with its golden loop
to attach to a chain.

The eggs we are familiar with today and are associated with his name,
the great imperial Easter eggs (each with its 'surprise'), were at the time
completely private gifts between members of the Royal Family and not
generally known about by the public until after they were all
assassinated. On estimation fifty-seven of them were made altogether,
and fortunately quite a few can be seen today both in Britain and the
States. The others have to be imagined from their descriptions.

138

Two of the imperial eggs, both privately owned, are worth describing in detail. Imagine a translucent egg-shape made from rock crystal, about four inches in length. It is not quite transparent as it has tiny little frost-flowers engraved on the inside and is covered on the outside with further frost-flowers shimmering with diamonds. This incredibly virginal egg seems imbedded in winter, for it is sculptured into another piece of rock crystal, solid enough this time, which looks like dripping ice, with fingers of frost embroidering the crevices, again of diamonds. Right at the top of the egg is a large moonstone (under which is the date of its giving) and, on

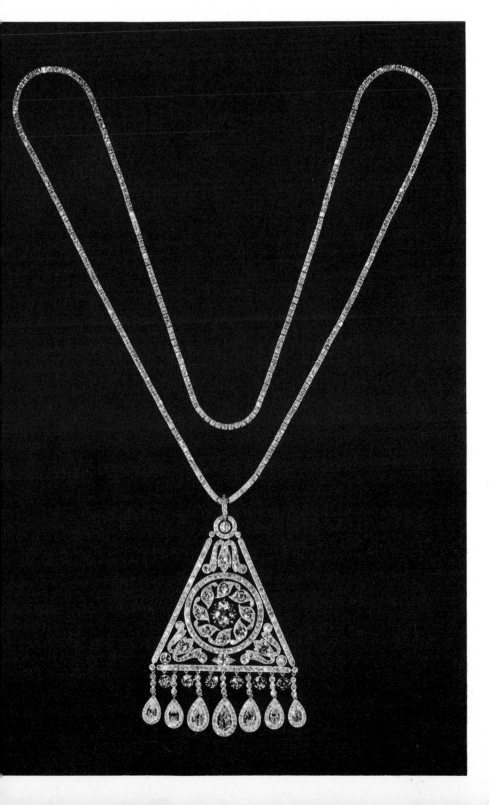

A beautifully supple diamond necklace with a fringed triangular pendant drop made by Carl Fabergé. Russia, *c.* 1900. Courtesy of Wartski.

pressing this stone the egg opens up into two halves, revealing a secret in its heart – a basket of spring flowers. This basket can be removed and is seen to be made entirely of ice-cold platinum, completely covered with diamonds, and the flowers it holds are star-shaped and made from white cachalong, centred with touches of colour – chilly olivines set in gold, and with small carved jade leaves. Altogether the basket is three and a quarter inches high. The whole concept is pure and perfect, cold as a snowdrift until it is opened and life is revealed inside.

The other egg is more reminiscent of summer. An ordinary egg-shape is enamelled all over gold in the palest mauve enamel, glowing with shades like shot-silk, turning in the light to look blue one way and pink the other. All over the egg is strewn the lightest of trelliswork in diamonds, little scroll-shapes which twist into rococo twirls and, wherever a trellis crosses the path of another, there is a bow of diamonds to mark the spot. It

A very beautiful fan mounted by Carl Fabergé onto mother-of-pearl sticks with a gold enamelled guard, a diamond rivet and a diamond monogram, crowned. Russian, *c.* 1895. Courtesy of Wartski.

stands on a little gold support and has a huge diamond at its summit, again engraved with the date of its giving.

The egg opens to show a tiny scene from nature which can be removed to the table surface. It is an exquisite little lake made from one large aquamarine, round in shape, and bordered with small golden water-lilies and their leaves. A handle of similar water-lilies, made from four tones of gold, lifts the 'lake' on to the table. On the 'lake' is a swan.

This gold and enamelled swan is automatic; meekly it sits with arched neck on its jewelled 'lake' until it is lifted up, a tiny device set in motion under one wing and then set down upon the table again, resting on its 'lake'. Immediately the swan paddles across in regal motion, its tiny golden webbed feet taking it along as it writhes its head and neck in characteristic fashion and then stretches out each wing, displaying each feather separately. At last it comes to rest again, the wings tucked in, the

Carl Fabergé has mounted a huge sapphire here in the most delicate diamond setting. As with all his jewels it is placed within its own personal velvet-lined case. Russian, c. 1890. Courtesy of Wartski.

A very grand (it is 6 cm across) brooch made for a twenty-fifth wedding anniversary; diamonds are shown on a shaped panel of enamels. Carl Fabergé. Russian, *c.* 1895. Courtesy of Wartski.

A miniature set of the Russian Crown Jewels made by Carl Fabergé. Russian, *c.* 1900. Courtesy of Wartski.

head quietly bent, so it can be replaced with its aquamarine bed accompanied by water lilies and gently secured within its oval housing. Its total height is a mere four inches.

Fabergé's work fits into no known niche. He made so many things which were quite unique. His techniques have never been mastered by others (although Grassi in Milan are making objects in the same hard-stone media today and Stuart Devlin makes Easter Eggs).

Naturally he made day-to-day jewels as well as his jewelled objects. They fell into two categories, the extraordinarily elaborate gem-set ceremonial Orders and the much quieter personal jewelry, underlined with good taste and never shrieking of money.

He is remembered for his enamelling and his Easter eggs, but Fabergé cannot be classed with other jewellers, as his range was too vast. All one can safely say is that he influenced most of the finest jewellers round the world by the sheer quality of his work, that he gave his name to an era of the last imperial Russian courts, waltzing as ghosts into history, and he left for posterity a legacy of sheer visual delight.

10. Into the Edwardian Age

From 1870 onwards the social revolution gathered speed, aided by scientific invention and the general acceleration of daily life. Electric light had become possible after the arc-light, invented by Davy in 1810, but it was not until Eddison and Swan had improved the incandescent carbon filament lamp in 1883 that electric lighting became practical in every home. In 1885 cycling became a fashionable craze, with plenty of cycling clubs. In 1890 the opening of the first electric underground railway in London by the Prince of Wales revolutionized London's traffic.

Then the motor car appeared in 1896 as a force to be reckoned with (before that the car was illegal in England unless preceded by a man with a red flag). Telecommunications between London and Paris were established in 1891. The cinema dates from 1896. Motor cycles appeared in 1902 and the first flying machine which was capable of making a prolonged flight stemmed from 1908.

In America Senator Chauncey Deprew put the prevalent excitement in a (curiously phrased) nutshell: 'There is not a man here who does not feel 400 percent bigger in 1900 than he did in 1896, bigger intellectually, bigger hopefully, bigger patriotically, bigger in the breast for the fact that he is a citizen of a country that has become a world power for peace, for civilization and for the expansion of its industries and the products of its labour.'

However, women's day-to-day fashions during the last ten years of the century reflected only little of these changes. Liberation from the constriction of Victorian dress was under way, particularly under the influence of sports clothes, but large quantities of material were still worn. Clothes for ladies meant voluptuous rustling; whatever their dress might be their undergarments were deliberately made to rustle and swish. Even if you were wearing an apparently simple woollen gown you would probably choose stiff taffeta for the petticoat, complete with underskirt of the same material, lined with tiny frills which would whisper against the fabric secretly.

Fashion now became lavish with various forms of trimmings: pleats, flounces, laces, embroidery and beads. A silk dress made in 1895, it was reported, was worked all over with gold tinsel and imitation pearls;

another had gold Venetian lace inserted and was embroidered with branches of elder set with crystal beads, whilst the hem of a third was trimmed with ostrich feathers. By the end of the century some dresses were accordion-pleated throughout, some were smothered with every form of lace and some, entirely covered with spangles, made their first appearance in 1899. It all cost a very great deal of money and was, quite naturally, reserved for the wealthy. In America the same was true, and some ladies still sent to Paris or London for their best clothes or fabrics. Even so it was quite possible to buy fashionable effects at a reasonable cost, and many were advertised in the popular magazines and newspapers.

One of the very best methods of seeing fashions of the period is to examine portraits by Millais, Boldini or Sargent, which give a superb impression of the entire epoch. Stylish and dashing, these artists seemed to understand their sitters perfectly, and attained a superb insight into the hearts of these women, many of whose names have become synonymous with glamour. They brought out all the qualities of the female Edwardian personality, with their long necks, their magnificent bosoms, small-boned waists and hour-glass silhouettes, but at the same time having enormous striking personalities.

So many of them had talent as well as beauty, women such as the Princess Marthe Bibesco and the Countess Henri Greffuhle with their wit and their humour in their salons; Consuelo Vanderbilt, the young American who became the Duchess of Marlborough; Viscountess d'Abernon and the many lovely Gibson girls who staggered people with their beauty and sheer vitality. No-one ever forgot the sight, once seen, of stunners such as Madame Gautrau, Miss Camille Clifford, Lina Cavaliere or Gabys Delys, with their chinchilla furs, their money, their dramatic motor cars, their exceptional clothes, their 'king's ransom' jewels and their little griffon lap-dogs.

So what did these beautiful women wear in the way of jewels? With their diaphanous chiffon scarves fluttering from their almost-bare shoulders, the dresses made from rustling silks and laces in palest sweetpea colours? They wore diamonds and they wore pearls.

If they wore gemstones then they were faceted brilliantly to sparkle the night through and set into almost invisible settings looking like the cobweb texture of lace.

Diamonds, after all, were not new. Not only were there plentiful supplies of them but they were brilliantly cut and there was enough money to buy them, but they did not have to be continually re-set when styles grew old-fashioned. They could be merely put aside in the bank and new ones bought in the latest styles, and the latest metal – platinum.

Gold and silver have been used as metals to set gemstones ever since memory began but platinum was very new in comparison. It is exceptionally strong; it does not tarnish; it is remarkably malleable and ductile, but it is rather heavy for jeweller's use, so it was mainly used for rings. One wonders why, when platinum had been available since its discovery in Colombia in 1730, it was not used before as a precious metal?

Basically the reason is platinum's very high melting point (1773°F). Throughout the history of metal-working a metal's melting-point has been crucial to its development – and because platinum simply did not react like silver, for instance, which it resembled, people felt it could not

145

be worked. However, in 1847 Robert Hare, an American scientist, invented the oxy-hydrogen blowpipe, which meant that platinum could now be worked with relative ease because of the higher temperatures which could be achieved.

Two of the group of six related metals to which platinum belongs are now very familiar to most people, palladium and rhodium. Palladium was first isolated in 1802; it is not very popular with jewellers, in spite of the fact that it is both lighter and cheaper than platinum, and it is mainly used for the settings of diamond rings. Rhodium is harder and whiter than platinum and often jewelry made from white gold, for instance, is then plated with rhodium because of its sheer hardness and its great

Fashion plate from *The Queen*, 1900. This shows an evening gown from Redmayne's Ltd of Bond Street, with its fluttering of pleated chiffon. Victoria and Albert Museum, Crown Copyright.

reflective capacities. Platinum and these other metals within the platinum range suddenly became extremely popular around the year 1900. Less metal needed to be used for setting stones as they were so strong, so the 'frost' look came into fashion in which stones appeared to be caught up into the air with no visible means of support. The colour of shining 'silver' looked lighter than air, too, far better than the heavy, rich look of gold.

As a change from diamonds some magnificent parures were made up from spinels, tourmalines, peridots or the fancy colours of pale sapphires framed by diamonds. These stones could be very large and extremely lustrous and took cuts of both conventional and unconventional shapes

Dresses at the Polo Club, *The Queen*, 1905. By now clothes were fractionally looser and more practical (after all one could never ride on an omnibus in a crinoline), and ladies might even attempt to play a leisurely game of tennis in dresses on these lines, complete with rubber-soled shoes – but retaining their high heels. By now the pale look had come in and jewelry was correspondingly colourless. Victoria and Albert Museum, Crown Copyright.

147

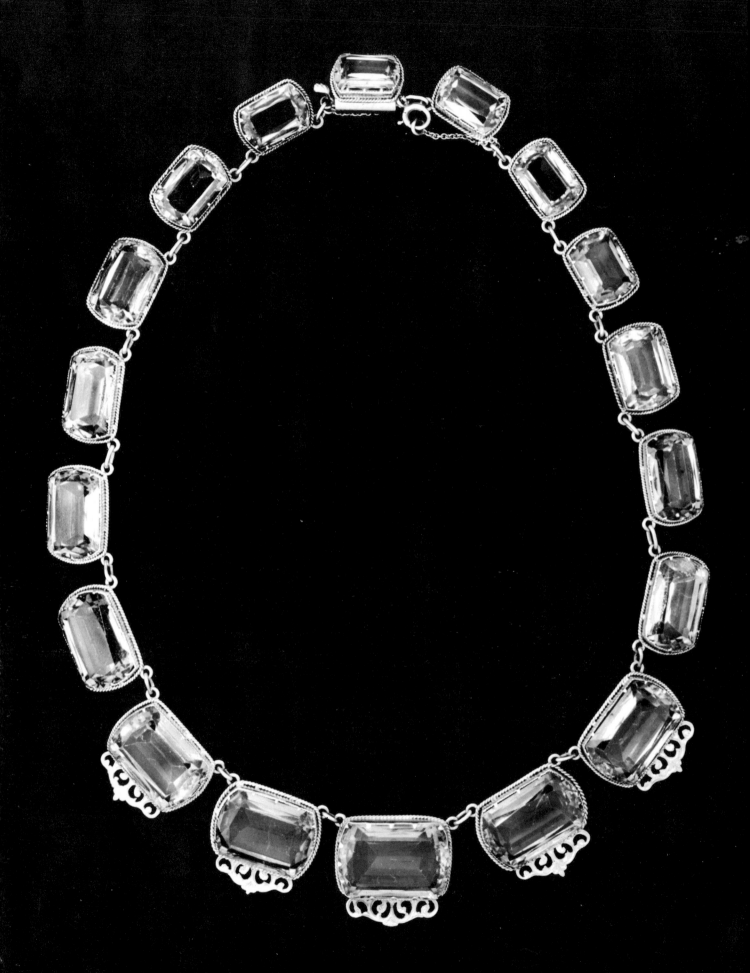

very well. They could be set *à jour*, meaning without any backing metal, and they were obtainable in a huge variety of colours, many never seen before.

By evening women must have looked very beautiful and memorable, with their becoming fashions, their jewelled combs, pins or even light tiaras in their hair (devoid of dye or lacquer), their parures of pale stones and diamonds or their dog-collars of creamy pearls.

By day their clothes were becoming rather mannish in style; although the silhouette was still the same, corseted and in control, but not extreme. Woman were now far more active; they enjoyed sports, they rode on buses – so textiles were tougher and colours more practical. Their evening jewelry would simply never have done to be worn by day, so for day-time there was an entirely different set.

Modest, smallish but always novel, the Edwardian lady would wear for her day-time jewelry a fox's mask on a new bar brooch to show she enjoyed hunting, or a small gold model of a riding crop or even a tiny bicycle. There were small diamond picks to commemorate a rock-collecting holiday, small gold or diamond horseshoes to celebrate some riding exploit. Wishbones, tigers' teeth and tigers' claws mounted in gold were worn, endless little gold bees, butterflies, dragonflies or owls; or 'jewelry' made from mother-of-pearl carved into leaf shapes for necklaces or ivory carved into every shape under the sun.

Art Nouveau jewellers could not keep pace with all this wealth and glitter. They could not find enough patrons to wear their extraordinary and expensive hand-made one-off fantasies in competition with the ropes of pearls and rivières of diamonds. The Art Nouveau depended entirely upon individual genius, it could not be successfully mass-produced. Once they tried to do so, after the year 1900 and an exhibition in Paris where Bing put in an entire house (apart from the kitchen) decorated in the new style, the whole movement became debased. Manufacturers came from all over the world to see it; they gawped, they sketched and then they raced back to their factories and started to churn it all out by machine. But it was all quite wrong; they simply could not capture that will-o'-the-wisp effect of things being blown together by fairy fingers, not by mortal man. Suddenly the leaders of the cult in France, Belgium, Germany and England were faced with copies of their own work – but so horrible that they could scarcely credit it. In disgust they took up other work, turned away in sorrow and the Art Nouveau phase suddenly began to sputter and die out.

Art Nouveau did an enormous amount for jewelry and catapulted design away from the conventions of the overblown and constricted mid-Victorian era. Some of it is absolutely exquisite, but it simply must be seen worn, rather than in a museum. The only designer who did not go under but adapted his designs to machines and still exists as important a firm today as at the turn of the century was Georg Jensen (1866–1935). His shops circle the globe and Jensen jewelry is easily recognizable, but for everyone else the game was up.

This was a period for jewelry for men too, with the Edwardian dandy. A fashionable man in his club might easily sport a monocle or lorgnette made of very fine gold, possibly with rubies or sapphires set into the handle. Fabergé made lorgnettes for both men and women and so did

149

Lalique, and many a delicate one can be seen today with an unfashionably small glass to see through but with the original spring interior intact. Occasionally the monocle-case was of gold, to match a stamp-case or even a propelling pencil, each with another gemstone inset.

The Edwardian gentleman would almost certainly have a Malacca cane or a walking stick or a sword-stick. Tipped with silver at one end and brass at the other, it would be elegant and useful. If he could possibly afford it he would buy a stick from Fabergé – or some of his imitators – or at least the handle for the stick or parasol. They came in a multitude of different shapes and colours.

Some of the actual sticks themselves were of strange and rare woods. Some were the common blackthorn and some were covered with very fine leather. The variety lay in the handle which might be made of chased silver, textured gold or a carved hardstone. All had to lie comfortably in the hand with no sharp corners, spikes or cutting edges to damage the fine leather gloves.

Most men would wear a gold 'Albert', travelling from one side of his waistcoat to the other, bearing a watch and possibly some seals or fobs. They would also have cuff-links, signet rings, shirt-front buttons, tie-rings, tie-pins and cravat-pins. Sometimes they were chosen entirely to be flamboyant, sometimes better taste prevailed and they were so quiet they were entirely unnoticeable. Just about all of those items were made from gold, which needed no attention and did not tarnish nor stain a garment. The most modest occasionally sported a small pearl or diamond in the centre of the cuff-link, for instance, or the gold was centred by onyx or bloodstone. Where there was immense variety on a tiny scale (apart from men such as Diamond Jim Brady, who never believed in doing things by halves) was the tie- or cravat-pin. These can be enchanting and can still be picked up today quite cheaply.

The pins were made from gold, polished their considerable length, with a section in the centre having an engraved line spiralling down; the reason being to give a textured effect, holding the metal in the fabric. The focal point was the head of the pin, which could be of one stone, perhaps a diamond, glinting and shimmering with colour; or a piece of morganite or kunzite. Or there could be a carved animal or human head perched on top of the slender gold pin made from coral or turquoise, jadeite or nephrite, showing the head of a god or Napoleon, the Pope or an alligator.

Quartz was much used for tie-pins, either as an opaque bloodstone or the enigmatic polished cat's eye. The first could have been taken at times for jade, being a green stone with tiny 'drops of blood' – said to have been Christ's blood from the cross dripping onto a green stone, whereas the cat's eye is another form of quartz enclosing the delicate fibres of amianthus, a kind of asbestos, which gives the stone its striking effect.

Sometimes there were small coins held in the pin: a half-dollar, perhaps, or a half-sovereign; many a tiny gold nugget was set, dug up possibly by the owner, and there were thousands of diamond horseshoes. Serpents writhed away, so did snails in their shells, sailors' knots streamed in the breeze and flags of ships or societies were enamelled into rock crystals. There was no end to their diversion, even when there was a period of mourning in the family and tie- and cravat-pins had to be bordered with black enamels.

Several gemstones came newly into use for jewelry in the last years of the nineteenth century and the early ones of the twentieth.

Among these morganite and kunzite are associated with Tiffany's minerologist, George Kunz. Both are different from the pink topazes which the Victorians had generally foiled in order to keep their colour even. Kunzite is a form of spodumene, a relatively rare gemstone. It was originally found in North Carolina, where it has since been worked out, but is mined today in California, Malagasy and Minas Gerais in Brazil.

Morganite is a pink form of beryl and named by Kunz in honour of the famous gem-collector and banker, Pierpont Morgan; it again comes from Malagasy but there is another source in Pala, California. Both stones really flash out when faceted, and whereas the kunzite has an orchid cast the morganite is more of a delicate pretty pink. Both, in their way, were unusual and a conversation-point in late Victorian society.

Other stones were used for opposite reasons, for their historical associations, especially jade and turquoise.

Jade was an overall term at the time, although few people knew it, for two minerals, jadeite and nephrite. A subject with a wealth of scholarship of its own, jade was carved, again and again, into 'oriental' shapes and symbols and highly valued for its aesthetic qualities as well as its colour. Sometimes one can find today a spray of white jade carved into flowers and buds, with frosted gold, which had been worn as a wedding ornament.

Turquoise was another stone much featured during the whole period, especially after Queen Victoria became Empress of India in 1876. It could be polished *en cabochon* or it could be carved, pale blue in colour, and named after the thirteenth-century French 'pierre Turquois' or Turkish stone, which was misleading as the stones came from Persia (Iran).

As a gemstone it has been used since history began and as it is found relatively near the surface of the earth it has been picked up and used as an amulet for hundreds of years. Turquoise jewelry has been found in Egyptian and Sumerian tombs, in Mexico and Tibet. It is soft enough to carve but hard enough to be durable. The most famous mines have been in Khorassan in Iran, others are in Turkestan south of Samarkand and in the Sinai peninsula; the oldest mines in the States are near Santa Fé in New Mexico.

The Victorians enjoyed them because they thought, erroneously, that they were helping a member of the British Empire, India (through which certain supplies *were* brought), and also because of their historic background. The Romans loved turquoises, and the head of a Roman emperor carved in that stone was both up-to-date and erudite.

Onyx, so often used in those years, was said to repel love and was popular for mourning jewels. Like the bloodstone and cat's eye, it is quartz, and can be found in either black or white forms (apparently it means 'fingernail' in Greek) and both banded agate and the moss agate are even further quartzes, very much sought after in male jewelry of Victorian times.

Two red stones were seen many times in the nineteenth century, coral and garnets. Garnets in fact come in every colour except blue. But in Victorian times the red colours were most valued, both faceted as a garnet and *en cabochon* as a carbuncle – they were the same stone. Men

A magnificent and curiously shaped baroque pearl set most delicately with diamonds in 'knife-edge' work. English or French, *c.* 1885. Courtesy of Cameo Corner Ltd.

enjoyed owning a carbuncle because it was one of the stones referred to in the twenty-eighth chapter of the Book of Exodus as being in the breast-plate of Aaron, the High Priest. Owning one yourself, glowing richly as it did like blood, put you onto a fictional plane with Moses and into the 'holy' range of colours.

It was believed that the Evil Eye was repelled by coral, hence the amount of charms still made in superstition-conscious Italy. The stone is formed from the calcareous skeletons of myriads of tiny polyps which live in colonies in warm water at a moderate depth. It comes in many colours from white to dark-red – the angel's skin colour was much in demand, as it is today and, because people have believed that corals will relieve a fever in children, jewelry in coral was mainly made for them. A soft stone, it is easy to carve, which meant that small pieces made excellent tie-pins.

Outstripping even the garnet in its wide range of colours is the tourmaline – colourless, browns, reds, greens, blues, violets and even two colours within the same stone, changing from a pale pink at one side to a pale green at the other. It is a comparatively hard stone and looks its best when shown off as large, step-cut stones, about an inch across, surrounded by diamonds and linked to the next motif, as a necklace.

Very much the same effect can be got through using spinels. They are bright and very transparent and even harder than tourmalines. Both these stones have a crystalline structure but they are composed of different chemicals and metals, and both of them are found in Ceylon (Sri Lanka) amongst other countries. Both of them have also, very often, been sold to some unsuspecting person as a more expensive stone. Many a spinel, for instance, has enriched a merchant's palm having been sold as a ruby or a tourmaline for an emerald, and many of the fine 'historic' gems in crowns and on reliquaries in cathedrals are really the more humble tourmaline or spinel. However, by the year 1900 these stones were being sold honestly for what they were, and an extremely lovely sight it must have been to see an Edwardian beauty at a dinner party with a dress of silver lace with lavender chiffon scarves floating from her shoulders and a parure of necklace, earrings, bracelets and brooch of palest violet tourmalines fringed with dazzling diamonds and set in finest platinum.

A final stone much enjoyed for its colour and its translucency was the aquamarine. This is technically from the beryl family, comes in large crystals, very clear and in a huge range of shades of blues – obviously a superb colour to be worn in the pastel Edwardian times.

Many a parure has been set with gold, with cannetille-work (very fine Neo-Etruscan granulation) to give it greater texture during the mid- and late-Victorian times, but by the end of the century the stones were more valued for their extreme simplicity and were set in the lightest of traceries in rococo scroll designs in platinum.

Epilogue

Queen Victoria died on 22 January 1901 and was succeeded by her fifty-nine year old son Edward VII with the beautiful, deaf and disabled Alexandra by his side.

Most people feel that this was the end of an epoch but it was not, it was merely the end of a life – Victoria's influence had not been felt in the world of fashion and jewelry for many years.

The Duke of Kent, about eighty years before, had described his baby daughter Victoria as 'rather a pocket Hercules than a pocket Venus' and so she turned out to be. A completely new era had begun with her reign and she personified all the Victorian virtues: national pride, imperialism, industry and, above all, family life. She became identified with the spirit of the age to such an extent that her name was attached to all kinds of objects, from cough lozenges to tin mugs, without the hint of an insult. Intensely emotional and impetuous as a young bride, desolate after her husband's death in 1861, she had made 'royalty' a favourite subject by the time of her own death in 1901.

Fashions and jewels of the Edwardian era became constricted in design through the example of the monarch and the court. Edward, denied his responsibilities for so long, showed unwearying industry, remarkable practicality, tact and a high sense of mission. Naturally he and Alexandra frowned upon the Art Nouveau which must have looked to their weary eyes as Nature blasphemously fragmented and as a product of dubious philosophy which refuted much of the teachings of the established Church, which he was obliged to uphold.

But quality was never in question and some of the finest jewelry was set in the years before the First World War. However, a dividing line was drawn between the sale of quality clothes and that of quality jewelry. Haute couture was made personally for a known customer; top jewels were bought across a counter and made anonymously for sheer profit. The first of the many chain-store retail jewelry shops began to creep across the country and jewels (by unknown and often unrecorded designers) became totally international.

Added to this synthetic stones were developed for the first time (the ruby in 1904, the sapphire in 1909) and Mikimoto established the cultured pearl industry in 1914. It was all becoming highly commercial.

The pound and the dollar became the dictators and wealth had to be seen to be believed. As a result Edwardian ladies in evening dress displayed everything they owned, of whatever period, at the same time.

Hair ornaments of diamonds (a bee, a house-fly, a crescent moon and a fern or feather) might all nestle together in the highly controlled coiffure; earrings of pink or grey pearl studs, or languidly dropping hinged diamond flowers, were seen because the ears were exposed. Chokers of diamonds (if possible) or row upon row of pearls, and longer rivières of pale pretty faceted stones, or crystals set in silver, would set off the full-bosomed look, and brooches would be scattered all over the bodice of the evening dress. These would be garlands or ribbon bows of diamonds in the lightest rococo settings of platinum, the older stars and crescent moons (handed down from their mothers) and the even older double hearts in diamonds too. These were the Luckenbooth jewels, Scottish symbols dating from 1700 when they were used as love-tokens or sometimes worn in Georgian days as a protection against witches. They were sold in the locked booths (hence Luckenbooth) around St Giles's Kirk in Edinburgh and most satisfactorily combined an interest in the past, an interest in Scotland and a sentimental attachment to the donor.

Finger-rings abounded in the paler shades of gemstones and there were beautifully flexible bracelets – sometimes delicately gemset in the shape of individually mounted amethysts centred with a spray of inlaid seed-pearls or diamonds. Floral designs were back on the lines of the Georgian rococo, feminine as Madame de Pompadour, and many sheets of anonymous designs were bought by retail firms to make beautifully sterile jewelry for faceless people.

The 1914–18 war put an end to the epoch. The German Bauhaus influence afterwards saw a new approach to jewels. Victorian work looked so hopelessly outmoded that it was put away in safety because even their stones could rarely be re-set into the new designs and it was not financially advantageous to attempt to re-use old stones or metals. Lately it has become the fashion all over again to wear Victorian jewelry, partly because the pendulum has swung back; very few people patronize couturiers but buy their clothes from retail stores and wear their Victorian heirlooms to make a personal statement of their individuality.

It says much for the sheer quality of the nineteenth century craftsman that such a huge quantity remains today in such excellent condition. Every human being appreciates quality and in Victorian jewelry, even the modestly priced, one can be sure of finding it.

Queen Alexandra at the turn of the century by Sir Luke Fildes. Here one can see the way women tried to look like butterflies, with their neat heads, slim throats encased with jewels, a broadening out at the bosom and hips with the tiniest of waists in between and with chiffon floating from the shoulders. To wear clothes like these they had to by hauled into rigid whalebone corsets. Note the snake bracelets and the jewel in her hair. National Portrait Gallery, London.

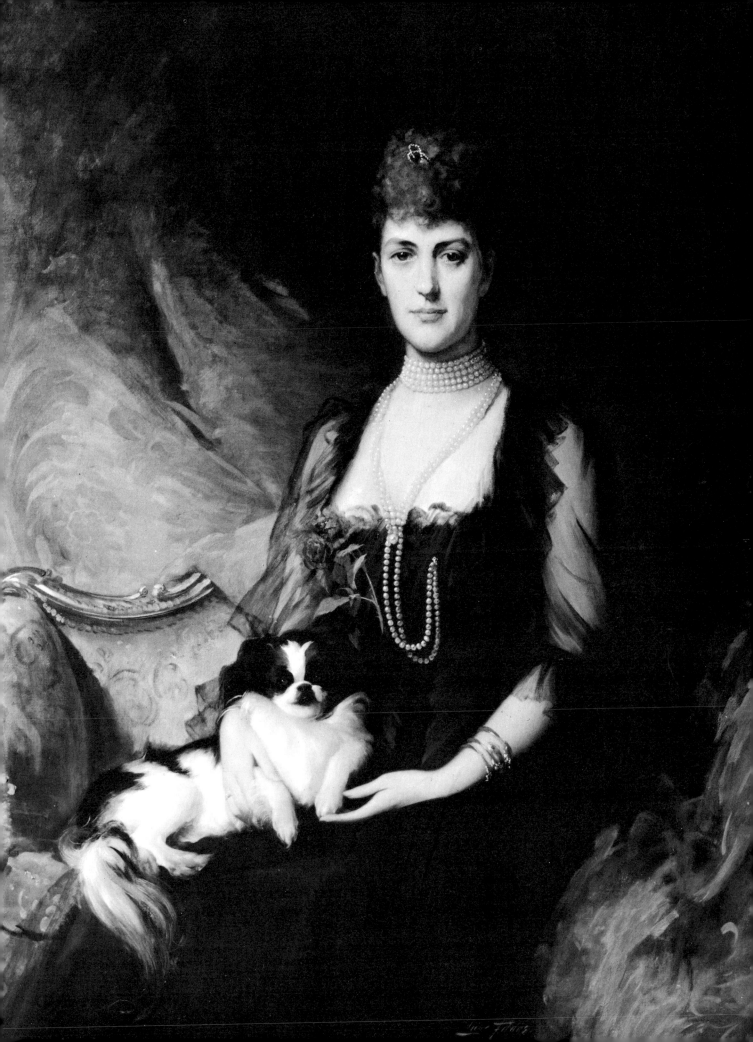

Appendix:
The Hardness of Stones

Frederick Moh (1773–1839) worked out a scaling of stones according to their hardness, in about 1820, and this is still in use. Any stone can cut or scratch the stones which are softer than itself. The 'pecking order' of gemstones is as follows:

10. Diamond.
 9. Corundum – rubies and sapphires.
 8. Beryl – emeralds, aquamarines and topazes.
 7. Quartz – amethysts, cairngorms, tourmalines, zircons.
 6. Orthoclase.
 5. Apatite.
 4. Fluorite.
 3. Calcite.
 2. Gypsum.
 1. Talc.

Generally speaking, stones ranging from 7–10 on the Scale are transparent, and those from 1 to 7 are opaque.

Many gemstones in the 1 to 6 range are very beautiful, even though they were not much used in earlier jewelry. Some are almost too soft to be used for jewels, those in categories 1 and 2 being, relatively speaking, about as hard as a finger-nail.

A number of organic stones are grouped among the gemstones: coral, for instance is $3\frac{1}{2}$, amber is $2\frac{1}{2}$ and so are pearls. Others used in jewelry are lapis lazuli at $5-5\frac{1}{2}$, opal at $5\frac{1}{2}-6\frac{1}{2}$, turquoise $5-6$ and jade at $6\frac{1}{2}$ for nephrite and 7 for jadeite. ('Jade' being the overall term for either of these two stones.)

Chemically speaking pearls are made from calcium carbonate and calcium albuminate. Seen under a very strong loupe a pearl looks like a brick wall joined together with mortar. Unfortunately they will readily dissolve in acid (because the calcium carbonate predominates in their composition) and their lovely sheen and lustre can be blurred by the chemicals in the atmosphere.

Pearls are very soft (two to three on the Moh Scale) and must be separated from all other faceted gemstones to prevent becoming scratched. If a pearl necklace has a jewelled clasp (these have often been added or subtracted over the years when being re-strung, so pearl necklaces cannot really be dated – but you can date the clasp) a separate wrapping of protective material should be tucked around it . . . unless one is keeping the necklace, as one should, in its original case which was designed to guard against the clasp touching the pearls.

The trouble taken to string pearls with a knot of silk between is essential, more today than ever before, because of the pollution in the air. If you were a gemmologist you would be aware that pearls are very absorbent and readily destructible.

The average life of a string of pearls in regular use is about 150 years, providing that they are re-strung on silk by a professional at least once a year (six months is better) however little they have been worn. In Victoria's time the advice would possibly have been 'every two years', but then there was far less pollution in the air and no-one had ever dreamed of hair-lacquer.

Silk thread helps to protect pearls by absorbing the acid from the wearer's perspiration ('ladies only *glow*'); nylon, which is designed to absorb nothing, obviously should never be used. The pearls should be cleaned every time they are used, either with a soft chamois leather or by rubbing them gently with warm bran, then polishing them with a soft cloth. The greatest dangers today are scent, soap and hair lacquer (filled with controlled acid, eating through pearls like a road drill) and they can also be damaged by a lack of oxygen if permanently kept in a safe. Extraordinarily fragile and needing great care, Victorian pearls are sometimes at their finest now and one of the silliest things to do is to wear them in bed.

Selected Bibliography

Armstrong, Nancy *Jewellery, an Historical Survey of British Styles and Jewels* Lutterworth, London 1973

Ashbee, C. R. *Modern English Silverwork* Essex House Press, London 1909

Bainbridge, H. C. *Peter Carl Fabergé* Spring Books, London and New York 1949

Bapst, G. *Histoire des Joyaux de la Couronne de la France* Paris 1889

Blakemore, Kenneth *The Book of Gold* André Deutsch, London 1971

Blakemore, Kenneth *The Retail Jeweller's Guide* Iliffe, London 1973

Blanc, Charles *Art dans la parure et le vêtement* Paris 1877

Bradford, E. D. S. *English Victorian Jewellery* Spring Books, London 1968

Bradford, E. D. S. *Four Centuries of European Jewellery* Spring Books, London 1967

Bruton, Eric, *Diamonds* NAG Press Ltd, London 1971

Bury, Shirley 'A Liberty Metalwork Experiment', *Architectural Review* London 1963

Bury, Shirley *An Arts and Crafts Experiment, the Silverwork of C. R. Ashbee* Victoria and Albert Museum Bulletin 1967

Bury, Shirley *Pugin's Marriage Jewellery* Victoria and Albert Museum Yearbook 1969

Clifford, Anne *Cut-Steel and Berlin Iron Jewellery* Adams & Dart, Bath 1971

Clifford-Smith, H. *Jewellery* Methuen, London 1908

Cunnington, C. W. & P. *Handbook of English Costume in the Nineteenth Century* London 1966, Plays Inc, Boston, Mass. 1971

Dickinson, Joan Younger *The Book of Diamonds* Frederick Muller, London 1965

d'Otrange, M. L. 'The Exquisite Art of Carlo Giuliano' *Apollo* 1954 vol 59

Edwards, Ralph, and Ramsay, L. G. G. (Eds) *The Connoisseur's Complete Period Guides* The Connoisseur, London 1956, 1957, 1958

Evans, Joan *History of Jewellery, 1100–1870* Faber & Faber, London (rev. ed), Boston Book and Art Shop, Boston, Mass. 1970

Faulkiner, Richard *Investing in Antique Jewellery* Barrie & Jenkins, London 1968

Ferriera, Maria *René Lalique at the Calouste Gulbenkian Museum, Lisbon* Connoisseur 1971 vol 177

Flower, Margaret *Victorian Jewellery* Cassell, London (rev. ed) 1967 *Jewellery: Eighteen Thirty-Seven to Nineteen Hundred and One* Walker & Co., New York 1969

Gere, Charlotte *Victorian Jewellery Design* Kimber & Co., London 1972

Haweiis, Mrs H. R. *The Art of Beauty* London 1878

Higgins, R. A. *Greek and Roman Jewellery* Methuen, London 1961; Barnes & Noble, New York 1962

Holme, C. *Modern Design in Jewellery and Fans* Studio, London 1901–2

Hughes, Graham *Modern Jewelry* Studio Vista, London; Crown, New York 1968

Hughes, Graham *The Art of Jewelry* Studio Vista, London 1972

James, Bill *Collecting Australian Gemstones* K. G. Murray, Sydney & Melbourne 1972

Kendall, Hugh P. *The Story of Whitby Jet* Whitby 1936

Kybalova, Herbenova, Lamorova *The Pictorial Encyclopedia of Fashion* Paul Hamlyn, London 1969

Laver, James *A Concise History of Costume* Thames & Hudson, London; Abrams, New York 1969

Lewis, M. D. S. *Antique Paste Jewellery* Faber & Faber, London 1970

Longford, Elizabeth *Victoria R.I.* Weidenfeld & Nicolson, London 1964 *Queen Victoria: Born to Succeed* Harper & Row, New York 1965

Longley, Margaret; Silverstein, Louis & Tower, Samuel (eds.) *America's Taste 1851–1959* Simon & Schuster, New York 1960

Martyn, Mrs S. J. *The Ladies' Wreath* New York 1848

Maxwell-Hyslop, K. R. *Western Asiatic Jewellery c.3000–612 BC* Methuen, London; Barnes & Noble, New York 1971

Oved, S. *The Book of Necklaces* Arthur Barker, London 1953

Peter, Mary *Collecting Victorian Jewellery* MacGibbon & Kee, London 1970; Emerson Books, New York 1971

Ritchie, C. I. A. *Carving Shells and Cameos* Arthur Barker, London 1970

Rutland, E. H. *Gemstones* Paul Hamlyn, London 1974

Snowman, Kenneth *The Art of Carl Fabergé* Faber & Faber, London 1953; Boston Books, Boston 1970

Steingraber, E. *Antique Jewellery* Thames & Hudson, London 1957

Sutherland, C. H. V. *Gold* Thames & Hudson, London 1959; MacGraw Hill, New York 1969

Uzanne, Octave *Fashion in Paris* Paris 1898

Walker, Mrs A. *Female Beauty* London 1837

Wilson, Henry *Silverwork and Jewellery* John Hogg, London 1903

Also periodicals such as *The Court Magazine* (1837), *The Illustrated Belle Assemblée* (1806–1810), *The Illustrated Exhibitor* (1852), *The Illustrated London Household Magazine* (1863), *The Illustrated London News* (1837–1914)

Index